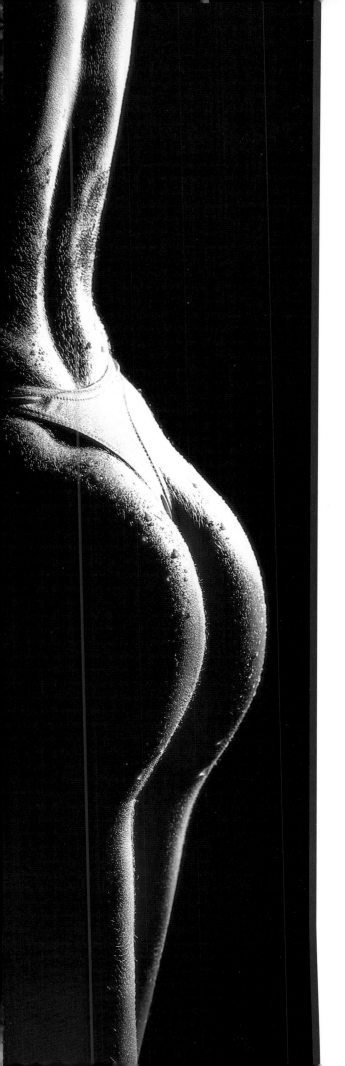

Lighting for Glamour Photography

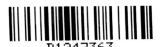

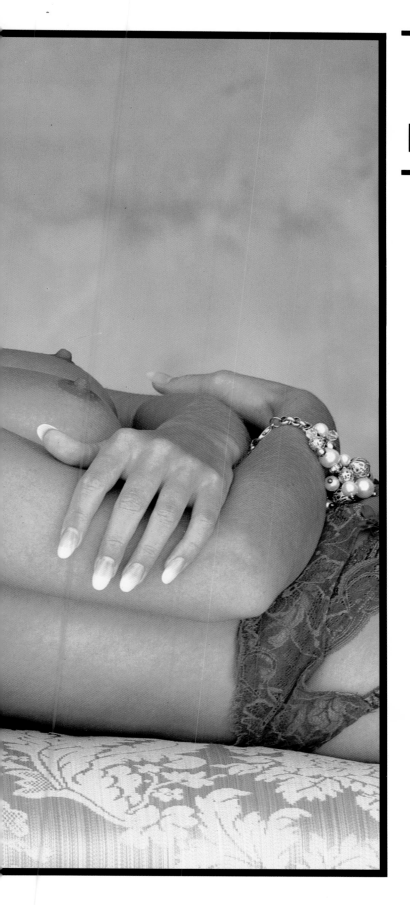

LIGHTING FOR GLAMOUR PHOTOGRAPHY

David Kimber

AMPHOTO
an imprint of
Watson-Guptill Publications
New York

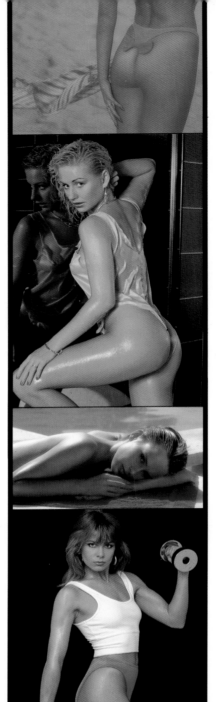

A QUARTO BOOK

Copyright © 1994 Quarto Inc
First published 1994 in New York by AMPHOTO, an
imprint of Watson-Guptill Publications, Inc., a division
of BPI Communications, Inc., 1515 Broadway,
New York, NY 10036.

Reprinted 1995

Library of Congress Cataloging-in-Publication Data

Kimber, David.
 Lighting for glamour photography/by David
 Kimber.
 Includes index.
 ISBN 0–8174–4230–8 (pbk.)
 1. Glamour photography. 2. Portrait photography
 – Lighting.
 3. Photography – Lighting. I. Title.
 TR678.K55 1994
 778.9'24 – dc20 94-9028
 CIP

This book was designed and produced by
Quarto Inc
The Old Brewery, 6 Blundell Street
London N7 9BH

Senior editor: Kate Kirby
Senior art editors: Penny Cobb, Anne Fisher
Designer: John Grain
Text editor: Joël Lacey
Diagrams: Chris D. Orr, David Kemp
Picture Manager: Giulia Hetherington
Editorial Director: Sophie Collins
Art Director: Moira Clinch

Typeset by Central Southern Typesetters, Eastbourne
Manufactured by Regent Publishing Services,
Hong Kong
Printed by Leefung-Asco Printers Ltd, China

Contents

1 EQUIPMENT

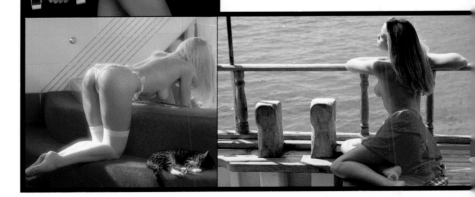

Foreword

For me, there is one quotation that captures the essence of glamour photography: "A lovely lady, garmented in light/From her own beauty" (Shelley). The photographer's task is to present a model in the best possible way, to flatter her and emphasize her natural allure. This inevitably involves understanding light, whether natural or artificial, and, while it is true that ideal lighting conditions make it possible to shoot beautiful pictures of models, equally, unflattering light can make even the most beautiful model appear quite ordinary.

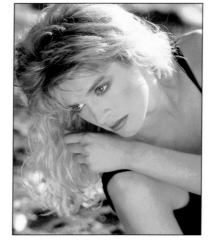

Light is the key to quality glamour photography: it has the potential to impress, excite and even humble you with its infinite variety of both quality and color; then again it is just as likely to mislead and frustrate. The aim of this book is to help you to learn how to analyze light, to make it work for you, and to take better glamour pictures. Much of the information is the result of my 15 years as a professional, and it's the kind of information I wish I had been able to glean from a single volume during my student years. It seems that many books have been written touching on the importance of lighting for glamour, but none has specifically targeted the subject.

The book opens with a short chapter on photographic equipment, which I have deliberately kept brief to allow the majority of the book to deal with the many facets of lighting. The second chapter concentrates on lighting indoor situations, both in the studio and on location. Such aspects as mixing daylight and artificial light sources are covered in some detail, as is the

How to use the symbols

Many of the pictures in this book are accompanied by diagrams which show the lighting set-up and indicate whether filters, backgrounds or other accessories were used and their relative positions.

MODEL
Model is represented by a reduced version of the featured picture.

WEATHER CONDITIONS

☀ Sunny

☁ Cloudy/Hazy/Overcast

TIME OF DAY
Time of day is represented by a sun symbol in a specific position

Morning Middle of day Afternoon Early evening

DIRECTION OF LIGHT
Direction of light is represented by arrows.

➤ Midday light

➤ AM or PM light

CAMERAS

▣ Medium format

▣ 35mm

useful technique of combining tungsten and flash. The Great Outdoors takes center stage in chapter 3, with an initial section appraising the quality of light at different times of day, followed by a look at the benefits of various weather conditions. The rest of the chapter is devoted to light modifying accessories, namely reflectors, fill-in flash, and filters. "Glamour Locations" (chapter 4) presents a selection of the most popular indoor and outdoor settings, from beaches to bathrooms, and forests to four-poster beds. The final chapter of the book considers the next step for the keen and committed amateur glamour photographer – namely, turning pro.

An appreciation of all aspects of light is the best possible foundation for a career in glamour, and it's equally valuable to the casual amateur. I hope this book may inspire all of you to pick up your cameras and practise the art of glamour photography. Good luck and happy shooting!

David Kinder

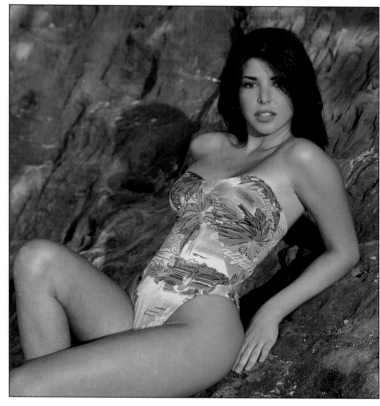

TRIPOD HEIGHT

Tall

Medium

Low

LIGHTING
Different height stands are represented in the symbols.

Fill-in flash

Video lights

Soft boxes

Tungsten spotlights

Reflector

Flash head

REFLECTORS
Reflector symbols are colored white, silver, or gold.

2 or 3 panels side by side

Panels

Mirrors

Circular hoop reflectors

BACKGROUNDS
Backgrounds are represented by a gray tint behind the miniature of the model.

HANDHELD
Hand held items are represented with a hand symbol.

FILTERS
Filter symbols are shown in the relevant color.

81a warm-up

81b warm-up

81c warm-up

Soft focus

Polarizer

Graduated

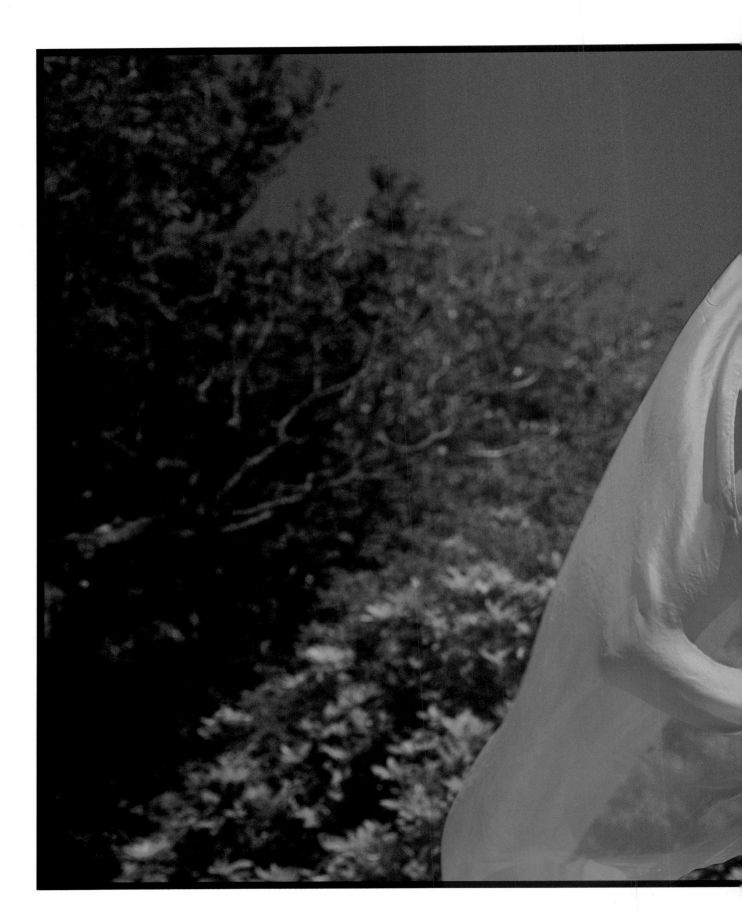

EQUIPMENT

The range of equipment available to the glamour photographer is vast, yet the most sensible advice is to keep your system as simple as possible, and to master each individual piece of equipment before investing in another. Remember that a camera is only as good as the photographer looking through the viewfinder and the model posing in front of it – all the equipment and accessories in the world do not make you a better photographer.

The impact of a polarizing filter on a clear blue sky is shown to good effect here, emphasized by the choice of a contrasting color for the model's costume. The matching wind-blown material adds an interesting element of movement to the shot.

TECHNICAL DATA
Camera
Bronica ETRSi
Lens 100mm
(medium telephoto)
Film Fuji RDP100
Exp 1/125th – f5.6

Cameras

Modern 35mm SLR (single lens reflex) cameras are extremely versatile, and are well-suited to glamour photography for many reasons. They are small, light, and easily portable. A 35mm camera fitted with a standard (50mm) lens can easily be hand-held at speeds as slow as 1/60th second without fear of camera shake becoming a problem – a tripod is only a necessity at speeds slower than 1/60th. They accept a vast range of interchangeable lenses and accessories, making for a very flexible camera system.

PRO POINTERS

■ 35MM CAMERAS ARE relatively cheap to buy and economical to run, in terms of images per roll of film, compared to larger format camera systems.

■ A LARGER RANGE OF film is available for 35mm cameras than for any other format.

■ THEY ARE HIGHLY sophisticated, providing total automation if required (auto focus, automatic metering, automatic exposure, autowind, etc.), but most can revert to full manual operation should you prefer to exercise more control over your pictures.

■ THE ONLY DRAWBACK with 35mm is the physical size of the image. When it comes to reproduction, there is no substitute for image area – the larger the negative or transparency, the better chance a printer has of making a perfect reproduction. For example, the degree of magnification needed to enlarge a 35mm image to poster size is much greater than is the case with a 6 × 7cm (medium format) original, so the final, much magnified reproduction quality of 35mm has little chance of matching the less-magnified quality of the larger format.

35mm SLR camera
Shown here are an actual size 35mm transparency and a section of the same image considerably enlarged.

Medium format cameras are less versatile than the smaller 35mm systems, but they all have the major advantage of producing larger negatives and transparencies. The film is 6cm wide, and picture formats may be 6 × 4.5cm, 6 × 6cm, or 6 × 7cm. These give higher-quality images for reproduction, and are therefore more suited to work intended for publication – given the choice, most publishers will use a medium-format image in preference to 35mm.

PRO POINTERS

■ MOST MEDIUM FORMAT systems offer interchangeable film backs, allowing you to shoot the same picture on several different types of film (color transparency and negative, or black and white) if required. Polaroid backs are also available, so instantly viewable test shots can be taken to establish image content and exposure.

■ MEDIUM FORMAT systems offer a range of lenses and accessories to rival 35mm, with the added bonus that they are primarily intended for professional use and thus tend to be manufactured to a higher mechanical tolerance than some 35mm systems.

■ THERE ARE DRAWBACKS to using medium format, but the following disadvantages are easily outweighed by the single advantage of greater image area.
The cameras are larger, heavier, and generally more expensive than 35mm. They are less economical on film than 35mm, with a maximum of 15 shots per film (6 × 4.5cm) and a minimum of 10 (6 × 7cm). Because they are heavier, the cameras are less easy to hand-hold, and a tripod becomes a necessity in most situations.

Medium format camera The lesser degree of enlargement necessary from a 6 × 4.5cm (medium format) transparency means improved image resolution.

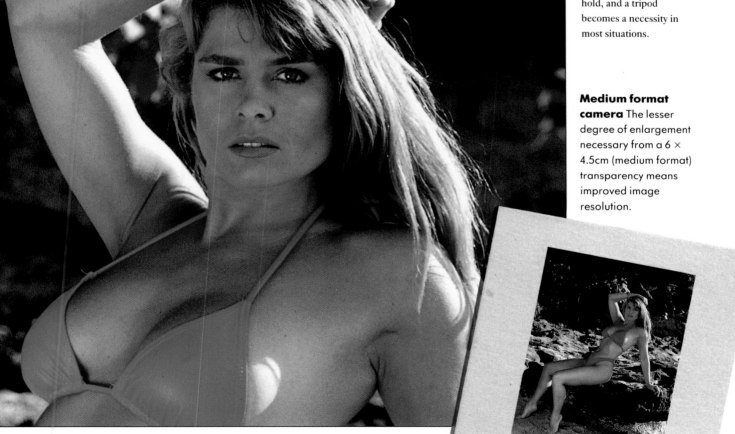

Lenses

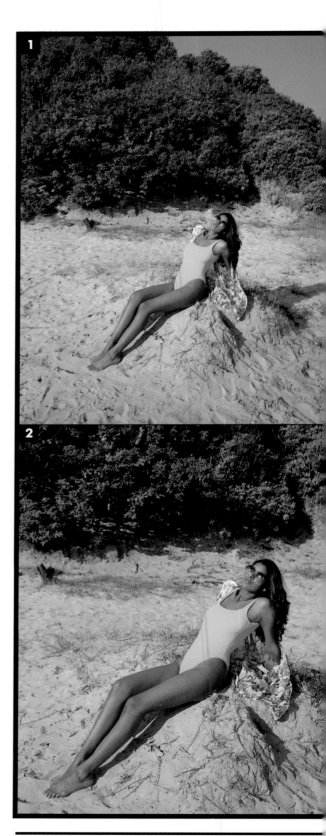

The lenses best suited to glamour photography are those within the short to medium telephoto range. For 35mm this includes 85mm and 135mm lenses, the former being the most useful. For medium format, lenses between 100mm and 150mm are the best choices.

Zoom lenses (short to medium telephoto) covering the focal range (eg. 70 – 150mm) are available for 35mm systems, and these offer you considerable creative flexibility, at the expense of extra weight, slightly less precise focusing, and increased risk of lens flare (due to there being more potentially reflective elements within zoom lenses).

PRO POINTERS

■ IF FUNDS PERMIT, AVOID zooms and equip yourself with fixed focal length lenses only.

■ THE REASON FOR SHORT to medium telephoto lenses being ideally suited to glamour is that the degree of enlargement they provide corresponds to an ideal camera-to-subject working distance – models hate to have a photographer working very close to their faces.

■ SHORT TO MEDIUM telephoto lenses have three other real benefits:– They enable you to throw backgrounds completely out of focus, by taking advantage of their wide maximum apertures (f2.8 or f4, for instance). The wide apertures also mean that the image in your viewfinder appears clear and bright. The narrower the maximum aperture of your lens, the darker the image appears. The longest lenses (500mm and 1000mm) are very difficult to use because their widest apertures (typically f8 or f11) make for a very dim viewfinder image, which can make focusing and selection very awkward. Short to medium telephoto lenses are generally small and light enough to permit hand-holding at useful speeds. As a rule, the shutter speed closest numerically to the focal length of your lens is the slowest speed recommended for hand-holding. For instance, an 85mm lens should be "holdable" at 1/60th of a second, while a 135mm should be usable without a tripod at 1/125th.

■ TELEPHOTO LENSES IN general provide a reduced "depth of field" compared to short focal length lenses (depth of field is the amount of front to back sharpness in an image). This "fall-off" becomes more pronounced the longer the lens used, and it is a useful feature to understand in glamour photography, as it enables you to isolate your model from the background.

TUTORIAL

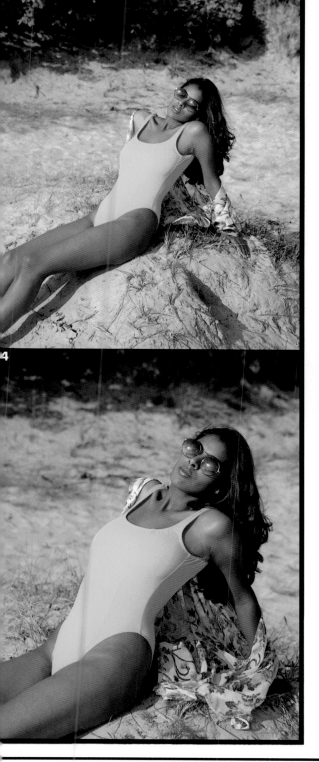

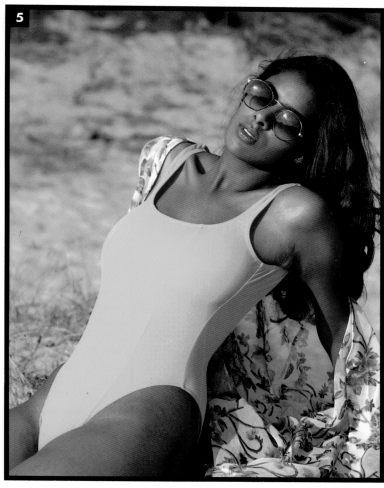

The effects of different lenses are clearly demonstrated here.
1 Wide angle lens – 50mm on Bronica (medium format). Equivalent 35mm format lens would be 28mm.
2 Standard lens – 75mm on Bronica (medium format). Equivalent 35mm format lens would be 50mm.
3 Short telephoto lens – 100mm on Bronica (medium format). Equivalent 35mm format lens would be 60mm.
4 Medium telephoto lens – 150mm on Bronica (medium format). Equivalent 35mm format lens would be 85mm.
5 Medium long telephoto lens – 200mm on Bronica (medium format). Equivalent 35mm format lens would be 135mm.

TECHNICAL DATA
Camera
Bronica ETRSi
Film Fuji RDP100
Exp 1/125th – f8

Films

In most situations, the best film for the glamour photographer to use is the slowest (lowest ISO) possible, given the lighting conditions. The slower the film, the finer the grain structure, the richer the color saturation, and the more impressive the image sharpness. For color work, 25, 50, or 64 ISO films are ideal, but all three require a high level of light.

Films with a medium ISO rating, approximately 100 ISO, represent the best compromise between increased light-sensitivity and image quality. They provide very good color rendition and image sharpness, without introducing too much grain.

Faster films (400 ISO, for example) feature coarser grain, weaker colors, and a slight reduction in image sharpness. In some cases, particularly when using tungsten light on daylight film, the effect can suit glamour subjects. As a rule, however, the noticeable loss in color saturation, outdoors especially, makes these films an unwise selection for the glamour photographer. When working with tungsten light and wishing to produce a "daylight" result, you have the option to use tungsten-balanced film. Alternatively, add an 80a (blue) filter to your camera if you only have daylight film.

Color transparency films demand a high degree of accuracy in exposure to produce the best possible results. Even small discrepancies can make your pictures noticeably lighter or darker. It is wise to bracket your exposures (that is, shoot three pictures: half a stop lighter than metered setting, half a stop darker than metered setting, and actual setting) to achieve the ideal exposure.

Different color transparency films have varying color characteristics. Ektachrome is cool; Kodachrome and Agfachrome are neutral, giving faithful color reproduction; and Fujichrome offers bright, warm colors with reds and greens appearing vivid.

IMAGE CONTRAST

Although the sensitivity of film is constantly being improved, even the highest quality color transparency film cannot record both extremes of light and shade in a high contrast situation. As a rough guide, expect 100 ISO transparency film to have a working range of six stops. If your exposure meter tells you that the difference between the highlight and shadow area of your picture exceeds six stops, then the options are: to allow the highlights to burn out; to let the shadows become very dark and without detail; to reduce the overall contrast by raising the light level in shadow areas with fill-in flash or reflectors.

PRO POINTERS

■ KEEP UNUSED 35mm films in their plastic canisters to avoid grit collecting in the light trap (through which the film emerges), which is made of felt and gathers dust and dirt very easily. A single piece of grit can lead to an entire roll of film being scratched.

■ DO NOT LEAVE FILMS in direct sunlight – high temperatures can affect the emulsion layers, leading to unwanted color shifts.

■ STORE FILMS IN A refrigerator if possible, but remember to remove them several hours before their intended use, so that they can return to room temperature.

■ ALWAYS PROCESS YOUR exposed films as soon as possible.

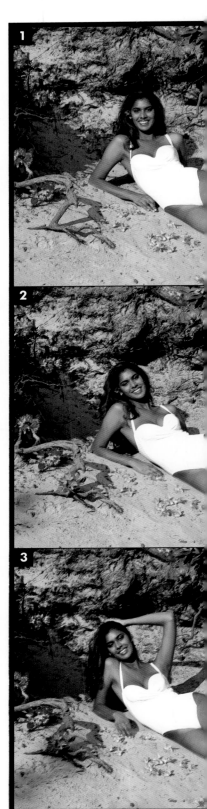

TUTORIAL

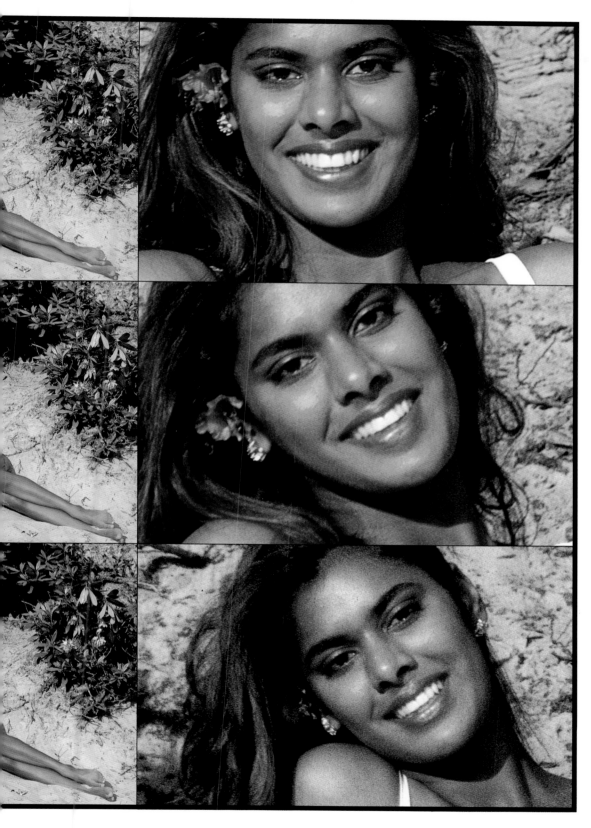

1 The slowest of the three films tested produces the best result. Image sharpness is excellent, and colors are realistic and well saturated. Fuji Velvia 50ISO was used; exposure 1/125th — f5.6.

2 Although not far behind its slower counterpart, the 100ISO film cannot quite match it either for sharpness or quality of color reproduction. Shot on Fuji RDP100; exposure 1/125th — f8.

3 The result here is typical of faster transparency films — grain becomes noticeably coarser and colors become washed-out and unrealistic. Shot on Fuji RHP400; exposure 1/250th — f11.

TECHNICAL DATA
Camera
Bronica ETRSi
Lens 100mm (short telephoto)

Accessories

Assuming that a standard 50mm lens on a 35mm camera can be hand-held at speeds no slower than 1/60th second, you are only able to make use of the other (slower) half of your shutter speed range by using a tripod.

Do not be fooled by tripods which are marketed as cheap, light and portable. The best tripods are of solid construction and therefore heavy. This may make them more expensive and a nuisance to carry around, but bear in mind that their purpose is to counter camera shake.

Motor drives are by no means indispensable, but they can be useful if you want to record your model in motion. Some permit up to ten frames per second to be exposed, allowing you to shoot a sequence of movement. Motor drives also have a "single-frame" setting, on which they function as a power winder. This is generally of more use than the "continuous" facility, permitting you to select the optimum moment for each shot, yet advancing the film swiftly and smoothly, thus preparing the camera for the next exposure far more rapidly than could be achieved manually.

These two sequences show how effectively a motor driven camera can record movement. Even if the multi-frame per second facility is not utilized, a motor drive is still an invaluable accessory – the rapid hands-free film advance affords you the invaluable luxury of devoting your undivided attention to the model.

TECHNICAL DATA
Camera
Nikon F801s
Lens 30–70mm AF (autofocus) zoom set at 70mm (short telephoto)
Film Fuji RDP100
Exp 1/125th – f8
Filter 81b (warm-up)

┤ LIGHTING PROPS AND ACCESSORIES ├

Barn doors Adjustable flaps used with a studio light to control the width and direction of the light spread.

Gobo (UK) A perforated metal sheet which, when slotted into a studio light, projects a focused image onto the background. Subject matter varies from abstract patterns to actual images, such as cityscapes.

Gobo (USA) A device used to shield a light source, directing the light so that it strikes only one particular area of a scene.

Fake palms Used to add a tropical feel to a shot. They can either be shown within the image or used to cast shadows across a scene.

Scrim A sheet of metal gauze used to soften light (usually with tungsten lights).

Snoot An attachment used to direct light accurately at a restricted area. Often attached to hair lights.

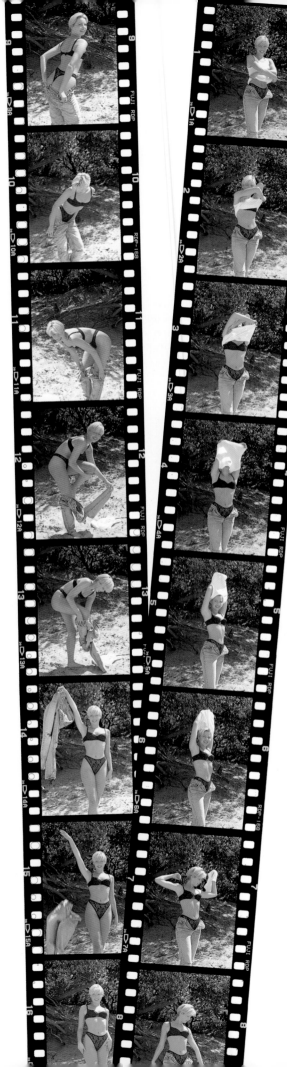

Lights

Of the items shown here, only the reflector, the fill-in flashgun and the exposure meter are primarily intended for outdoor use, although tungsten spotlights, normally used indoors, can usefully be converted to battery power for location work outside.

The studio lights illustrated here are representative of the two types of electronic flash, as discussed in detail on page 24.

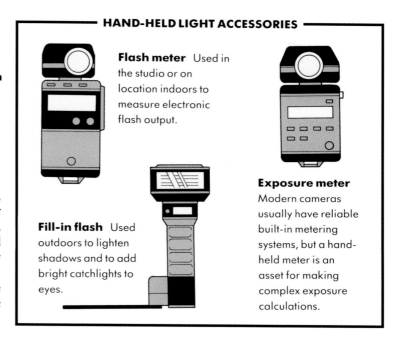

HAND-HELD LIGHT ACCESSORIES

Flash meter Used in the studio or on location indoors to measure electronic flash output.

Fill-in flash Used outdoors to lighten shadows and to add bright catchlights to eyes.

Exposure meter Modern cameras usually have reliable built-in metering systems, but a hand-held meter is an asset for making complex exposure calculations.

Soft boxes Sometimes known as "wafers," these large but very light accessories provide a wide, even spread of flattering, diffused light, making them ideal for glamour work.

Flash head with snoot Used for directing a concentrated light at a limited area

Flash head with brolly Umbrellas create a softened, relatively diffused light, and come in three colors – white, silver, and gold.

Flash head with reflector dish Self-contained flash heads (monolights) like this vary in power output from 200 to 1500 w/s. Different-sized reflector dishes can be added to vary the quality of the light, from soft and subdued to harsh and defused.

Tungsten spotlight Shown here fitted with optional barn doors, these units, usually between 800 and 2000 watts in capacity, provide a constant source of light with a color temperature of 3200k.

Generator Used to power up to three flash heads, these units have output capacity of between 1500 and 6000 w/s (watts per second). The most advanced units can cope with asymmetric lighting ratios, allowing the photographer to select a different output level for each of the three outputs, if required.

Quad flash head Example of the type of flash head connected to a generator or power pack.

Circular reflector Collapsible 1 yard reflector made of fabric and available in white, silver, and gold, usually with a different color on each side. Large 2 × 1 yard panel reflectors are also widely used.

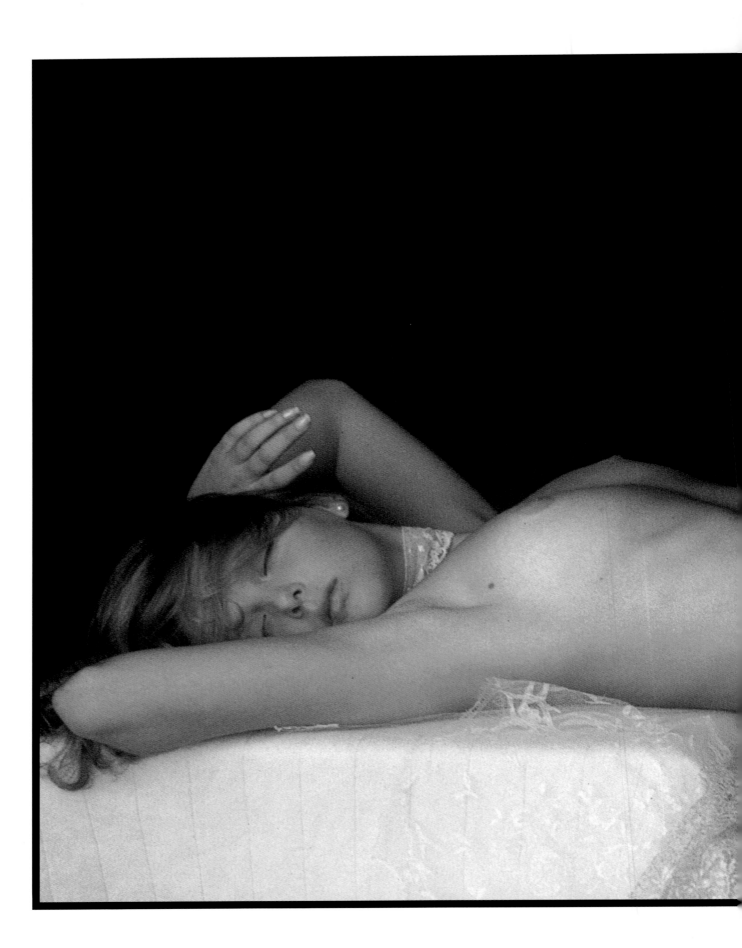

INDOOR LIGHTING

2

Indoor glamour photography holds one major advantage over outdoor work, namely the high level of control which can be exercised over lighting compared to the ever-present element of unpredictability outdoors.

This control is particularly relevant in the studio, where everything needed for glamour photography should be conveniently within reach. The privacy aspect of indoor locations is also important, helping to create a comfortable working environment for both model and photographer.

This delightfully cool image utilizes a single greatly diffused light source placed almost directly above the model – bathing her in a pool of soft, nearly shadowless light.

TECHNICAL DATA
Camera Nikon F3
Lens 85mm (short telephoto)
Film Fuji RHP400
Exp 1/125th – f8
Filter 81a (warm-up)

IN THE STUDIO

This shot shows the three-quarter lighting position, with two lights placed one above the other, to camera right. White reflectors to camera left soften the shadows. A large panel to camera right between the lights and background prevents light spillage on the backdrop. Note how the lights show off the curvaceousness of the model's body, and reveal the texture of the white satin sheet. Simple "non-colors" (black, white, gray) draw the viewer's attention directly to the model.

In nature, there is only one light source – the sun. The many different lighting effects that occur outdoors are all the result of light from the sun being modified by clouds, water, sand, foliage, and so on.

The same theory should be applied in the studio, and on location indoors. Base your glamour photography on one main light – a "key" light – to provide the majority of the illumination, and govern the exposure, for each shot. Think of your key light as you would the sun. Be prepared to control the effect of this light by reflection or diffusion before you complicate the situation by introducing additional light sources. These may be added, of course, but their purpose should only be to control shadows, illuminate your background, or introduce specific effects.

TECHNICAL DATA
Camera
Mamiya RZ67
Lens 250mm
(medium telephoto)
Film Fuji RDP100
Exp 1/60th – f8

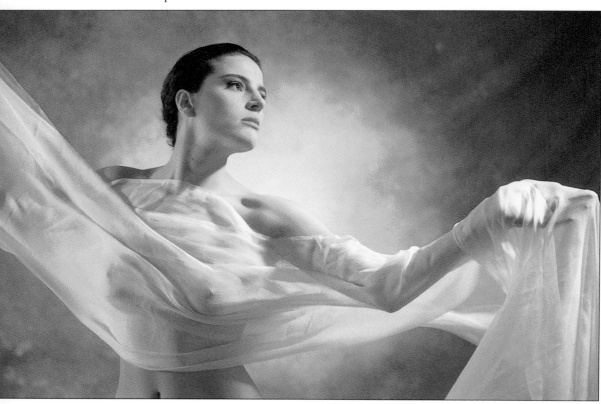

This striking image utilizes side lighting to dramatic effect – a single undiffused light source placed high up at 90° to camera right creates shape-enhancing shadows around the model's face and body, while reflectors to camera left ensure that shadow detail is not lost. Unusually, a dry-ice machine has been used to produce the "smoke effect," which helps to separate the model from the canvas background.

TECHNICAL DATA
Camera Nikon F3
Lens 50mm
(standard)
Film Fuji RHP400
Exp 1/60th – f5.6

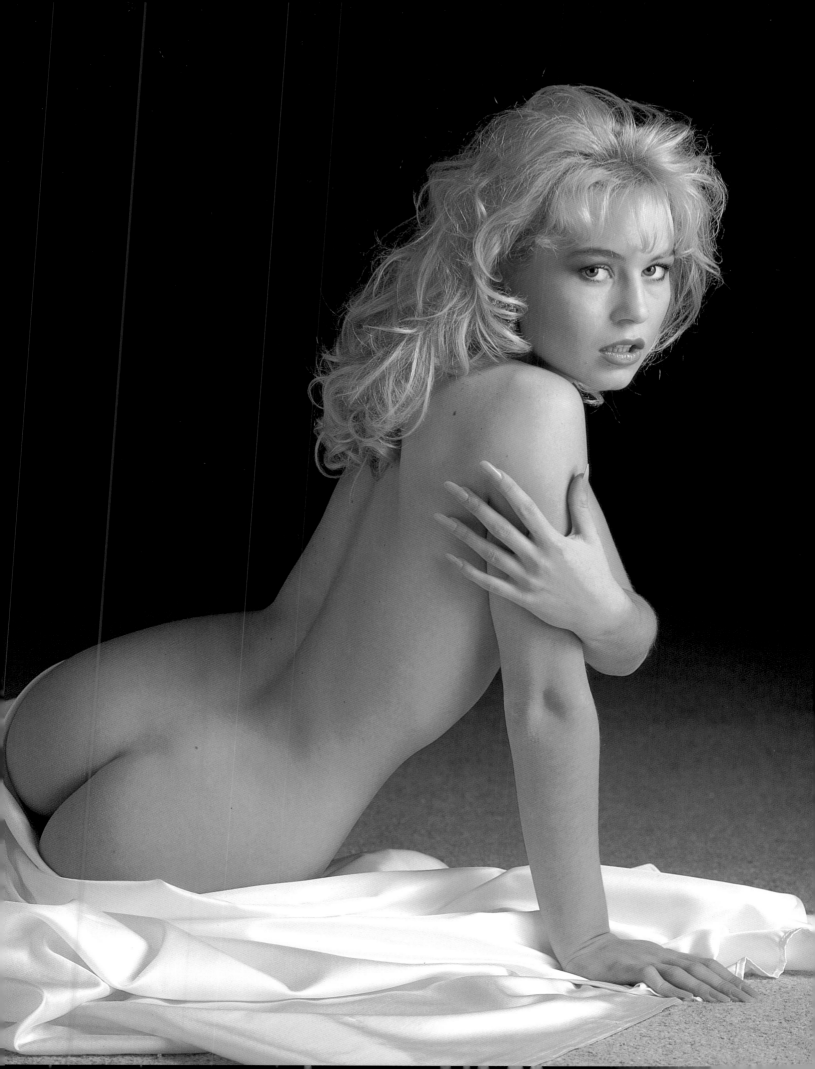

Working with one light

The fastest way to learn how lighting works is to keep it simple. Starting with just one light is the ideal way to learn the theory of studio lighting. Place the light in various positions around your model, maintaining the same height, which should be just above her eye level. Adjust the position of the light by about 45 degrees each time, and note the effect of each different position on your subject. The following are the four main positions for a key light:

Frontal lighting accurately portrays color in your model's body and clothing, but, by only casting shadows behind her, gives little impression of depth or shape.

Side lighting introduces strong shadows to one side, producing bold and dramatic results, and creating a very strong, three-dimensional feel. The results are probably too dramatic for conventional purposes.

Back lighting is also of little use for glamour photography, as it results in your model appearing in silhouette form only, with her outline possibly rimmed with light. Back lighting is most usefully employed to add life to your model's hair, but only as an addition to front or side lights, which reveal her face and body.

Three-quarter-front lighting is the ideal key-light position for glamour photography. Place your light at approximately 45 degrees to your camera position. Be aware that a light placed too high replicates midday sun, which is by far the least successful time of day to be shooting glamour out of doors. The "just above eye-level" position echoes the natural light of early morning or evening – the most flattering periods for glamour photography.

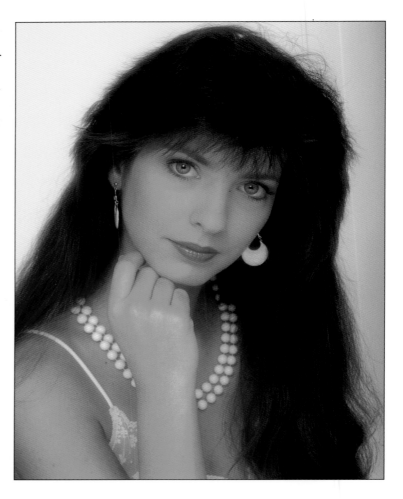

This shows the ideal three-quarter-front position for a single light set-up, with a gold reflector held to camera left to reduce shadows. Note that the light source common to all the shots on these two pages is less diffused than would normally be used in order to emphasize the shadow positions. A soft box would have produced a more flattering diffused light.

TECHNICAL DATA
Camera
Bronica ETRSi
Lens 150mm (medium telephoto)
Film Fuji RDP100
Exp 1/250th – f11

— TUTORIAL —

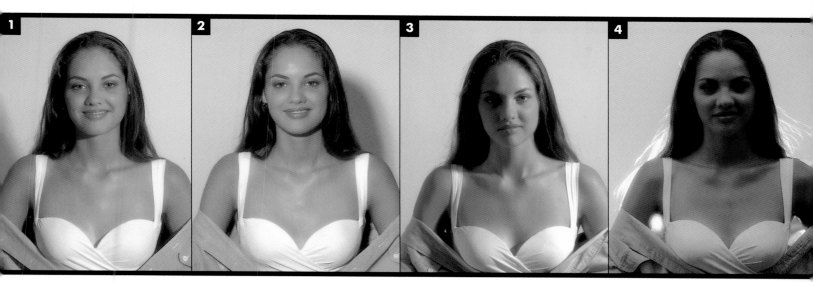

To study the effects of light, experiment with a single light source in different positions.

Conventionally the light source is always just above eye level.

1 This shows three-quarter-front lighting with the light correctly positioned just above the model's eye level.

2 An example of near frontal lighting with the light positioned as close as possible to the lens axis.

3 This shows side lighting with the light positioned at 90° to camera right.

4 Here the model is backlit with the light positioned directly behind her head.

TECHNICAL DATA
Camera
Bronica ETRSi
Lens 150mm
(medium telephoto)
Film Fuji RDP100
Exp 1/125th – f11

— TUTORIAL —

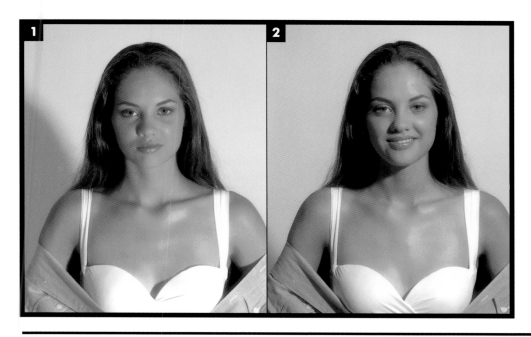

This tutorial demonstrates the use of high and low lighting.

1 This shows an unusually low lighting position, which lends a dramatic feel.

2 In this case an unusually high lighting position produces unflattering shadows.

TECHNICAL DATA
Camera
Bronica ETRSi
Lens 150mm
(medium telephoto)
Film Fuji RDP100
Exp 1/125th – f11

Electronic flash

Most studio-based glamour photographers use electronic-flash systems because they are reliable, powerful, and adaptable. The greatest advantage of flash over any other light source is its color temperature (see page 26) which, at 5,500K, is the same as daylight. This means that all normal daylight-balanced color film can be used with electronic flash in the studio without any adjustment or compensation being necessary. Studio flash units are available in two main types:

Power pack and heads

In this set-up the power pack is a separate unit, and has facilities for up to four heads (the flash equivalent of lamps) to be attached. The power available is likely to give more than enough light for the photographer to use a slow film together with a fast shutter speed/narrow aperture combination. This abundance of power is the main advantage of the single power-pack option.

Monolite

This type of flash unit is smaller and less powerful, but has the benefit of being self-contained: the flash head and power pack are within the same body. Several of these lights may be used independently within a single lighting set-up. The individual monolite may have its own flash sensor or "slave," enabling the photographer to connect the camera-synchronization lead ("sync lead") to the key light only. The built-in slave sensors on the other lights "see" the key light flash and trigger automatically.

A studio-lighting system, based on multiple self-contained flash units, has a distinct advantage over the single power-pack method. Should your single power pack malfunction, that will be the end of your shoot for the day. If one of the monolites develops a fault, it can be withdrawn without affecting the performance of the others.

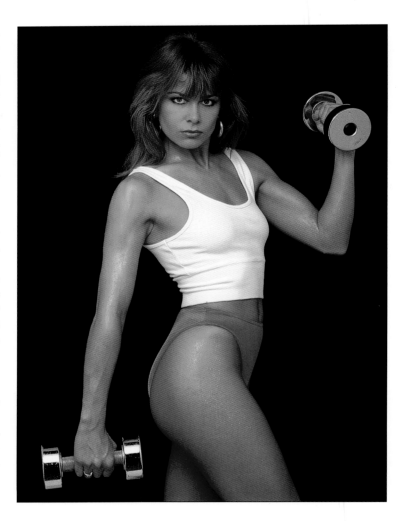

A single three-quarter front light to camera left is placed at 45° to model, above head height, tilted down to illuminate both her face and her body. Her skin was coated with baby oil, then sprayed with water to add to the effect.

TECHNICAL DATA
Camera
Mamiya 645
Lens 150mm
(medium telephoto)
Film Kodak EPR64
Exp 1/60th – f11
Filter 81b (warm-up)

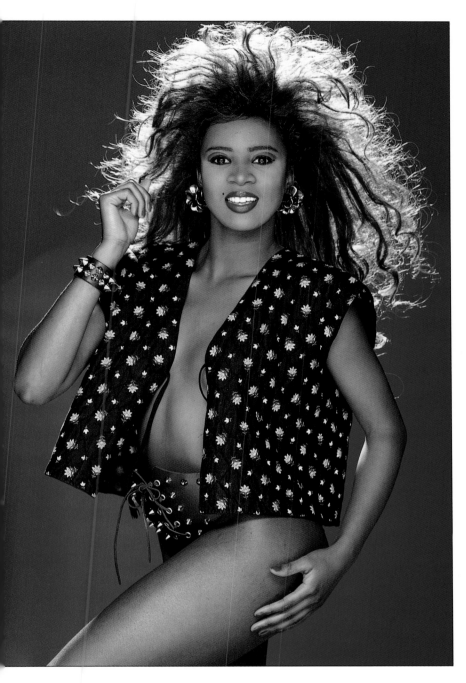

PRO POINTERS

■ THE HIGH POWER capacity of studio flash units facilitates the use of a wide range of light-modifying accessories, such as reflective umbrellas, soft boxes and even larger "swimming-pool" diffusing boxes. These attachments produce a broad spread of low-contrast light, giving flattering, virtually shadowless results. Note that the actual area of a light source is directly responsible for the "texture" (harsh or soft) of the light produced – the larger the source, the softer the look.

■ ELECTRONIC FLASH holds a distinct advantage over tungsten (see page 28) as a studio-lighting source, in that very few tungsten lamps can accept the addition of large diffusing accessories (which are invaluable to the glamour photographer) without their power being diminished to an unusable level. Moreover, the extreme heat of tungsten bulbs inside large diffusers is undesirable from a safety angle.

■ MOST STUDIO FLASH units have a built-in fan which cuts in to cool the apparatus whenever it reaches a certain temperature. The fan works without affecting the performance of the unit, so the photographer may work all day if necessary, without any risk of lights overheating.

■ STUDIO FLASH SYSTEMS require the use of a special meter to gauge flash output accurately, and consequently to establish correct exposure. The meter is simply pointed *from the model's position* toward the light source, and takes an "incident" reading when the flash is fired. The reading is given for a specific film speed and is shown as a suggested aperture setting. This information is then transferred to the camera.

■ ONE OF THE VERY few drawbacks of electronic flash is its price. High-capacity studio units, while a justifiable expense to the professional glamour photographer, can be sufficiently costly to preclude their purchase for many amateurs. Most hire studios contain flash equipment, however, so outright purchase is not strictly necessary for either amateur or professional.

This shows the impact of high-wattage lights in small reflector dishes. The near point-source gives shape to the body, unlike the diffusing effect of a soft box. The sharp, direct light adds bright highlights and increases the gloss. A top light adds rim-light to hair, to make the model stand out from the background.

TECHNICAL DATA
Camera
Mamiya RZ67
Lens 180mm (short telephoto)
Film Fuji RDP100
Exp 1/125th – f16

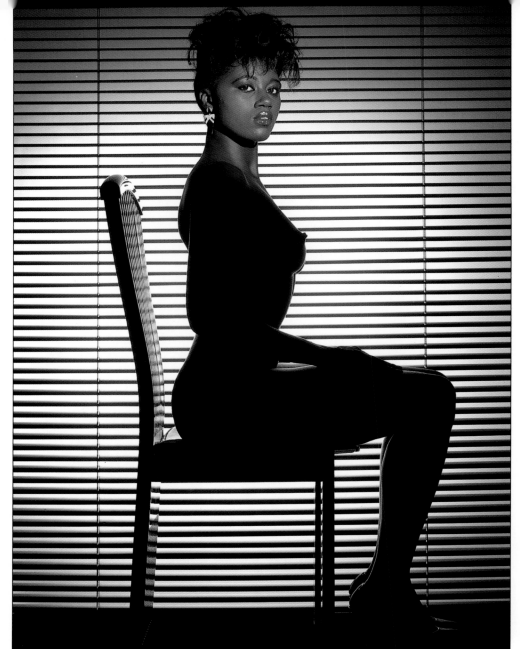

This is an interesting combination of front and backlighting. Backlight alone would render the model as a silhouette. But there is a front light, with snoot, directed only at the model's face, making for a surreal image. The stark outline of the chair, blind, and silhouetted body contrast with the fully revealed facial detail.

TECHNICAL DATA
Camera
Mamiya RZ67
Lens 180mm (short telephoto)
Film Fuji RDP100
Exp 1/125th – f11

KEY TERM: COLOR TEMPERATURE

Different light sources give different colors to the subjects photographed under them. This is because the light sources have different "color temperatures." On the same film, shoot pictures under fluorescent light, at sunset, and in sunshine on water. The same model will look, respectively, green, red, and blue because the color temperature of the light sources is in each case different from that for which the film is balanced. Paradoxically, as the color temperature falls, the picture looks "warmer."

See page 54 for more information on times of day and color temperature.

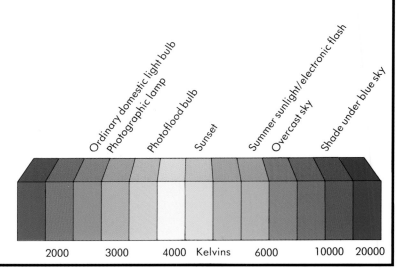

Ordinary domestic light bulb
Photographic lamp
Photoflood bulb
Sunset
Summer sunlight/electronic flash
Overcast sky
Shade under blue sky

2000 3000 4000 Kelvins 6000 10000 20000

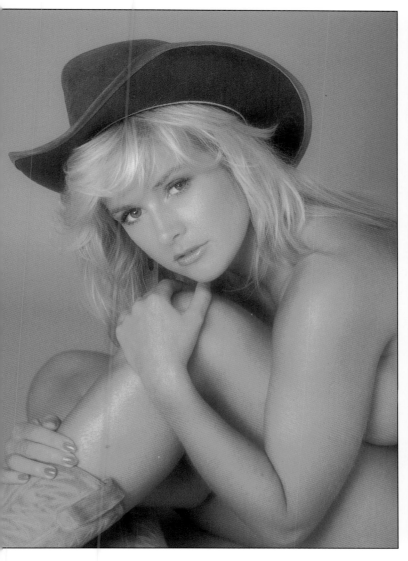

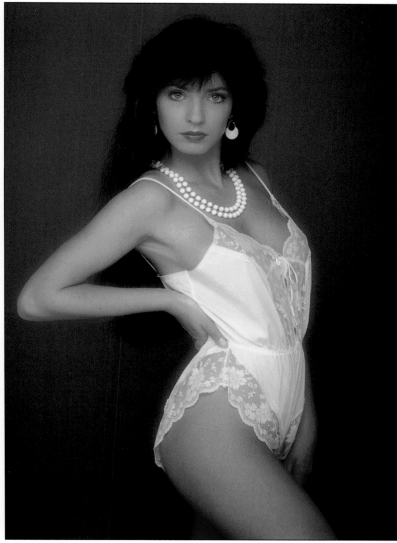

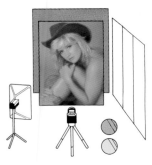

Tight cropping, a warm atmosphere, the sheen on the skin (body lotion), and a single soft box give a clearly defined but soft, shape-enhancing result.

TECHNICAL DATA
Camera
Mamiya 645
Lens 150mm
(medium telephoto)
Film Kodak EPR64
Exp 1/60th – f11
Filters Soft-focus
plus 81b (warm-up)

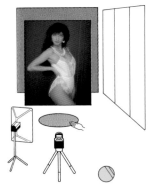

Diffused lighting from the left, and floor-to-ceiling white reflectors to the right, reduce already soft shadows. The light reveals texture, while the 81b filter warms tones, except the pearls.

TECHNICAL DATA
Camera
Mamiya 645
Lens 150mm
(medium telephoto)
Film Kodak EPR64
Exp 1/60th – f11
Filter 81b

27

Tungsten

The main advantage of using tungsten for studio lighting is that it is a continuous light source, as opposed to an intermittent one (as with electronic flash). Tungsten is easier to control, because, in simple terms, what you see is what you get – although sometimes the result can be slightly higher in contrast than the human eye sees at the time of shooting. The fine balance between light and shade on your model is far easier to achieve when the effect of each lighting adjustment is visible to the naked eye. Electronic flash does not offer this flexibility – the final effect of flash can be accurately gauged only by using Polaroid film as a test.

Tungsten lamps are incandescent, meaning that they work by burning a filament. The temperature at which the filament burns determines the color of light that the lamp produces – the higher the temperature, the less orange the color. Domestic tungsten bulbs burn at approximately 2,800K, which is considerably cooler than daylight (5,500K), and therefore produce a distinct orange cast when used with normal daylight film. Studio tungsten lighting, however, is normally based on quartz-halogen lamps which have a slightly higher colour temperature of 3,200K, but still produce a yellowy-orange cast when used unfiltered with daylight film. This cast, if carefully controlled, should show on film as a rich, golden glow, very flattering to the female form and therefore entirely appropriate to glamour photography.

Note that if this effect is not desired for some reason, the cast can be minimized by using an 80a (blue) filter over the lens, or by using dedicated tungsten film, which is balanced to produce daylight results when used with quartz-halogen lamps.

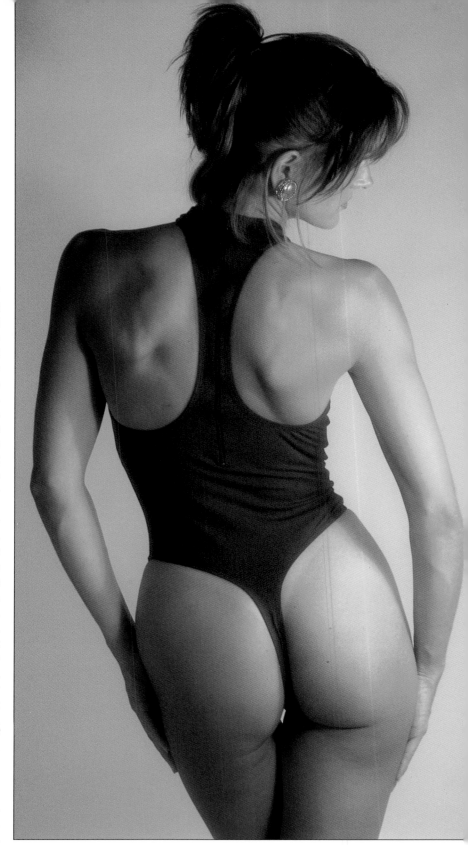

A video light was positioned low down to create drama, but the constant nature of the light source makes shadow control easy.

TECHNICAL DATA
Camera Bronica ETRSi
Lens 150mm (medium telephoto)
Film Kodak EPT160 (tungsten)
Exp 1/30th – f5.6

This picture illustrates the golden glow that can be achieved by using a quartz-halogen video lamp, creating sharp-edged shadows

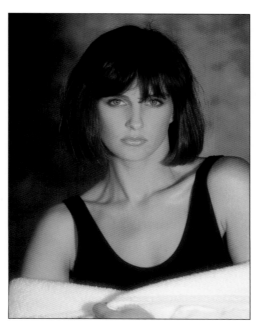

and high contrast. Both shadows and image contrast have been lessened with a soft-focus filter and a gold reflector placed to camera left.

TECHNICAL DATA
Camera
Bronica ETRSi
Lens 200mm (medium-long telephoto)
Film Fuji RHP400 (daylight)
Exp 1/60th – f8

Lighting comes from 250-watt tungsten modeling bulbs fitted to two 2000-joule flash heads, fitted with soft boxes. A gold reflector reveals extra detail in face and hair. A large panel prevents light from spilling onto the backdrop, retaining stark contrast.

TECHNICAL DATA
Camera
Bronica ETRSi
Lens 150mm (medium telephoto)
Film Fuji RHP400 (daylight)
Exp 1/30th – f5.6
Filter Soft-focus

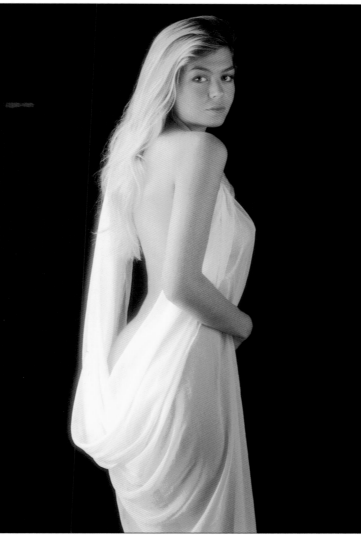

PRO POINTERS

■ IF THE GOLDEN glow of tungsten gives a warm and intimate atmosphere to your glamour pictures, it does so partially by creating an equivalent atmosphere in your studio – the warmth of tungsten lamps and the sultry opulence of their glow create a very pleasant environment for both photographer and model.

The only problem is that the lamps can become so hot that they need a brief cooling-down period, which can interrupt the flow of your session. Good glamour photography is based on the relationship between model and photographer/camera, and the subtle ambience of a tungsten-lit studio is far more conducive to promoting the necessary intimacy than cool, clinical electronic flash – it is like the contrast between the subdued light in a bistro and the harsh reality of a hamburger joint.

■ AS TUNGSTEN IS A continuous light source, a special meter for checking light levels and ascertaining exposure is not required – your camera meter is perfectly capable of performing this task. A useful point to remember when using daylight film is that the cast created by tungsten lamps on this type of film has an exposure value of its own, which cannot be metered. Overexposing the film by half a stop lifts and lightens the pictures

29

slightly, and prevents the deliberate use of the "wrong" film looking like a mistake.

■ FOR THE AMATEUR glamour photographer wishing to set up a studio, tungsten has the advantage of being much cheaper than electronic flash – even high-wattage household bulbs can be used as a starting point if quartz-halogen lamps prove too expensive initially. Remember that household tungsten has a lower Kelvin rating than quartz-halogen, so be prepared to use some (blue) filtration if your first "warm" results are cloyingly so, as opposed to pleasantly golden.

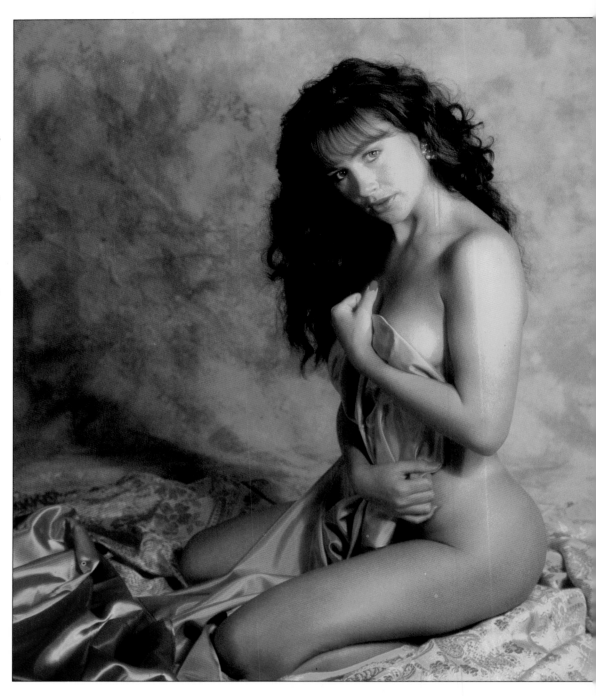

Rich fabrics such as satin and silk create an erotic mood, which the tungsten glow enhances. A wide aperture threw the handpainted canvas background out of focus, to avoid distracting from the model.

TECHNICAL DATA
Camera
Bronica ETRSi
Lens 150mm
(medium telephoto)
Film Fuji RHP400
(daylight)
Exp 1/60th – f4.5

TUTORIAL

Note the difference the film makes to tungsten-lit shots.

1 This has the typical golden cast resulting from using tungsten lights (3200k) with daylight-balanced film (Fuji RHP400 – 5500k).

2 Tungsten-balanced film (Kodak EPT160) removes the cast, giving a daylight-balanced image.

TECHNICAL DATA
Camera
Bronica ETRSi
Lens 150mm
(medium telephoto)

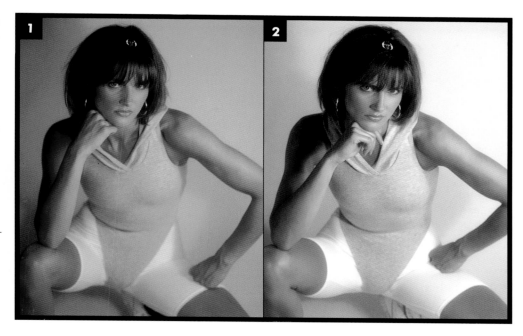

TUTORIAL

The dramatic light and shade effects of non-diffused tungsten can appear very harsh, especially on fast, grainy film. This is not in keeping with the golden warmth that characterizes tungsten-lit pictures on daylight film. A filter softens the overall texture of the image, so the potentially conflicting elements of grain and warmth are made to complement each other.

1 On fast, grainy daylight film (Fuji RHP400) the color is pleasingly warm, but the flesh tones lack appeal.

2 With a soft-focus filter added, the harsh grain structure is

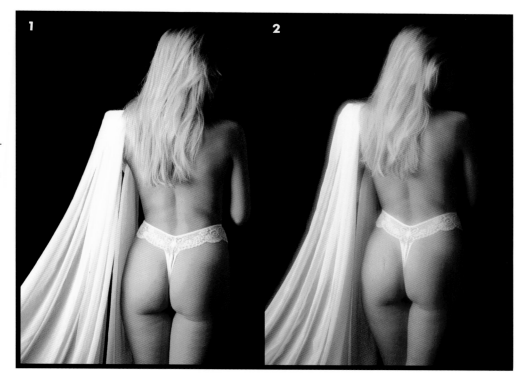

diffused though not removed, and the result is more successful.

TECHNICAL DATA
Camera
Bronica ETRSi

Lens 150mm
(medium telephoto)
Exp 1/30th – f5.6

Mixing tungsten and flash

Having seen the respective advantages and disadvantages of flash and tungsten, there would seem little point in using both at the same time. By mixing the sources in a single situation, the glamour photographer can control the extent to which the golden glow influences the results. As a rule, allowing the tungsten to contribute ½ to ⅔ of a stop more light than the flash to the combined exposure results in a very pleasing balance. The tungsten cast is reduced, but not removed, promoting a less exaggerated, and therefore more realistic, level of warmth within the image.

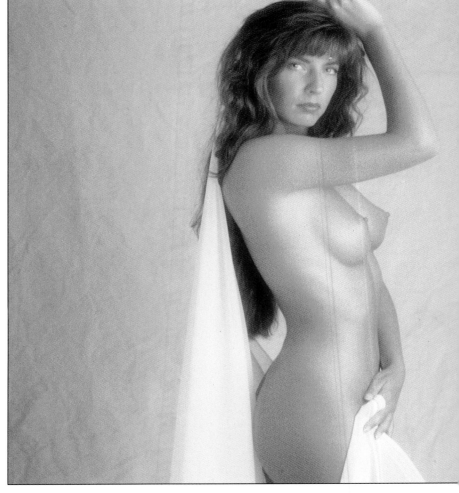

PRO POINTERS

■ A FURTHER BENEFIT is that the flash, if diffused with an umbrella or soft box, provides a spread of fill-in light which has the effect of softening the harsh shadows created by the tungsten, without killing the atmosphere of the shot.

■ TAKE THIS PRINCIPLE one stage further: try separating the tungsten and flash by lighting the model with tungsten but illuminating the background with flash only. In this case, your camera meter reading, taken from the model's body, should be precisely the same as the flash meter reading taken from the backdrop – there should not be sufficient flash striking the model to affect the tungsten reading. The results should show your model's flesh tones enhanced by the tungsten's golden touch, while the background is not influenced by the tungsten to any noticeable degree, therefore convincing the viewer that the model's appealingly warm flesh tones must be quite genuine.

The tungsten spotlight "warms" flesh tones while the flash lights only the backdrop with "daylight," canceling out the tungsten shadows. It is more attractive for shooting on a very fast film with a distinctive grain.

TECHNICAL DATA
Camera
Mamiya 645
Lens 150mm
(medium telephoto)
Film Agfa 1000RS
(daylight)
Exp 1/60th – f11

The same lights as below left are set close together, so the glow and shadows are reduced. The warm result lacks the cast that often occurs with tungsten light on daylight film.

TECHNICAL DATA
Camera
Mamiya 645
Lens 150mm
(medium telephoto)
Film Fuji RHP400
(daylight)
Exp 1/60th – f5.6
Filter Soft-focus

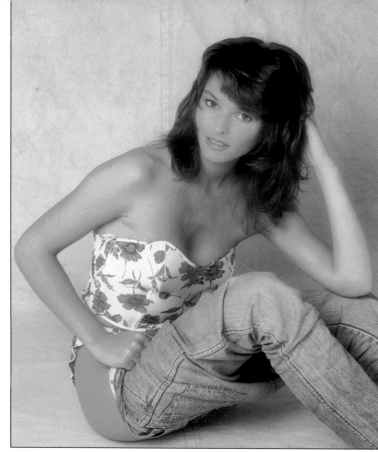

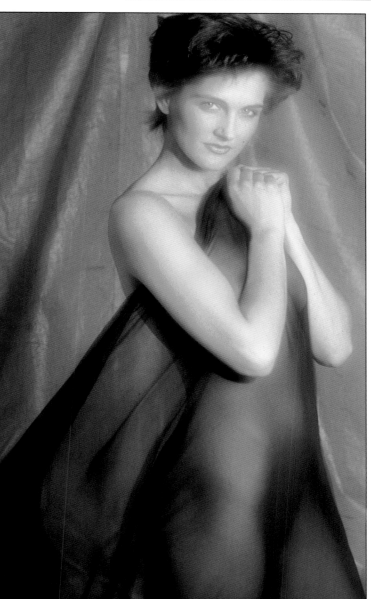

Here the lights are to camera right, and the tungsten has been allowed to influence the overall exposure to a greater extent, overpowering the flash input by about two thirds of a stop. This emphasizes the warmth of the tungsten.

TECHNICAL DATA
Camera
Bronica ETRSi
Lens 150mm
(medium telephoto)
Film Fuji RHP400
(daylight)
Exp 1/30th – f8
Filter Soft-focus

33

Picture Portfolio

1 & 7 Both pictures show the bold, bright result typical of powerful flash heads firing through large diffusing soft boxes.

2 Coarse-grained 1000 ISO film with a single tungsten spotlight creates a sensual, moody image.

3 The lighting here again comes from flash with soft boxes, side-on positioned to encourage shadows to be revealed, and to add mood to the shot.

4 Careful combination of flash and tungsten can produce warm but realistic results on daylight film.

5 Using a tungsten video light instead of the usual tungsten spotlights gives a less obviously golden color cast. The video light's higher kelvin rating (3800k as opposed to 3200k) produces a closer-to-daylight color balance.

6 This is lit with tungsten alone and shot on daylight film for a rich, golden glow. Black clothing concentrates interest on the flesh tones.

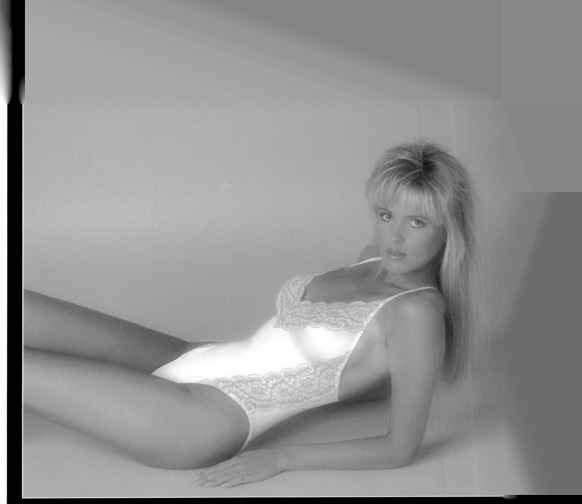

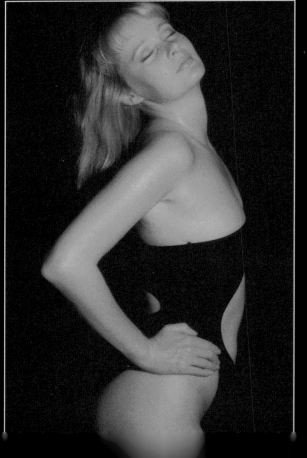

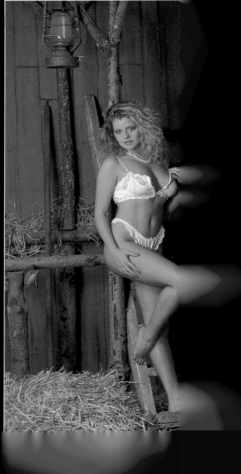

Lighting for graphic effect

It is unfortunate that black and white (b/w) is not a more popular medium in glamour photography, as the qualities that make b/w so suited to journalism can make it equally effective for glamour. B/w photographs generally deliver a message far more succinctly than an equivalent color image, simply because the viewer has less information to assimilate.

B/w remains the accepted medium for "glamour" in a fine-art sense. Perhaps part of the reason is that b/w does offer the photographer considerably more scope for artistic experimentation, manipulation, and creative interpretation than color, thanks to its suitability for home development. The "hands-on" approach is an ideal way for the photographer to learn to appreciate and control the many techniques of lighting the female form.

PRO POINTERS

■ THE RELATIVE cheapness of b/w, compared to color, makes it more practical to experiment, and you should do so as much as possible. Provided that you have lit your model carefully at the shooting stage, a wide variety of different results may be obtained from the same negative.

■ CROPPING AND printing selectively from b/w negatives can widen the range of available results yet further.

■ As B/W FILM generally has more latitude in its light sensitivity than color film, the tendency can be for the photographer to handle lighting and exposure with less care than when dealing with color film. This is a mistake – it is true that no color correction or special filters are required when using b/w, but your approach to lighting should still be one of care and precision to enable you to achieve consistent, high-quality results.

The gentle sensuality is the result of carefully controlled, diffused three-quarter front lighting. It accentuates the appeal of face and body, and reveals texture.

TECHNICAL DATA
Camera
Olympus OM2
Lens 80-200mm
zoom set at 80mm
Film Ilford XP1
(400 ISO)
Exp 1/60th – f11

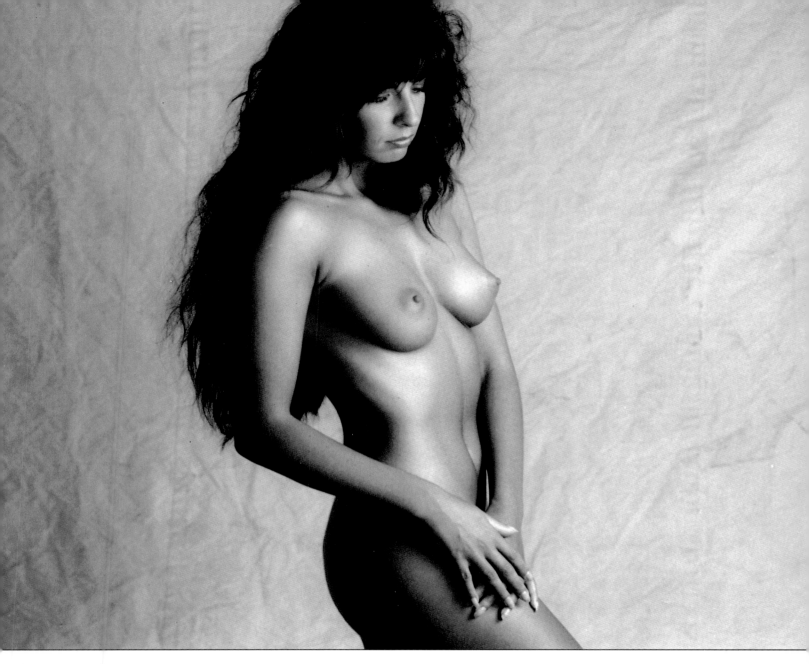

The warm sepia tone of this picture is well-suited to the richly erotic image. The sepia emphasizes the contrast in texture between the model's silky glowing flesh and the rough canvas

backdrop. Lighting is a mixture of tungsten and flash – the tungsten is used to accentuate the model's shape and skin, while the flash eliminates background shadows.

TECHNICAL DATA
Camera
Mamiya 645
Lens 150mm
(medium telephoto)
Film Kodak Tri-X
(400 ISO)
Exp 1/30th – f5.6

KEY TERM: LATITUDE

One of the greatest friends to the inexperienced photographer is what is known as the latitude of print film. Latitude means that an under- or overexposed negative (especially in black and white) can still produce a reasonable printed result. This "forgiveness" of errors can rescue a shot on print film that would have been lost if taken on slide film. However, there is a corresponding disadvantage, which is that some very subtle exposure manipulations will simply not show up on print film.

Hand-tinting can add a new dimension to black and white prints. Selected details can be individually colored to pull them out of the main image, like this tonal emphasis on pinks and golds.

TECHNICAL DATA
Camera
Bronica ETRSi
Lens 100mm (short telephoto)
Film Kodak T-Max (400 ISO)
Exp 1/125th – f8

Hand-tinted details highlight aspects of the model to contrast with the foliage. Lighting is a single studio flash head firing into a silver umbrella.

TECHNICAL DATA
Camera
Bronica ETRSi
Lens 100mm (short telephoto)
Film Kodak T-Max (400 ISO)
Exp 1/250th – f5.6

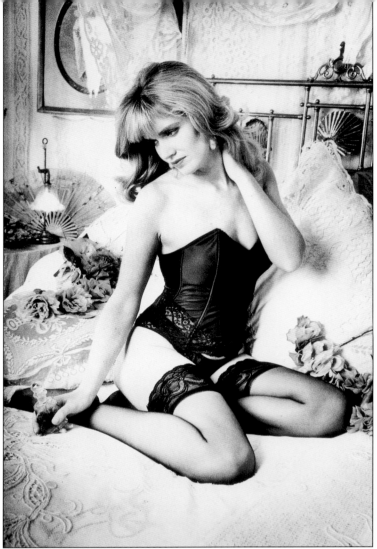

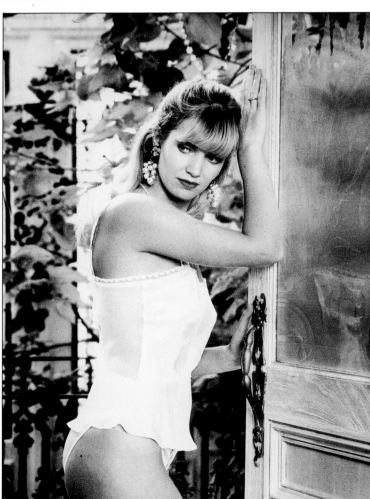

Right: A single color can be very effective when applied to a straight black and white image. Here, the rich blue tone helps to create a cool, slightly mysterious mood, which is emphasized by the high camera angle and the model's dark hair and clothes. These and the direct gaze help to concentrate interest on her face. Lighting comes from camera left in the shape of a single tungsten 1000-watt video light, fitted with barn doors to direct the light predominantly at the model's face.

TECHNICAL DATA
Camera
Bronica ETRSi
Lens 200mm (medium-long telephoto)
Film Kodak Tri-X (400 ISO)
Exp 1/60th – f5.6

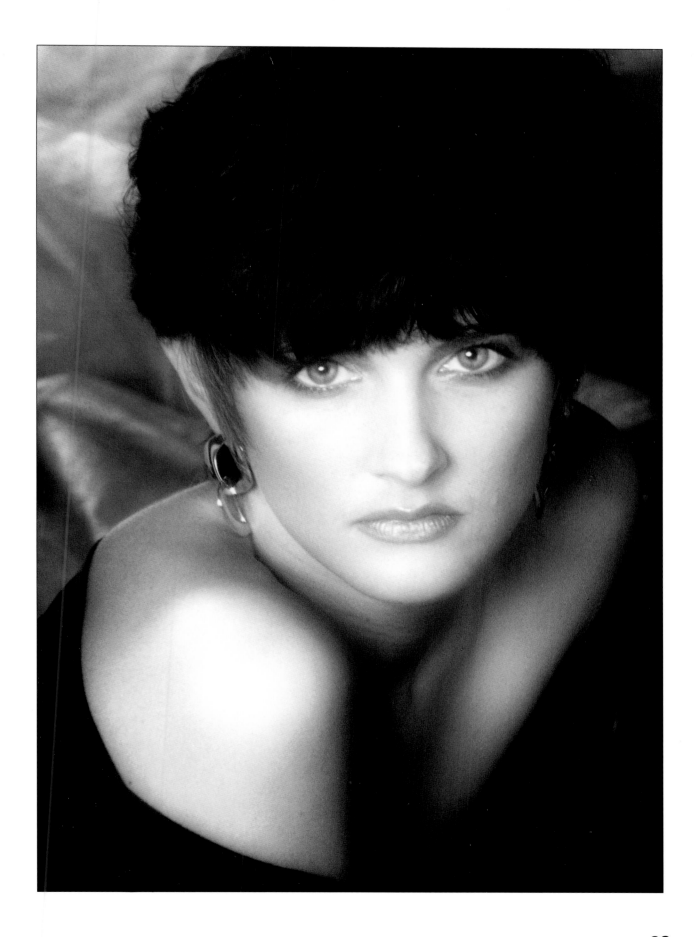

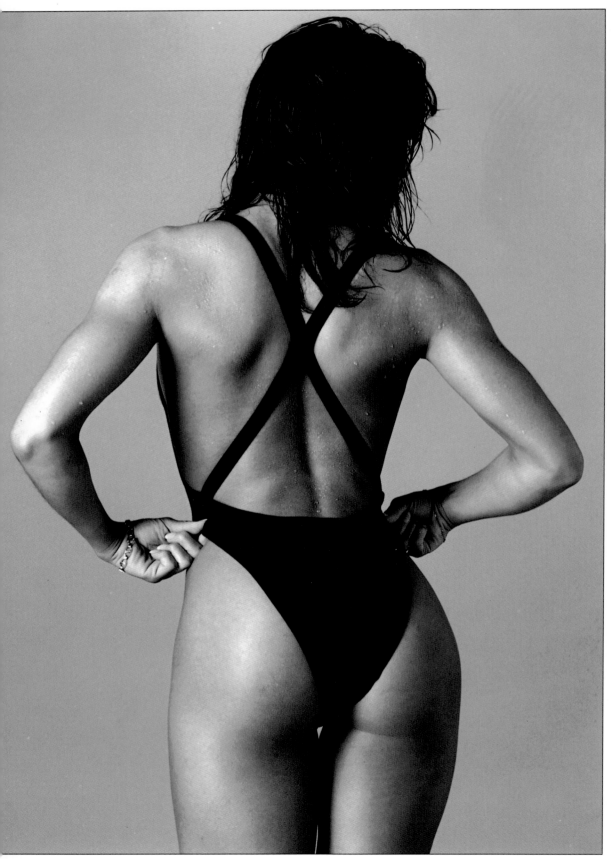

This shot relies on two main aspects for its success – the graphic quality of the shot, which makes good use of the model's well-toned body and simple but striking cross-strapped black costume; and the sepia tone, which adds a flattering bronze tint to the model's flesh. Note that definition in the model's athletic body is greatly enhanced by the liberal application of baby oil and then water spray. Lighting is from camera left, and is diffused enough to avoid unwanted sharp highlights, but directional enough to create figure-enhancing shadows.

TECHNICAL DATA
Camera
Mamiya 645
Lens 150mm
(medium telephoto)
Film Kodak Tri-X
(400 ISO)
Exp 1/60th – f11

TUTORIAL

These two pictures show how different effects can be achieved by using monotone or color film on similar subjects.

1 The bold impact of black and white is apparent – the model's mane of black hair contrasting with the pure white underwear. Lighting comes from high up to camera left, revealing shape and detail in the various textures.

TECHNICAL DATA
Camera
Olympus OM2
Lens 80-200mm zoom set at 80mm (short telephoto)
Film Ilford XP1 – 400
Exp 1/60th – f11

2 Although very similar, this shot lacks the impact of picture 1, relying instead on a more sultry approach helped by using tungsten lamps on daylight film (warm cast) and a soft-focus filter. The peach-colored lingerie also has some influence on the mood of the image.

TECHNICAL DATA
Camera
Mamiya 645
Lens 150mm (medium telephoto)
Film Fuji RHP400 (daylight)
Exp 1/60th – f8
Filter Soft-focus

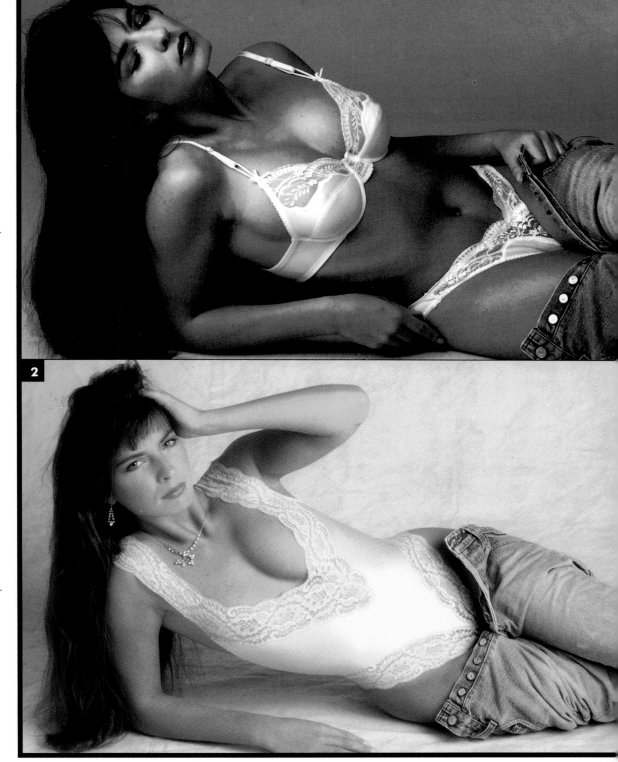

SHOOTING INDOORS

If you are intending to shoot glamour indoors, it is vital that you should visit the chosen location prior to the shoot in order to check thoroughly its potential as a working environment, and to sort out any problems in advance.

You should firstly establish such apparently obvious factors as power supply – note the number and position of power sockets and test them to make sure that they are live. Try to imagine your lighting set-up for each particular situation, and ask yourself whether you need to bring electronic flash, tungsten lamps, or reflectors, or a combination of the three. Consider your intended lighting positions relative to the power sockets: will you need to bring long extension cables, or, in extreme cases, your own power generator?

It is very important that you should be aware of the space, or lack of it, that you have at your disposal – shooting indoor glamour on location is quite different to working in the studio, where you begin with an empty room and plan your own set. On location you must adapt to the existing layout. You may, for instance, discover an especially interesting and attractive room which is just too compact dimensionally for you to set up your lights as you would wish. Remember: it is seldom wise to compromise, so move on.

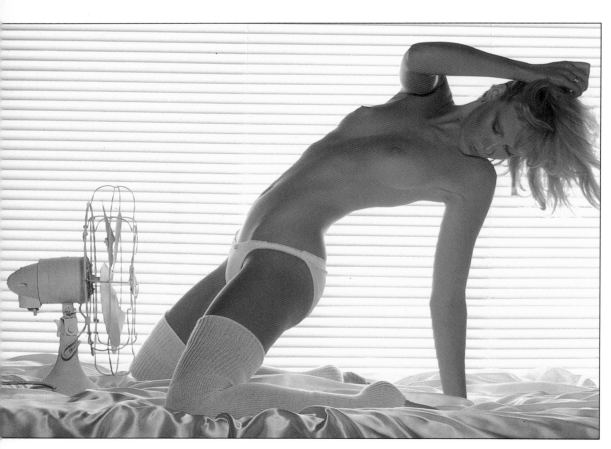

Bright sunlight shining through the blinds backlights the model. Studio flash heads in the room provide frontal illumination without overpowering the daylight.

TECHNICAL DATA
Camera Nikon F3
Lens 28-70mm zoom set at 70mm (short telephoto)
Film Fuji RDP100
Exp 1/125th – f5.6

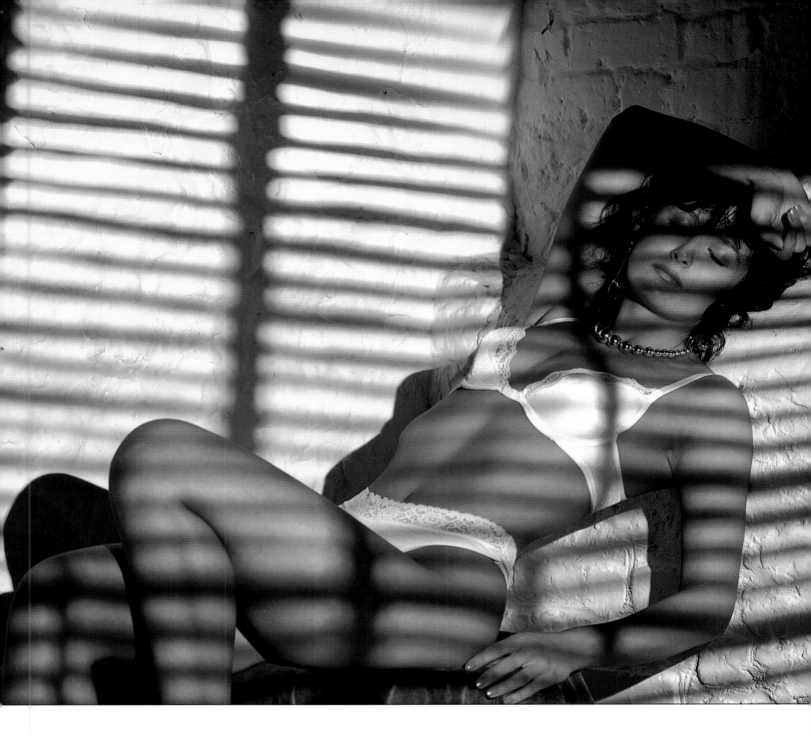

This shot was taken with natural light only. Sunlight shining through shutters casts a distinctive pattern. The exposure has been correctly taken from the highlight areas of the model's body, allowing shadows to under-expose and thus record on film as stark and lacking in detail.

TECHNICAL DATA
Camera
Mamiya RZ67
Lens 180mm (short telephoto)
Film Fuji RDP100
Exp 1/60th – f5.6

43

Window light

If you are working with natural light in an indoor location, the likelihood is that the daylight is being filtered into the room through a window. Window light can be an excellent source of slightly muted illumination, the subtlety of which makes it ideally suited to a gentle, more romantic style of glamour photography.

The diffusing effect of the glass enables you to place your model close to the window area to maximize the light level, and makes it relatively easy to control shadows using either reflectors or a small amount of artificial fill-in lighting. The more natural you can make your window-light shots, the more successful they are likely to be, so use the absolute minimum of fill-in light possible to achieve a realistic result, and utilize large reflectors in preference to additional lighting.

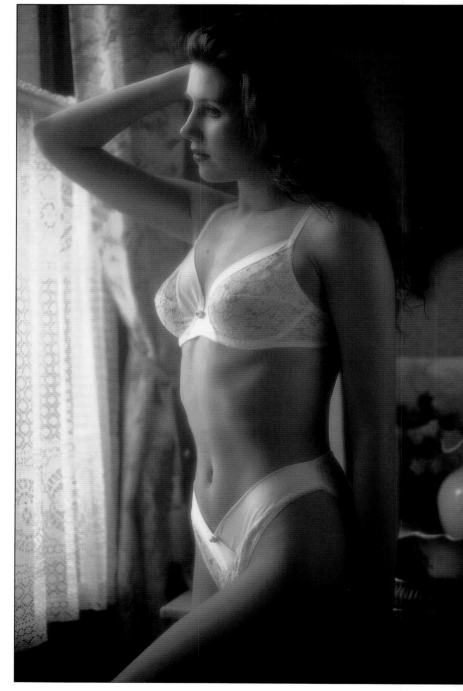

Daylight is the only source of light in this shot, diffused both by the panes of glass in the window and the lace curtain. Reflection from gold panels reduces the density of the shadow areas, and adds a warm cast to the interior details and the model's left arm. Soft-focus and warm-up filters add to the gentle, reflective mood.

TECHNICAL DATA
Camera
Mamiya RZ67
Lens 180mm (short telephoto)
Film Fuji RDP100
Exp 1/60th – f5.6
Filters Soft-focus plus 81b warm-up

44

Sunlight can be used as the main light source for an indoor shot. In this location, light floods in from three sides, and gold reflectors redirect this to provide warm frontal illumination. A touch of fill-in flash ensures the model is well exposed and the image of the windows on the floor is faithfully recorded.

TECHNICAL DATA
Camera
Mamiya 645
Lens 110mm (short telephoto)
Film Kodak EPR64
Exp 1/125th – f5.6
Filter 81b (warm-up)

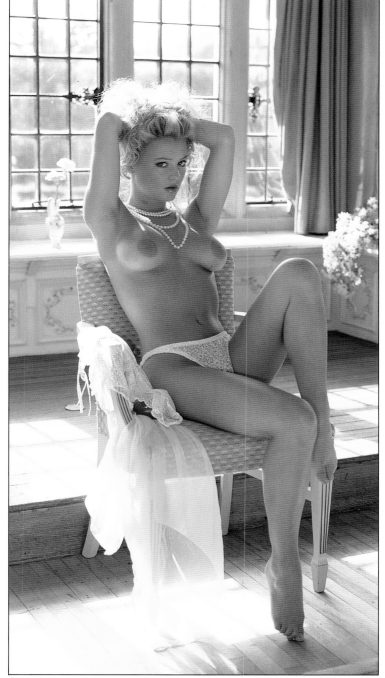

■ POSING YOUR MODEL close to a window can sometimes make it difficult to expose the outdoor part of the picture correctly, the tendency being for it to be overexposed relative to the indoor aspect. While this satisfactorily proves the theory that the window glass has a muting, diffusing effect, it can result in an unbalanced, unfinished and unprofessional look to your pictures. In order to correct this fault, you can either move to a different camera position so that the "view" through the window is of no pictorial value to the result; or, alternatively, you may choose to boost the level of artificial light within the room so that it balances the outdoor level. If you choose the second option, be aware of the risk of detracting from the appeal of your pictures by making the source of your indoor light too obvious. At all costs, avoid over-powering the natural light with your fill-in lighting, as this is sure to defeat your attempt to create a good atmosphere.

■ BEFORE YOU ACTUALLY begin shooting, try to find an opportunity to familiarize yourself with the likely position of the sun, relative to your indoor situation. It is well worthwhile establishing as accurately as possible the best time of day to work, and the most

45

favorable positions from which to take your photographs.

■ IF THE LIGHT outdoors is exceptionally bright, avoid posing your model in a pool of direct sunlight. In spite of the diffusing effect of the window, the transmitted light may still be sufficiently bright to give harsh results because the contrast between highlights and shadow areas is too extreme. Experiment by using the sun exclusively as a back or side light, with frontal lighting provided by another source.

■ WINDOWS SOMETIMES cast strong patterns of light and shade on interior walls. Posing your model within a pattern can lead to a striking opportunity for glamour photography. Expose for the highlight areas of your model's body, and, in this case, do not attempt to reflect light back into the shadow areas – the picture will rely on the dramatic contrast between light and shade.

■ INDOOR LOCATIONS produce plenty of opportunities for influencing mood and atmosphere by using soft-focus filters, but bear in mind that a lightness of touch is of paramount importance to avoid compromising overall image quality – the excessive filtration of back lighting can cause your model's outline to dissolve into a blur.

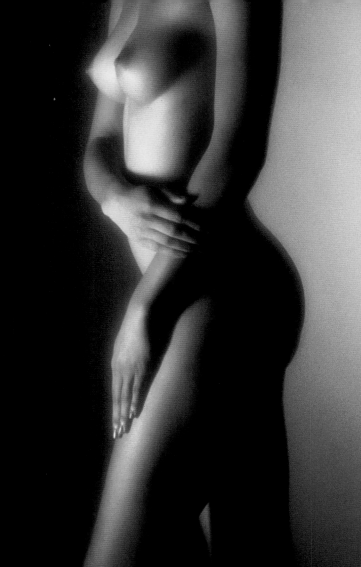

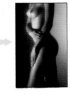

Left: Using window light as the sole light source gives a rounded quality. Using an empty, white-walled room has added to the effect, as reflected light provides enough fill-in for the shadow areas to retain some detail.

TECHNICAL DATA
Camera Nikon F2
Lens 85mm (short telephoto)
Film Ektachrome 100
Exp 1/60th – f4
Filter Soft-focus

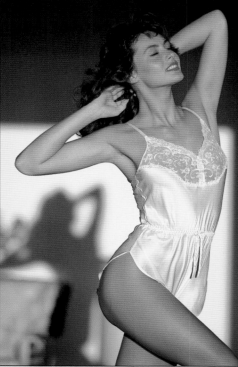

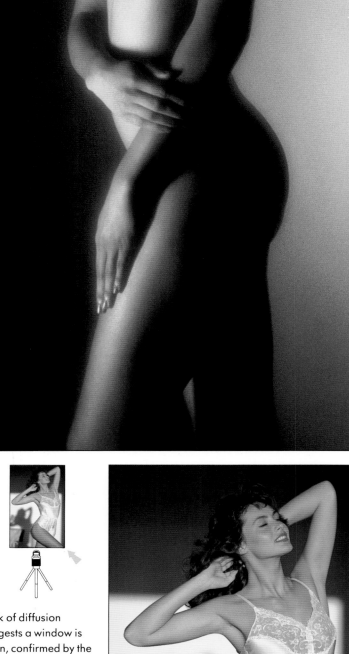

Lack of diffusion suggests a window is open, confirmed by the bright highlights.

TECHNICAL DATA
Camera
Mamiya RB67
Lens 180mm (short telephoto)
Film Fuji RDP100
Exp 1/125th – f5.6
Filter 81b (warm-up)

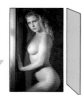

Right: A gold reflector out of shot to camera right lights the model's back and cuts the contrast level.

TECHNICAL DATA
Camera
Mamiya RZ67
Lens 180mm (short telephoto)
Film Fuji RDP100
Exp 1/60th – f5.6

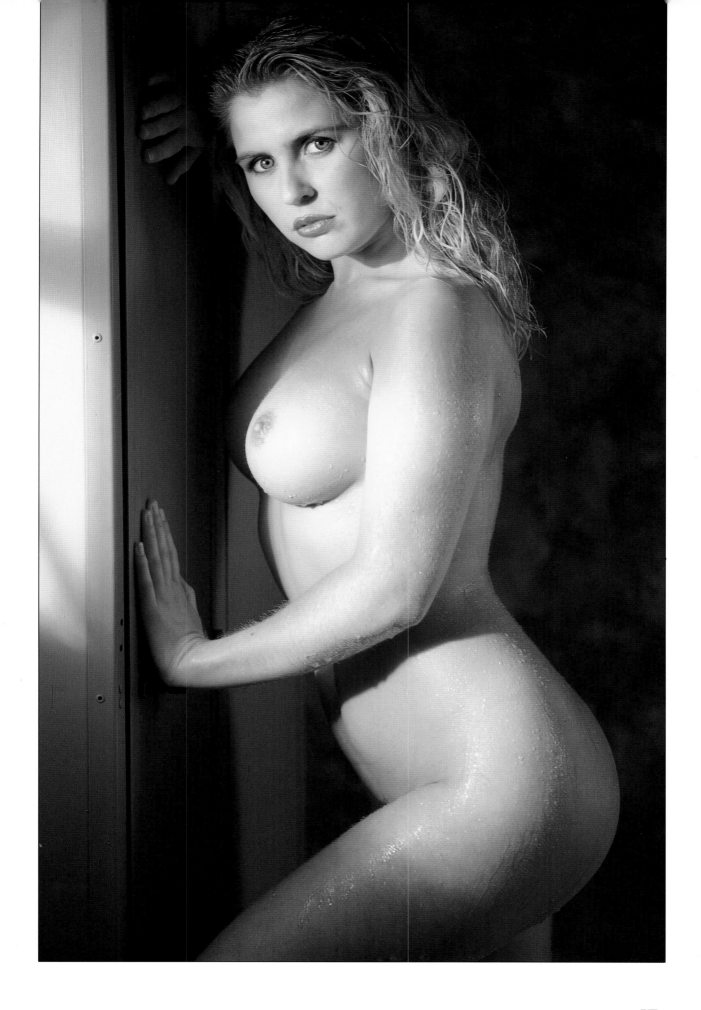

Mixing light sources

In a situation in which your model is positioned indoors, but your background takes in an outdoor scene, the simple rule to remember is always to base your exposure on a meter reading taken from the natural light source. The reason for this is obvious: you have no control over sunlight, but complete control over artificial light, so adjusting the strength and direction of your flash to balance the outdoor light level is the correct procedure.

Let us assume that your meter reading taken through the open window is 1/60th of a second at f/5.6. To achieve a balance of flash to daylight, adjust the position and power output of your flash unit until the incident flash meter reading taken from your model's position also reads f/5.6.

KEY TERM: FILM SPEED

The "speed" of a film is a means of describing its sensitivity to light. The higher the rating of a film, the more sensitive it will be. The speed of a film can be expressed, for example, as either ISO 100 or 100 ASA. These both denote the same sensitivity.

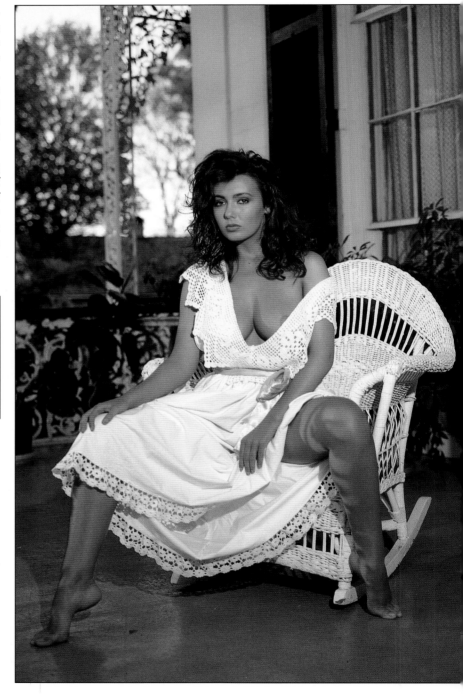

Flat daylight has been augmented with a tungsten spotlight to record as a rich, warm orange tone, radically changing the mood of the image. Careful metering made sure both daylight and tungsten were correctly exposed.

TECHNICAL DATA
Camera
Mamiya RB67
Lens 180mm (short telephoto)
Film Kodak EPR64
Exp 1/30th – f5.6

TUTORIAL

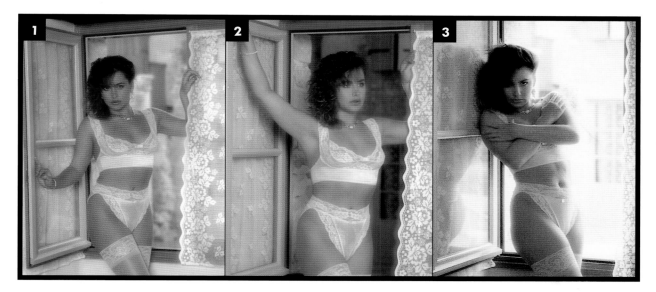

These three shots illustrate the effect of correct and incorrect balances of flash and daylight, and also offer an alternative approach to the mixed lighting scenario.

1 This has the correct flash-to-daylight exposure ratio. The flash is moved until its exposure matches the daylight. Shot on Fuji RDP100 film at 1/60th – f5.6.

2 The shutter speed was adjusted from 1/60th to 1/125th of a second. While the flash was constant, outdoors was under-exposed by a stop.

3 This uses a very fast film (Agfa 1000RS) with a 250-watt modeling bulb. The result – an imbalance between indoor and outdoor light levels.

TECHNICAL DATA
Camera
Bronica ETRSi
Lens 150mm
(medium telephoto)

Daylight is the constant element, and the tungsten was adjusted so the exposure of both sources read the same. Used to accentuate the contrast between the forest and the glow of the indoor scene, the tungsten also adds a bright highlight to the model's seductive eyes.

TECHNICAL DATA
Camera
Mamiya 645
Lens 150mm
(medium telephoto)
Film Kodak EPR64
(daylight)
Exp 1/30th – f5.6

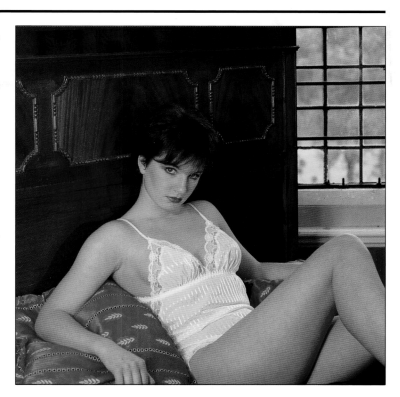

Picture Portfolio

1 This utilizes bright sunlight shining through windows as a backlight, while gold reflectors ensure there are no dark shadows.

2 The photographer is standing outside the room looking in. The model is subtly lit with a combination of direct and reflected daylight.

3 & 5 Both pictures make use of the same location and plentiful supply of backlight through the multi-paned windows, but the sources of indoor light are different for each shot. **3** uses tungsten as a frontal light source that separates the model from her background. A soft-focus lens adds to the effect of the diffused light. In **5,** the only fill-in comes from a small burst of fill-in flash and a gold reflector.

4 This also uses window light, but here a tungsten spotlight balances the light levels.

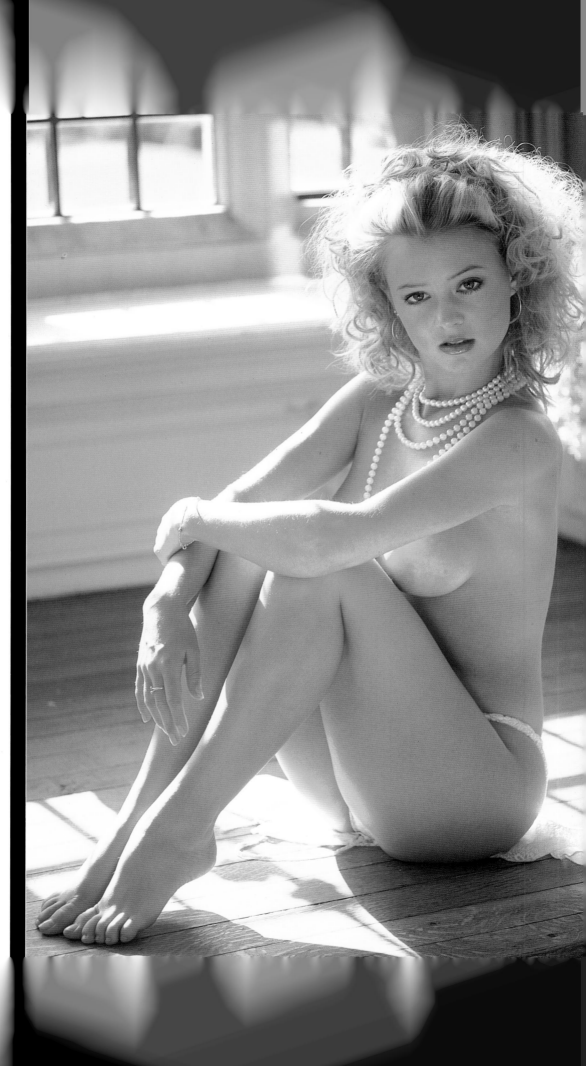

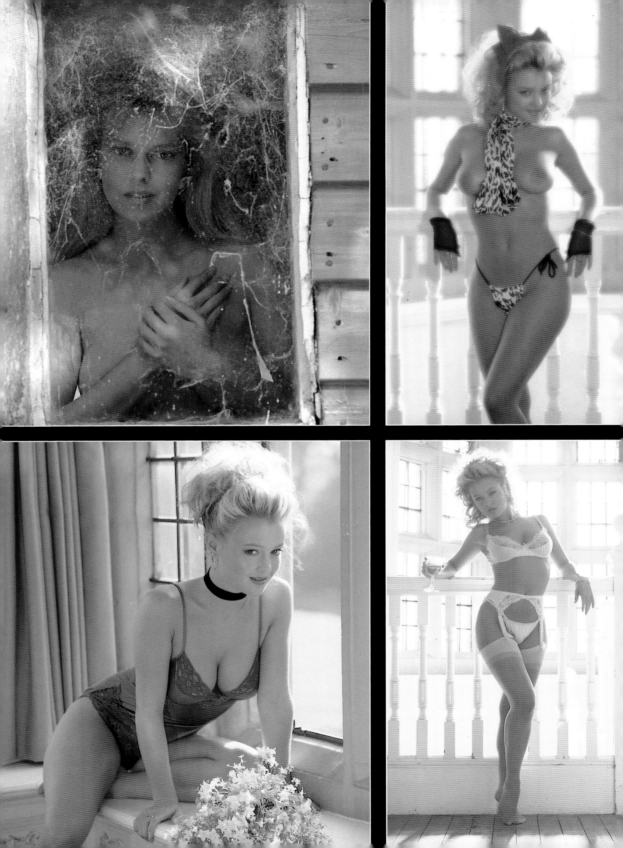

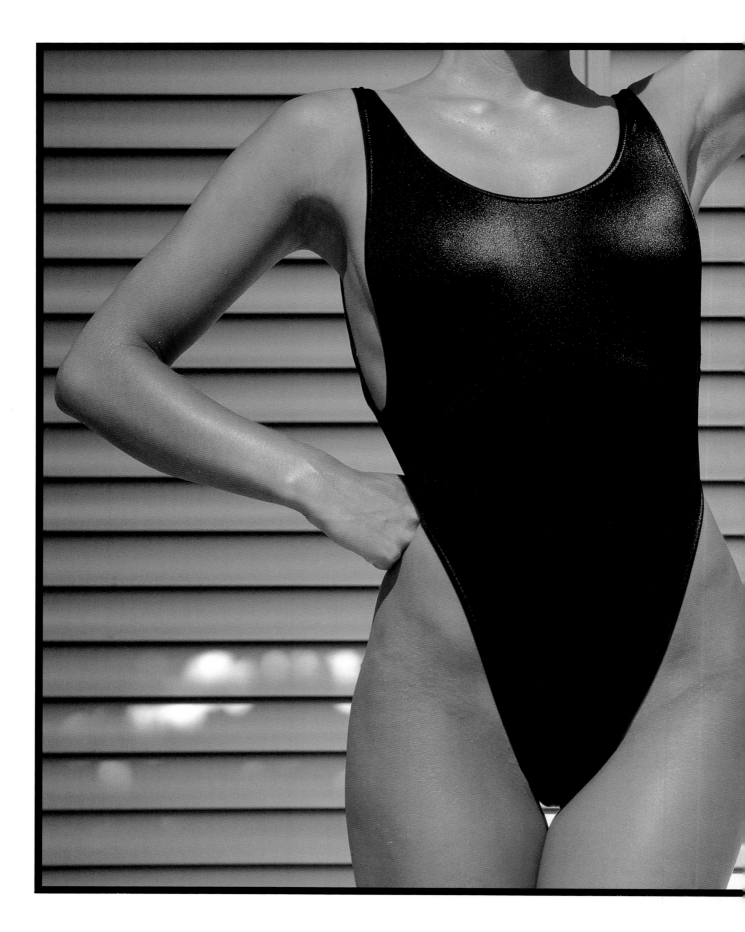

OUTDOOR LIGHTING TECHNIQUES

3

In order to produce successful pictures outdoors, the glamour photographer needs to appreciate the many and varied qualities of natural light. This includes understanding color temperature as governed by time of day, and knowing how to cope with different weather conditions. Filters, reflectors and fill-in flash all play their part in outdoor work, so it is also necessary to know how and when to use these light-affecting accessories to their best advantage.

This was shot in afternoon sunlight which is too strong for facial shots, but ideal for body shots. There are no long shadows to distract attention from the clean lines of both the model and the background. The direct sunlight accentuates the wet look of the black swimsuit.

TECHNICAL DATA
Camera
Mamiya 645
Lens 150mm
(medium telephoto)
Film Kodak EPR64
Exp 250th – f8
Filter 81b (warm-up)

TIMES OF DAY

The color of natural daylight changes throughout the day. At sunrise and sunset, for instance, the light looks much redder (warmer) than it does at midday. Artificial light sources also have their own color. These variations of light are referred to as the color temperature, which is measured in degrees Kelvin (K). Warm light has a low Kelvin value, and cool light a high value.

Our eyes adapt automatically to changes in color temperature – much as the auto-white balance on a camcorder does – making any type of light look more or less white, a process known as chromatic adaptation. Photographic film is less versatile, however, and is balanced to give "natural" results in light with a specific Kelvin rating. At midday, in "average" weather, the color temperature is around 5,500K, and normal daylight film is balanced for this light. By sunset, the temperature has dropped to 3,000K, so your pictures will take on a warm cast. By way of contrast, clear blue sky over water can produce a temperature as high as 20,000K, which will give your pictures a blue cast.

It may often be beneficial to your pictures to allow these casts to remain, but there are situations in which it will be preferable to cancel them out. Remember especially that blue casts and glamour seldom go together.

The solution is found in color-correction filters. Light, at its extremes of temperature, is either orange or blue, so adding a filter of the complementary – that is, opposite – color has the necessary neutralizing effect. Various densities of each colored filter make it possible, if required, to maintain a color balance of 5,500K throughout the day. You will, however, have to increase your f-stop to allow for the filters.

This lively shot was taken in bright, early evening sunlight. Using the sun as a backlight means that the model is shown as a silhouette, and that the sun's rays highlight the splashing water. The picture makes a feature of the low sun, which turns the background sea into an almost silver/white blur of reflected lights. Note that a fast shutter speed has resulted in the "airborne" water being "frozen" in motion, and that the photographer has under-exposed the shot slightly (by half a stop) to make the model and her actions stand out more clearly from the background. Use of a wide aperture blurs the sea all around the model, again helping to focus attention on her.

TECHNICAL DATA
Camera Nikon F3
Lens 80-200mm zoom set at 150mm (medium-long telephoto)
Film Fuji RDP100
Exp 1/500th – f4

KEY TERM: COMPLEMENTARY FILTERS

White light is made up of a combination of three primary colors — red, green, and blue. Add any two of these together and they make a complementary or secondary color. Red + green = yellow, red + blue = magenta, and blue + green = cyan.

If you imagine a six-spoked wheel with each pair of primary colors separated by the secondary color that they form, you can easily find the complement of any color. Opposite blue is yellow (the combination of the other two primary colors, red and green), opposite green is magenta (red plus blue), and opposite red is cyan (blue plus green). In any picture, if the light is of one of the primary or secondary colors, you only need to place a filter of the complementary color to correct for it, leaving a white-balanced picture.

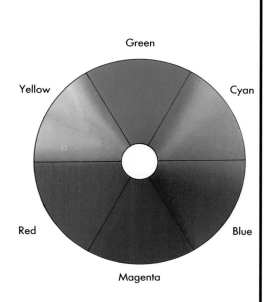

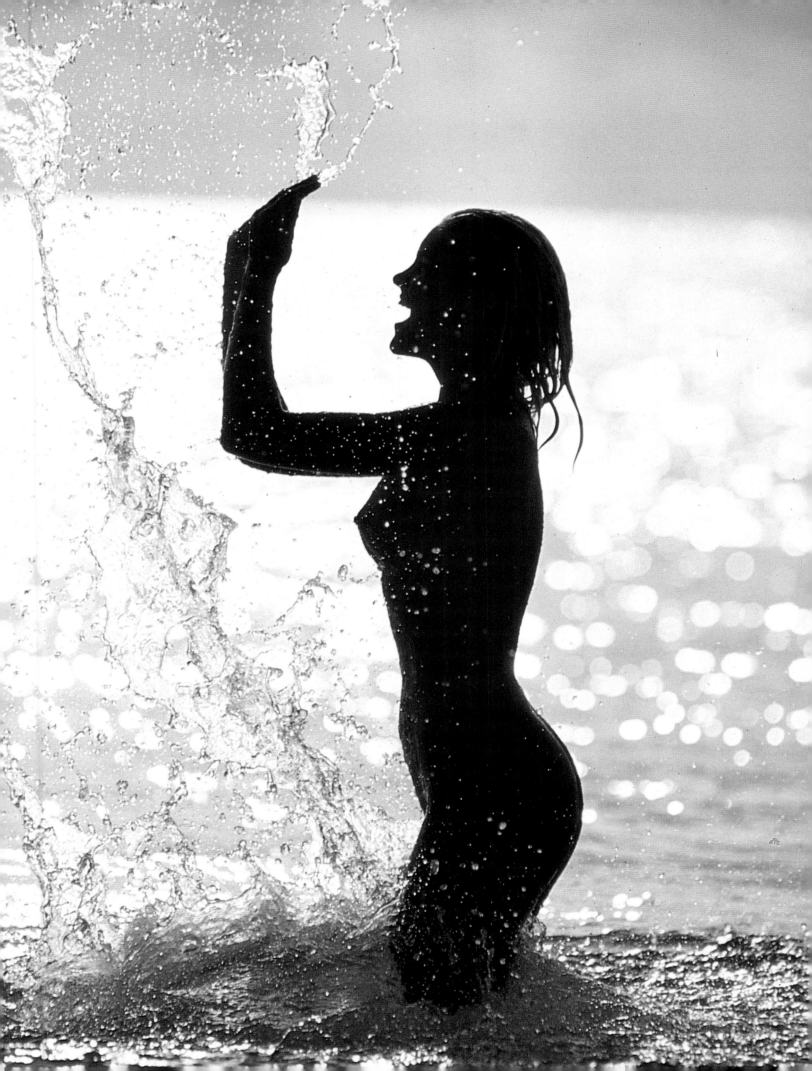

Morning light

First light provides a unique environment for those dedicated enough to leave the warmth of their beds. Depending on the season, the hours between 5 a.m. and 9 a.m. present you with a world so peaceful that it can be inspirational. As the atmosphere has been cleansed (that is, polluted less) during the night, the early rays of sunlight are crisp and clear, undiluted by atmospheric pollution which increases through the day.

This is the time favored by landscape photographers, as veils of mist hang over water and cascade from mountain slopes, but the glamour photographer can also make good use of this special time.

PRO POINTERS

■ THE TRANQUILLITY of the early hours allows you to work undisturbed at virtually any location of your choosing.

■ COLOR TEMPERATURE is still relatively low, so the sun's rays have a warmth which suits glamour.

■ THE LACK OF SOLAR intensity also makes it possible for you to pose your model facing the sun, with eyes open if you wish, without putting her to any discomfort.

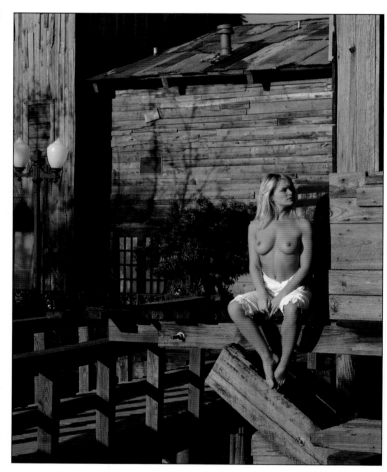

The tranquillity of early morning can be found even in a public place, as at this time interruptions and objections are unlikely. The sheer quality of the light highlights the textures of the wooden buildings. The white clothing makes a feature of the matching streetlights in the background.

TECHNICAL DATA
Camera
Mamiya RB67
Lens 250mm
(medium telephoto)
Film Kodak EPR64
Exp 1/30th – f11

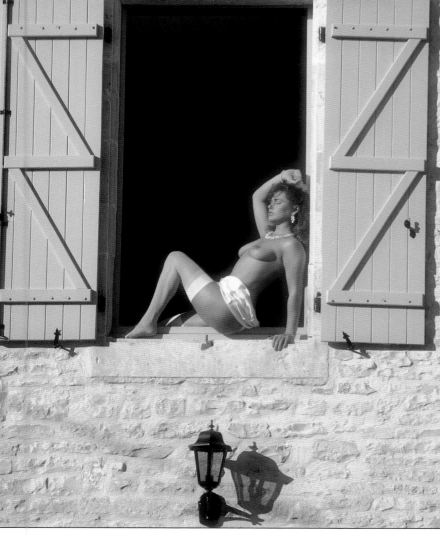

The angle of the shadow cast by the wall-lamp clearly reveals the earliness of the hour, the warm, slanted rays of the sun catching the golden-tanned model still in sleepy mood at her bedroom window.

TECHNICAL DATA
Camera
Bronica ETRSi
Lens 200mm (medium-long telephoto)
Film Fuji RDP100
Exp 1/60th – f8
Filter Soft-focus

Early morning light illuminates the model on a wooden deck, bringing out the warmth in the wood and the model's flesh.

TECHNICAL DATA
Camera
Bronica ETRSi
Lens 100mm (short telephoto)
Film Fuji Velvia 50 ISO (rated at 40 ISO)
Exp 1/60th – f5.6

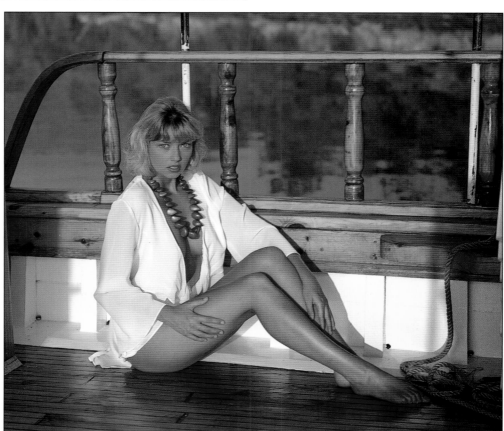

Midday madness

As the morning progresses towards midday, the sun climbs into the sky, becoming ever more intense. Its warmth gradually fades back to white, shadows become shorter and harsher as contrast increases, and the opportunities for good sunlit glamour photography become more restricted. Between approximately 11 a.m. and 2 p.m., depending on your location, the best advice is to move into the shade.

PRO POINTERS

■ REMEMBER THAT THE sun is at its highest color temperature at midday, so color-correction filters of the 81 series (warm-up) are needed to neutralize the blue cast that otherwise will affect your pictures.

■ A FREQUENTLY USED technique when working in the shade is to use gold reflectors to bounce light onto your model.

■ IF YOUR MODEL lies at 90° to the overhead sun, this will obviate the need for contrast-reducing reflectors, because what little shadow there is will fall directly below her body. Eye contact will be impossible, however, so you have the choice of either using sunglasses as props, or showing your model "asleep."

In this striking and unusual image, the high position of the sun is made very obvious by the angle of the shadows on the wall. The photographer has chosen the "sunglasses option" for the models, as the sun is obviously far too bright to permit eye contact.

TECHNICAL DATA
Camera
Bronica ETRSi
Lens 150mm
(medium telephoto)
Film Fuji RDP100
Exp 1/250th – f8
Filter 81b

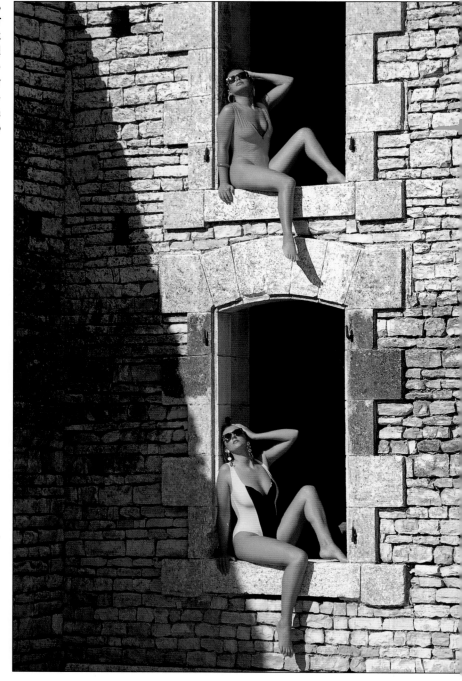

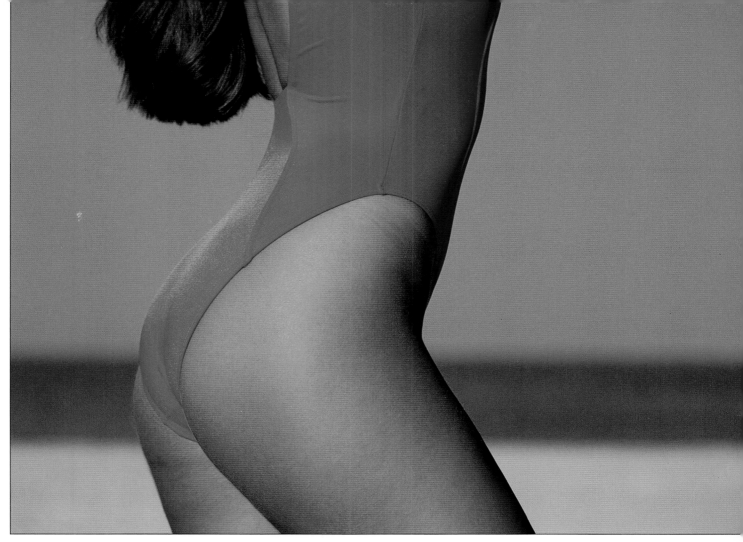

Above: The already bold colors are intensified by slight under-exposure (up to half a stop).

TECHNICAL DATA
Camera
Bronica ETRSi
Lens 200mm (medium-long telephoto)
Film Fuji RDP100
Exp 1/250th – f11
Filter 81b (warm-up)

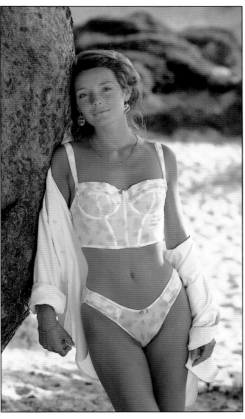

Left: Working in the shade at midday, light from a gold reflector placed in the direct sunlight was bounced to illuminate both model and tree trunk, and additional reflection is provided naturally by the white sand.

TECHNICAL DATA
Camera
Bronica ETRSi
Lens 150mm (medium telephoto)
Film Fuji RDP100
Exp 1/250th – f5.6

Dusk

By midafternoon, the sun is descending toward the horizon, the light warms up, and direct-sunlight photography is once again the obvious choice. With flatter, more oblique rays, texture, shape and form become more defined, lending a three-dimensional quality to your pictures.

During the mid- to late-evening phase, the world – and your model – are bathed in a rich, golden light. Only atmospheric pollution – more prevalent in urban areas – prevents this light from matching the crystal clarity of first light. Indeed, the "denser," polluted atmosphere scatters and diffuses the warm rays, making the light richer than at dawn.

PRO POINTERS

In order to maximize the effectiveness of your pictures, bear in mind the following points:

■ As SUNSET approaches, the sun drops at a startling pace. If it is practical, visit your chosen location at a similar time on a day prior to your shoot. Establish where, and when, your best pictures may be achieved. Note precise timings, and try to anticipate any relevant details such as filters that you may need to compensate for the exceptionally warm light that precedes sunset.

■ WITH A LITTLE LUCK – and good judgement –

early-evening light can be made to outline your model with a halo of gold. This has the added benefit of distancing her from the background, enhancing the three-dimensional effect.

■ BECAUSE THE LIGHT level is low, your model can look toward the sun (without squinting), and bask in its warm rays.

■ BE AWARE that, as the light level diminishes during the day, a tripod becomes a necessity in order to avoid camera shake.

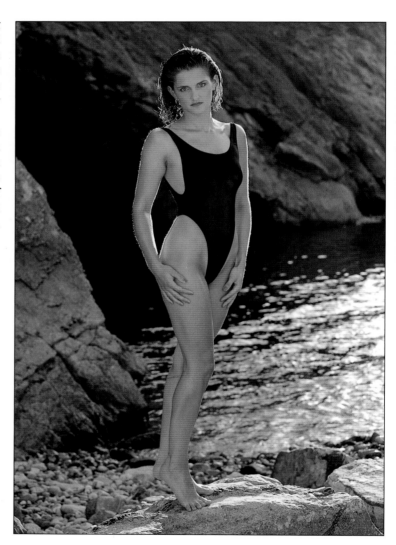

Low-angled rays reflecting from the surface of the water create a halo around the model's head and upper body. Frontal fill-in light comes from the rocks and a gold reflector.

TECHNICAL DATA
Camera
Mamiya 645
Lens 150mm
Film Kodak EPR64
Exp 1/60th – f5.6

The slanting rays are used to rim-light the model, while a gold reflector to camera right gives fill-in light to soften the shadows.

TECHNICAL DATA
Camera
Bronica ETRSi
Lens 100mm (short telephoto)
Film Fuji Velvia 50 ISO (rated at 40 ISO)
Exp 1/125th – f5.6

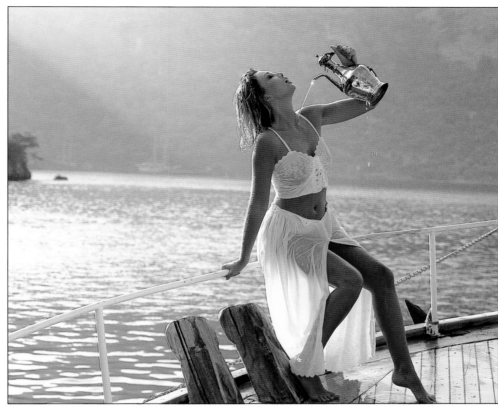

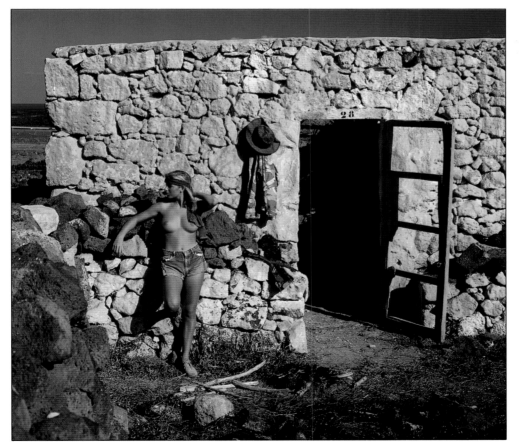

This scene uses bright early evening light as frontal illumination. The qualities of raking evening light are fabulous for texture.

TECHNICAL DATA
Camera Hasselblad
Lens 100mm (short telephoto)
Film Kodak EPR64
Exp 1/125th – f8

Sunset times

Some of the most dramatic – and glamorous – photographs are those taken at sunset. The sky becomes a constantly changing canvas of sometimes wild and impressionistic color, which water can reflect to enhance your pictures further.

KEY TERM: BRACKETING

One of the most useful techniques in the glamour photographer's armory is that of bracketing. This system of making one exposure longer and one exposure shorter than the meter's recommended settings allows a greater chance of "getting it right." Furthermore, bracketing, especially on slide film, also shows the changes in saturation of the sunset's colors and model's skin tones that even just a slight change in exposure can offer.

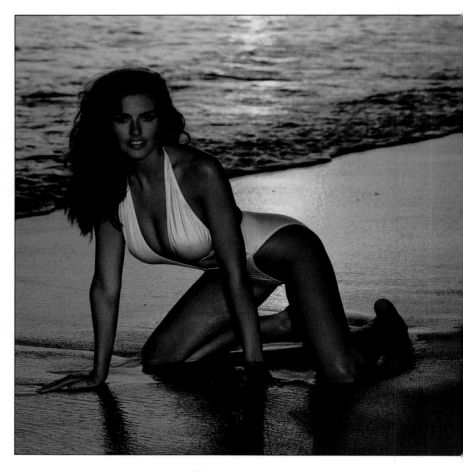

PRO POINTERS

■ LEAVING YOUR CAMERA set on automatic exposure, or taking a manual reading from the sky only, will result in a faithful reproduction of the sunset but leave the model as a silhouette. This can be effective, provided the figure is angled to display a flattering profile.

■ WHILE THE SUN is still relatively high in the sky, it should be concealed behind the model's body to avoid lens flare.

■ BE AWARE that when the sun starts to drop, it does so very quickly. Unless your camera is fully automatic, you will find it necessary to take meter readings every few seconds.

■ SUNSET IS THE perfect time for experimenting with fill-in flash or synchro-sun. By varying the setting on your flash gun, and adjusting your lens aperture and/or camera shutter speed, you can either illuminate your subject fully, or add just a touch of modeling light.

■ MOST IMPORTANTLY, make sure you have sufficient film in your camera to capture the complete sunset sequence. If possible, have two cameras loaded, or additional film-backs prepared, if appropriate. Even changing film can take just long enough to miss the optimum moment, so two camera bodies could help you to capture the shot of a lifetime.

The setting sun at almost water level with a minimal amount of fill-in flash gives a minimalist sunset lighting effect.

TECHNICAL DATA
Camera Hasselblad
Lens 150mm
Film Fuji RDP100
Exp 1/60th – f4

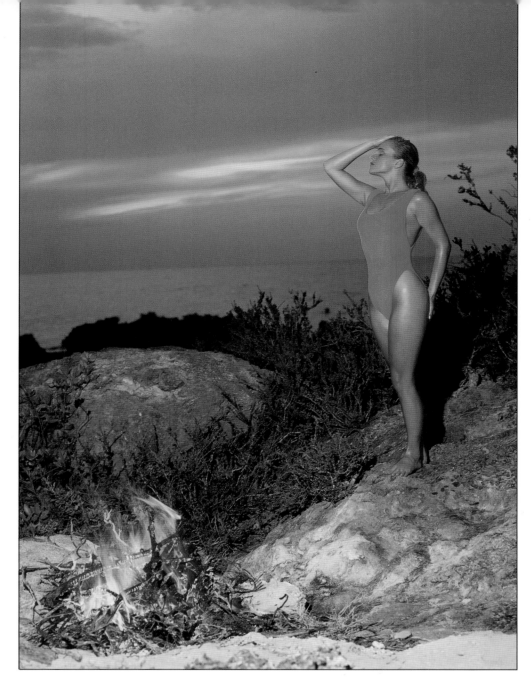

The sun has set, and its afterglow is the only available light used. A tungsten spotlight picks out the model and the fire with a warm beam of light.

TECHNICAL DATA
Camera
Mamiya RZ67
Lens 180mm
Film Fuji RDP100
Exp 1/15th – f8

Graduated filters are best used at opposite ends of the day, when they enhance the amazing sky effects.

TECHNICAL DATA
Camera
Mamiya RB67
Lens 180mm
Film Fuji RDP100
Exp 1/60th – f8

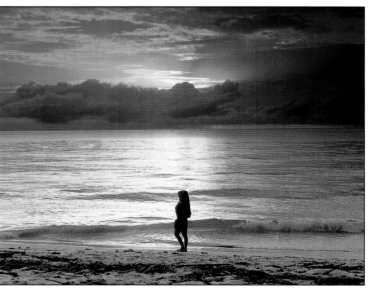

63

Picture Portfolio

1, 3 & 4 These illustrate three approaches to shooting at midday. **1** exploits the shade, using reflection to illuminate the model. **3** has the model lying down in direct sunlight, creating minimal shadow areas. **4** shows the third midday option – shooting graphic body shape pictures.

2 This is a late evening scene, with the model in the last golden rays of the almost setting sun.

5, 6 & 7 These show different approaches to shooting sunsets. In each, the photographer exposed for the sunset, and relied on fill-in light for the model.

5 makes use of the low rays coloring the sea, and fill-in from a tungsten spotlight.

6 uses a low camera angle with frontal illumination provided by fill-in flash. **7** uses no fill-in at all, so the model is in silhouette, but it has a graduated filter.

8 This makes use of a partly cloudy sky at sunset, and features the highlighting effect of fill-in flash.

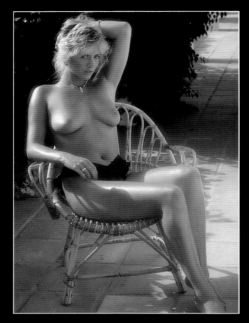

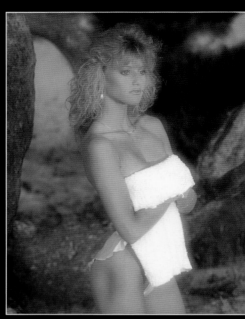

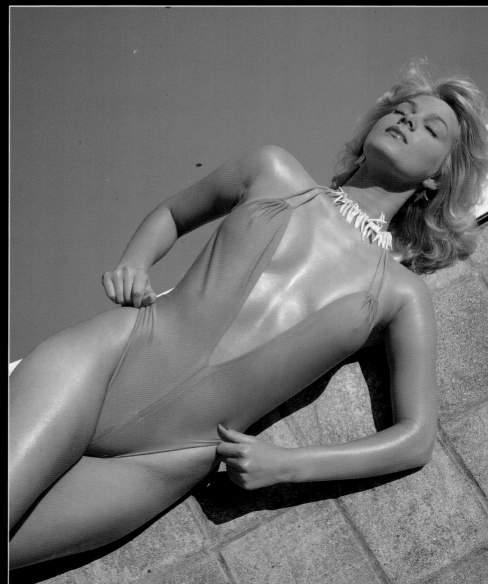

64

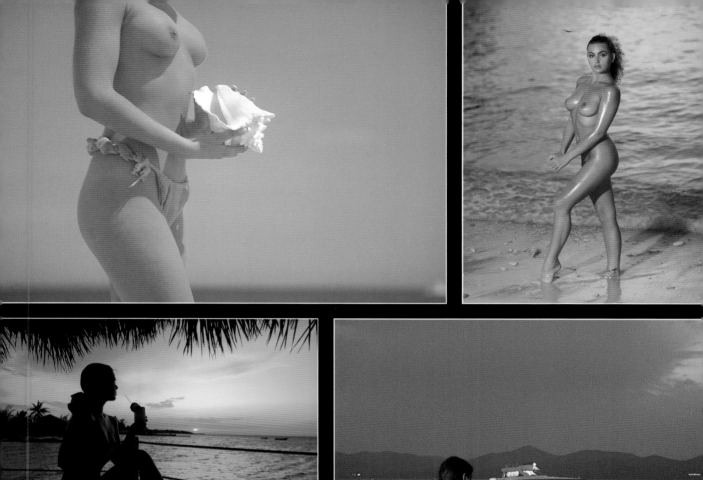

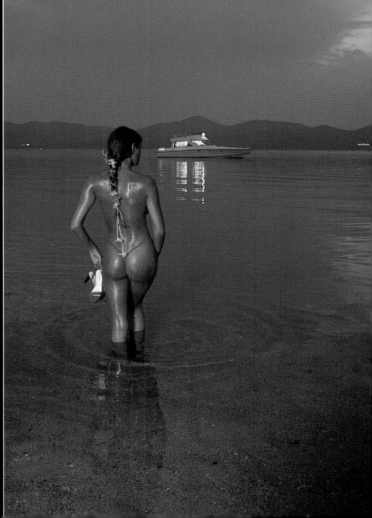

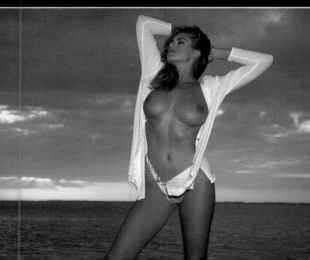

POOR WEATHER

Outdoor glamour photography is subject to one major controlling factor – the weather. More time is wasted, money spent, and frustration caused by this than by anything else. It can be too hot, too cold, too wet, too windy, or just too dull. The weather is predictable only in its unpredictability. It frequently defies the forecasts of professional meteorologists, in spite of their state-of-the-art technology. It has the ability to change when least expected, catching the photographer unawares, anywhere in the world.

There is no escaping the weather; instead, the photographer should learn to adapt to its many manifestations, turning them to advantage. A lack of strong, direct sunlight is not necessarily a problem, though it can be difficult to cope with rapidly changing light levels when sun is intermittent. But cloudy, windy, or even snowy conditions can be exploited for atmospheric glamour shots.

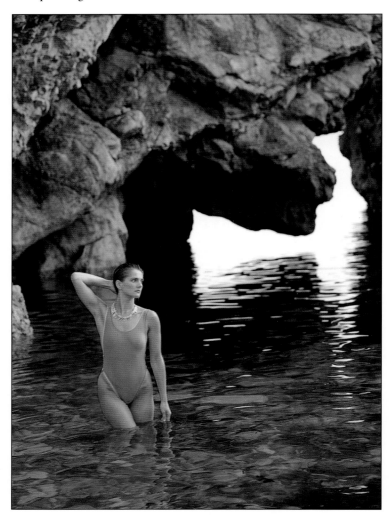

Here there is no sunlight to cause reflections on the surface of the water, and no blue sky to influence its color, so both sea color and underwater detail are genuinely reproduced.

TECHNICAL DATA
Camera
Mamiya 645
Lens 150mm
(medium telephoto)
Film Kodak EPR64
Exp 1/125th – f5.6
Filter 81b (warm-up)

The even illumination reveals details of texture and color in the natural elements of flesh and wood, which sunlight might have subdued. The low light level has made it possible for the photographer to use a wide aperture to drop the palm tree out of focus.

TECHNICAL DATA
Camera
Mamiya RZ67
Lens 180mm
Film Fuji RDP100
Exp 1/125th – f4

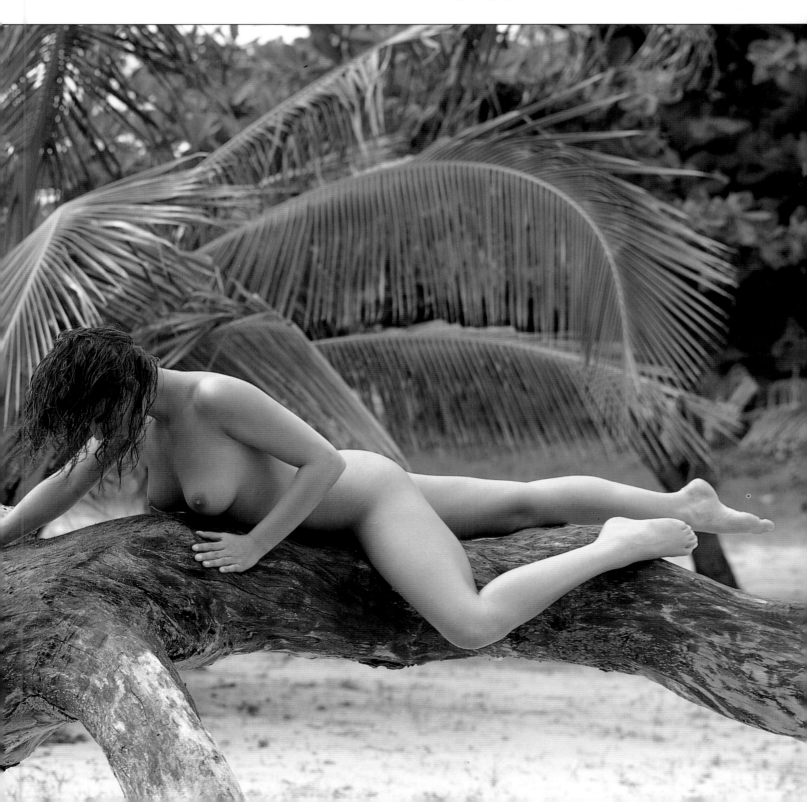

Low light levels

Variations in the weather obviously have a marked influence on the quality of light. While direct sunlight can be intense and sometimes too harsh to be photogenic, a small cloud covering the sun in a predominantly blue sky has the beneficial effect of diffusing the light and softening shadows.

When too many clouds begin to appear, however, the situation rapidly becomes frustrating for the photographer. The sun going in and out at frequent but irregular intervals makes for an awkward metering situation, where three light levels have to be considered – sun out, sun behind cloud, and sun part-obscured by cloud.

Much easier to handle is the layer of thin, hazy cloud that completely obscures the sun, but without obliterating it. A constant light level is the result, varied only by the density of the cloud cover.

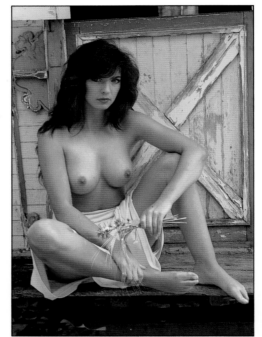

Left: A bluish cast caused by overcast conditions produced an appealing, cool result.

TECHNICAL DATA
Camera
Mamiya 645
Lens 150mm
Film Kodak
Ektachrome 200
Exp 1/60th – f5.6
Filter Soft-focus

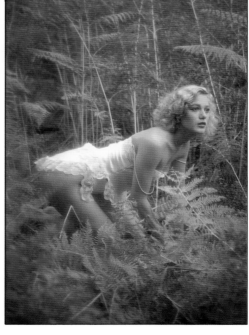

Low mist produced unusual lighting conditions.

TECHNICAL DATA
Camera Mamiya 645
Lens 150mm
Film Kodak EPR64
Exp 1/125th – f5.6
Filters Soft-focus and 81b warm-up

Right: The orange props were selected to contrast with the flat, gray sky. The tiniest touch of fill-in flash added detail.

TECHNICAL DATA
Camera
Mamiya 645
Lens 150mm
Film Kodak EPR64
Exp 1/60th – f5.6
Filter 81c warm-up

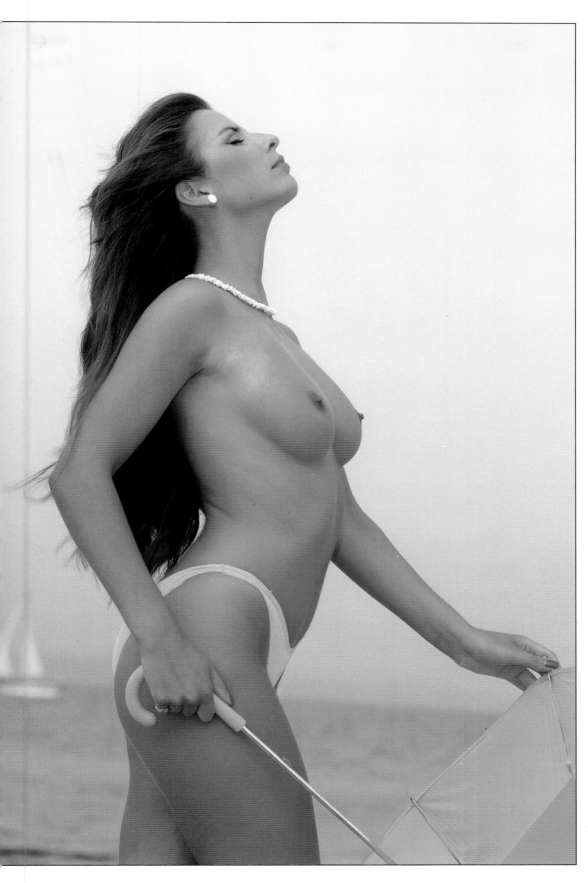

PRO POINTERS

■ A THIN LAYER of haze in the sky acts as an overall diffuser, transmitting sufficient soft sunlight to illuminate your model to stunning effect.

■ SEAWATER CAN look exceptional in overcast conditions. With very little reflected light sparkling on the water's surface, a real impression of depth can be conveyed, while underwater detail and color are both considerably enhanced.

■ WORKING IN LOW LIGHT, you should use warm-up filters of the 81 series because overcast lighting is heavily influenced by ultraviolet rays and will, if unfiltered, lend a blue cast to your pictures that is far from ideal for glamour subjects.

■ A THICKER CLOUD covering eliminates shadows altogether. This light is actually very flattering, but you will need to choose your model's surroundings carefully. Avoid dark, lifeless backgrounds, and take care that her clothing makes the most of the low light levels – detailed fabrics, such as lace, are ideal.

■ A TOUCH OF FILL-IN flash can be used to lift your pictures a little, adding sparkle when the sun fails to shine.

Snow and wind

Snow for glamour? Well, why not? The combination of sun and snow can make for spectacular lighting. The massive amount of reflected light results in an unusually bright but low-contrast situation that is wonderful for glamour photography.

Windy conditions in any weather can be a blessing or a curse. Your model's hair may be flowing gracefully behind her one second, and wrapped around her face the next, while the chiffon skirt blowing so prettily in the breeze can easily become wrapped around her legs in a most unflattering fashion.

Of course, if the wind is blowing consistently and predictably, without sudden changes of strength or direction, it can add another dimension to your pictures. Wind in the hair is an image frequently used to represent freedom and change, so a photograph of a glamorous model on a deserted beach, hair flowing, is laden with symbolism. It is seldom damaging to your pictures to instill an element of escapism – especially if it fires the viewer's imagination.

Finally, be aware of wind on a sandy beach. It can cause serious damage to the workings of your camera. Salt is highly corrosive and sand highly abrasive, and together they wreak havoc, so take care in this situation.

TUTORIAL

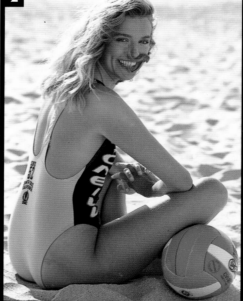

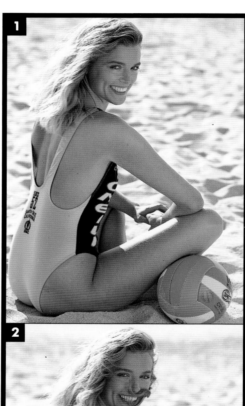

These pictures are a graphic demonstration of how windy conditions can work to your advantage or detriment.

1 The wind lifts the model's hair tidily away from her face. A fast shutter speed arrests the movement, adding life to the bright, summery mood. A gold reflector increases the light level on the model's face, and puts sparkling highlights into her eyes.

2 How easily it can all go wrong. A change of wind direction blows her hair across her face and knocks over the reflector, losing the golden fill-in light and highlighting.

TECHNICAL DATA
Camera
Bronica ETRSi
Lens 150mm
Film Fuji RDP100
Exp 1/250th – f5.6

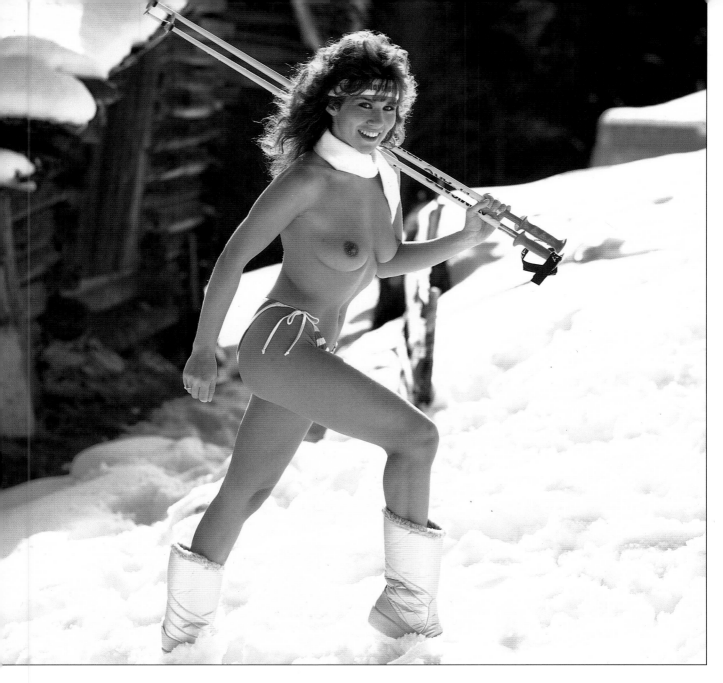

The high brightness level created by snow is apparent in this picture. The length of the background shadows indicates that the picture was taken early in the morning, yet no fill-in light was needed thanks to the highly reflective quality of the snow.

TECHNICAL DATA

Camera Hasselblad
Lens 150mm (medium telephoto)
Film Fuji RFP 100
Exp 1/250th – f5.6

PRO POINTERS

■ IT IS ASKING a lot to expect a model to remove nearly all her clothes in the snow, but the novelty of the idea is sure to appeal to the more adventurous type. The same novelty should help your pictures to be successful. If you ever have the chance to try "snow glamour," make the most of it.

■ CONDITIONS where such photography could be considered may be found in mountain ski resorts, which keep their snow until well into the spring. In early spring, for instance, a snow-covered slope that is facing the sun but sheltered from the wind can actually be pleasantly warm.

■ EARLY EVENING in a snowy location can also be a photogenic time, as the reflected light boosts the light level even as sunset approaches. This enables you to keep shooting in "daylight" until later in the day.

■ NOTE THAT fill-in flash can be used to advantage.

■ DO NOT EXPECT your model to remain uncovered for long. Once the novelty of the idea wears off, the cold sets in. Be sensitive, and decide that it is time to stop before your model does.

REFLECTED GLORY

TECHNICAL DATA
Camera
Bronica ETRSi
Lens 150mm
(medium telephoto)
Film Fuji Velvia 50
(rated at 80 ISO)
Exp 1/250th – f5.6

The essence of glamour photography is, quite simply, to make your model look her best, a task made much easier by the right light. For outdoor purposes, early and late sunlight provide the best direct illumination for glamour photography (see Times of day on page 54). The advice for working through the middle period of the day – to avoid direct sunlight and to work in the shade – is not as negative as it sounds. Simply by turning your model around, so that the sun is at her back, you will be able to take photographs against the light, or *contre-jour*.

By taking your meter reading from the shaded face and body of your model, and exposing accordingly, you will almost certainly overexpose the background. If this is the effect that you are trying to achieve, this is all well and good. There are occasions, for example, when it is desirable to disguise some detail in the background.

If this is not the case, you must push some light back onto your model, in order to reduce overall image contrast, and ensure that detail is revealed in both highlight and shadow areas. There are two ways in which to achieve this – by using reflectors or fill-in flash (see page 86).

Of the two methods, reflectors have several major advantages. First, their effect is visible to the naked eye and can be accurately measured with your exposure meter. The effect of fill-in flash is difficult to assess at the shooting stage, even in the hands of a professional photographer. Second, by varying the size and color of your reflectors, and their distance from your model, you can exercise considerable control over the shadow area in any *contre-jour* situation, balancing the level of light to suit your requirements. Fill-in flash is far less versatile, as adding filters to change the color of the light makes it virtually impossible to calculate exposures correctly. Also, as your flash head is most likely to be attached to your camera by means of a very short sync lead, the source position of your "fill-in" will not be readily adjustable.

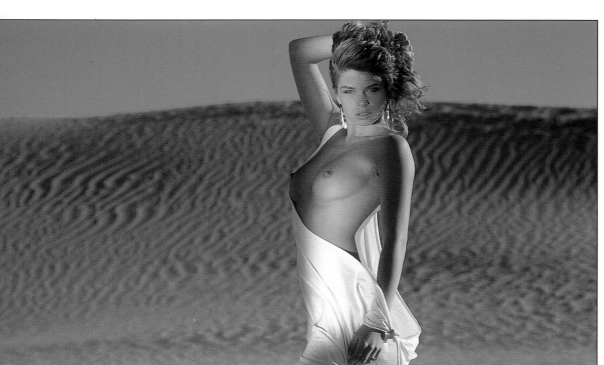

TECHNICAL DATA
Camera Nikon F3
Lens 135mm
(medium-long telephoto)
Film Fuji RDP100
Exp 1/250th – f5.6

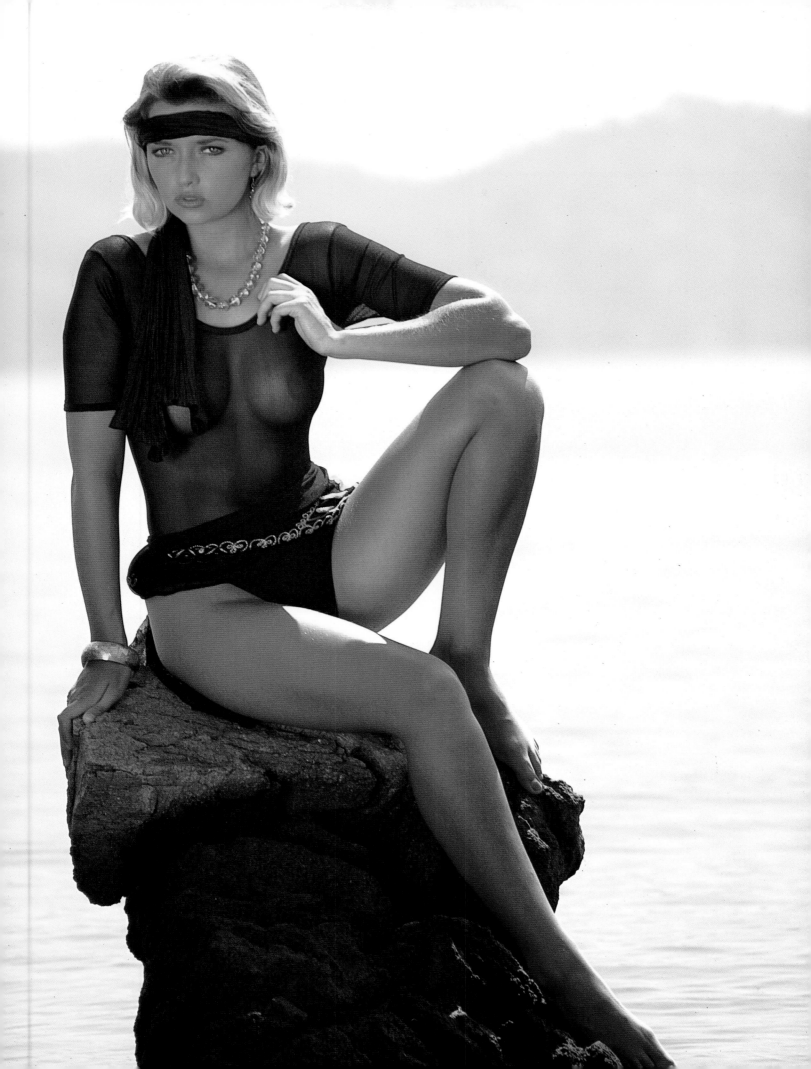

Reflector types

Reflectors come in all shapes and sizes. Among the most popular are the circular fabric types, measuring approximately 3¼ feet in diameter, which fold up (with a little practice) to be carried in a very compact bag. These are available with a different reflective color on each side. They are an excellent choice for the glamour photographer, being light, flexible, easily portable, and surprisingly hard-wearing.

Much larger reflectors can be purchased, usually 6½ feet by 3¼ feet, which consist of a collapsible plastic frame and separate fabric cover. The cover is elasticated at all the corners to enable it to be attached to the frame in seconds. Being larger in dimension, these obviously reflect more light, and are ideal if you are shooting full-length photographs. Their biggest drawback is lack of wind-resistance. Due to their size and lightweight construction, they cannot be propped and left unattended if there is any breeze blowing, unless you enjoy a chase.

You may think that it should not be necessary to buy expensive, ready-made photographic products in order to reflect light. Surely a sheet of cardboard has the same effect? Initially, yes, but the edges disintegrate and the surface soon breaks up, and you would need to replace your cardboard every few weeks. In the long term, proprietary reflectors are better value, because their reflective qualities do not diminish in spite of repeated usage.

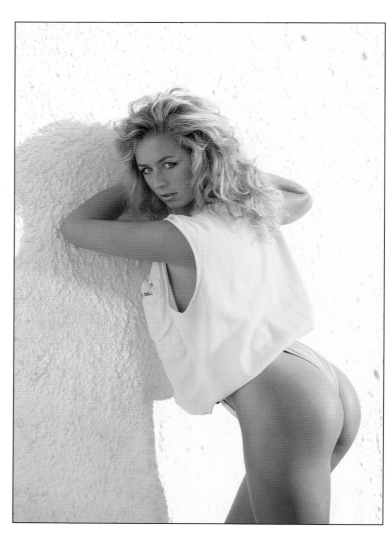

A small gold reflector to camera left adds warmth and detail to the model's face, and softens the shadow cast on the wall by her head (note how harsh the unsoftened lower body shadow is).

TECHNICAL DATA
Camera
Mamiya 645
Lens 150mm
(medium telephoto)
Film Kodak EPR64
Exp 1/125th – f8

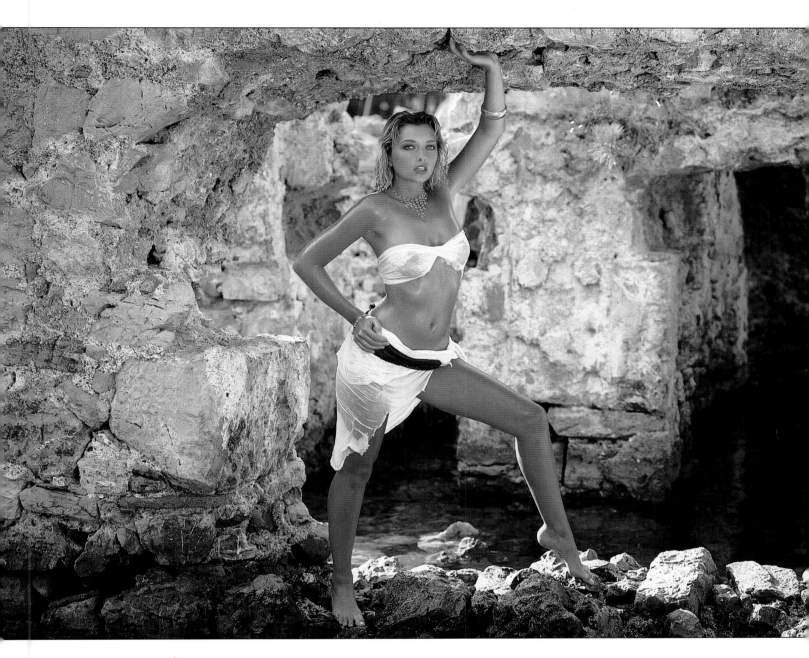

Low sunlight through the hole in the wall bounces from a gold reflector in an otherwise unlit spot.

TECHNICAL DATA
Camera
Bronica ETRSi
Lens 150mm
(medium telephoto)
Film Fuji Velvia 50
(rated at 80 ISO)
Exp 1/60th – f5.6

PRO POINTERS

■ IT IS ADVISABLE to have an assistant to hold your reflector for you, as it may sometimes be impossible to prop a reflector at precisely the right angle to transmit the sun's rays. Your assistant can provide a mobile support for your reflector, while doubling as a weather lookout and passing you vital information about approaching clouds or the sun's imminent reappearance from behind a cloud. If you have to keep looking up to do this, your vision is sure to be affected for a few seconds each time, and a temporarily blinded photographer seldom takes good pictures!

Fill-in colors

The most popular colors for reflectors are gold, silver, and white. Given that you are most likely to be using your reflector to cut the contrast level in a sunlight-and-shade situation, gold is likely to be the most useful of the three. As already stated, midday sun has a high color temperature, and a tendency to record as blue in shadow areas. A gold reflector serves two purposes, both reflecting the light – canceling out the blue cast – and avoiding the need for costly light-absorbing color-correction filters.

PRO POINTERS

■ EVEN IF THE sun is not at its brightest, gold is still often the color to go for. Glamour pictures are seldom spoiled by being too golden, yet many are ruined by the model's flesh appearing gray and cold, if not actually blue. Gold and glamour are natural companions – it is difficult to overstate a golden tan, for instance – and the associations of gold as a color can transmit a message of warmth and contentment to the viewer.

■ SILVER IS ACTUALLY a more reflective color, but silver reflectors are likely to leave you needing warm-up filters to compensate for the resulting cast. This defeats the object of using silver for its extra reflective qualities, but

makes it a good bet if your desired result is to create a cool image, unusual in glamour photography.

■ WHITE CAN BE very useful if you want to reflect less light. It makes for a softer reflection that is less likely to be "colored" than when either using gold or silver. For this reason, its main use is in professional fashion/glamour, where colors of items of clothing must be faithfully reproduced for advertising purposes.

■ SURPRISINGLY, BLACK "reflectors" are also used on occasion. Their purpose is to negate reflected light, an effect necessary when one-sided lighting is required, with no fill-in whatsoever from the opposite side.

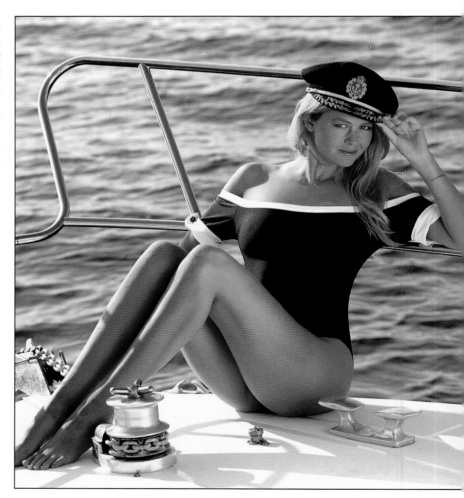

Low evening sunlight (boosted by reflection from the surface of the sea) is used as sidelight. A reflector held by the assistant to camera right bounces golden light into the model's face and body, making a strong contrast to the blues of sea, swimsuit, and hat.

TECHNICAL DATA
Camera
Bronica ETRSi
Lens 100mm (short telephoto)
Film Fuji RDP100
Exp 1/125th – f8

TUTORIAL

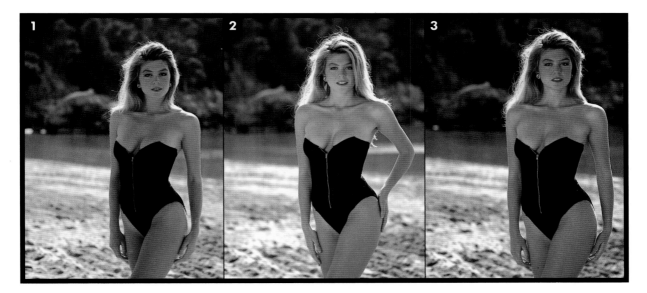

Here are the different effects created by using gold and silver reflectors, or with none at all.

1 No reflector was used. The model is backlit by the sun, and frontal illumination is minimal, resulting in a dull, colorless image.

2 A gold reflector is used this time, which adds an extra dimension of color to the image – the model is bathed in the flattering golden glow that is rightly popular in glamour photography.

3 This shows how placing a silver reflector to camera left instantly changes the shot, with the sharp but neutral-colored fill-in light lifting the level of frontal illumination considerably, adding detail to the black costume and bright highlights to the model's eyes.

TECHNICAL DATA
Camera
Bronica ETRSi
Lens 150mm
(medium telephoto)
Film Fuji RDP100
Exp 1/125th – f8

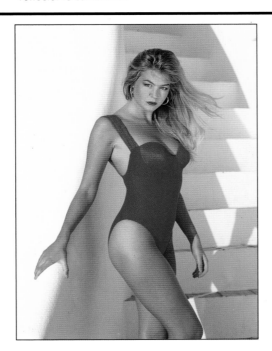

Unusually, the reflector has been used here to actually boost the direct early evening sunlight illuminating the model. A strong nose shadow was being cast by the sunlight from camera left, and this has almost been canceled out by positioning a gold reflector to camera right. Additional benefits of using the reflector are added color in the model's face and hair, and powerful highlights in her eyes.

TECHNICAL DATA
Camera
Bronica ETRSi
Lens 150mm
(medium telephoto)
Film Fuji RDP100
Exp 1/250th – f8

Improvised reflectors

Any surface which does not absorb 100% of the light directed at it is, by definition, a reflector. It follows that light-colored surfaces have greater reflective qualities than dark ones, so sand and water are both good options. They can always be relied on to boost the light level in photographs, and are also helpful in reducing the image contrast.

If sand and water are the best natural reflectors, white walls have no equal among manmade surfaces. White is by far the most popular color for buildings in hot climates, because of its reflective qualities: the majority of the sun's rays are deflected, the occupants stay cool, and the glamour photographer is provided with as much reflected light as could possibly be desired.

PRO POINTERS

■ BE PREPARED to add color-correction filters when using either water or white walls as reflectors, particularly through the middle of the day when the sun is at its highest color temperature. Early and late sunlight produce warmer-colored shadows, which are less likely to present filtration problems.

■ WITH REGARD to swimming pools, the blue lining of many pools can produce a very cold-colored reflected light, which needs to be balanced. Add either 81c or 85b warm-up filters,

depending on the time of day (see Pools on page 128).

■ HIGHLY POLISHED, white-bodied boats are spectacularly reflective, continuing to reflect even if the weather is not favorable. Once again, you should consider using warm-up filters, in this case 81a or 81b.

■ GOLDEN SAND does away with the need for color-correction filters because it reflects a very pleasing warmth of its own, particularly when lit by the sun.

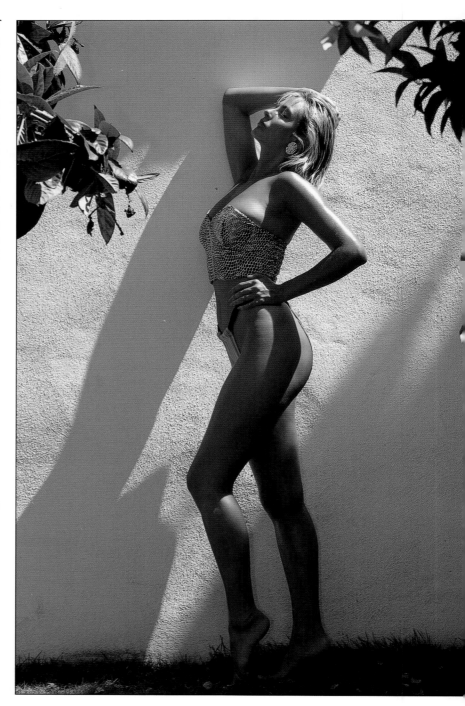

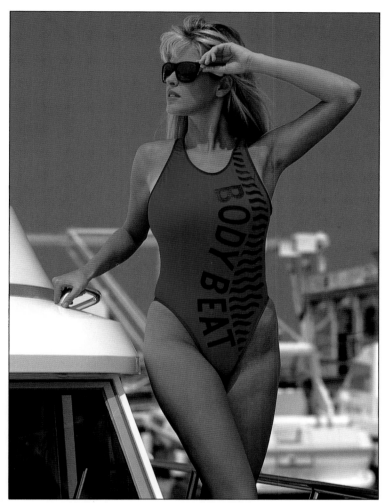

The white super-structure of a single boat can reflect a spectacular amount of light. A large group of them can boost overall light levels to an unbelievable high. It is a virtual necessity for a model to wear sunglasses and bold, brightly colored costumes.

TECHNICAL DATA
Camera
Bronica ETRSi
Lens 150mm
(medium telephoto)
Film Fuji RDP100
Exp 1/250th – f11

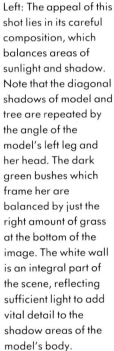

Left: The appeal of this shot lies in its careful composition, which balances areas of sunlight and shadow. Note that the diagonal shadows of model and tree are repeated by the angle of the model's left leg and her head. The dark green bushes which frame her are balanced by just the right amount of grass at the bottom of the image. The white wall is an integral part of the scene, reflecting sufficient light to add vital detail to the shadow areas of the model's body.

TECHNICAL DATA
Camera
Mamiya 645
Lens 150mm
(medium telephoto)
Film Kodak EPR64
Exp 1/250th – f8
Filter 81b (warm-up)

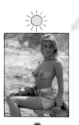

The benefits of sand are level of reflection and golden color.

TECHNICAL DATA
Camera
Bronica ETRSi
Lens 150mm
(medium telephoto)
Film Fuji RDP100
Exp 1/250th – f8

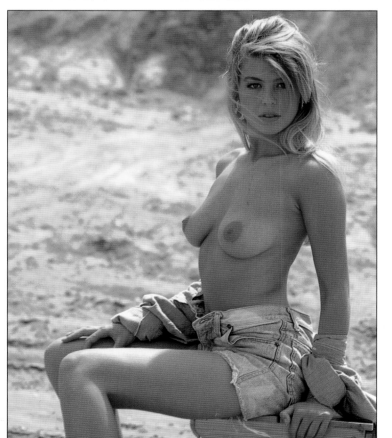

Mirror images

If you intend to use mirrors to boost frontal lighting, do so with great care. Used indiscriminately, in strong sunlight, a mirror has the potential to damage your model's eyes. Remember that, unlike all other types of reflector, a mirror transmits almost 100% of the light it receives, so you are, in effect, asking your model to look straight at the sun. Unless you are shooting in either early-morning or late-evening light, this is likely to prove uncomfortable, unflattering, and even hazardous to your model. Be careful!

Consider also the implications of sunlight arriving from two directions simultaneously – an unnatural situation. You have two options at your disposal. First, you can be aware of the potential to provoke a reaction in your viewer, and emphasize the effect accordingly. Second, you can deceive the viewer into believing that your mirror is the sun, provided that your photographs play down the natural shadows and emphasize those cast by the mirror. This can be a very satisfying technique if used thoughtfully.

This technique can sometimes save the day. As long as the sun is shining, you will be able to bounce light into even the most apparently inaccessible of locations with the aid of mirrors.

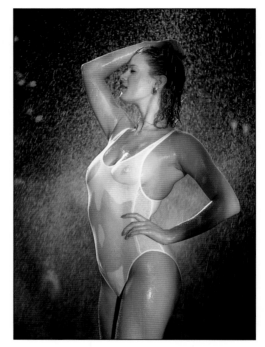

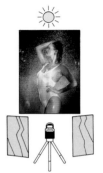

Two upright mirrors reflect the bright sunlight (used as backlight).

TECHNICAL DATA
Camera
Mamiya 645
Lens 150mm (medium telephoto)
Film Kodak EPR64
Exp 1/125th – f11

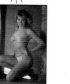

Fill-in light was created by a mirror-tiled panel.

TECHNICAL DATA
Camera
Mamiya 645
Lens 150mm (medium telephoto)
Film Kodak EPR64
Exp 1/125th – f5.6

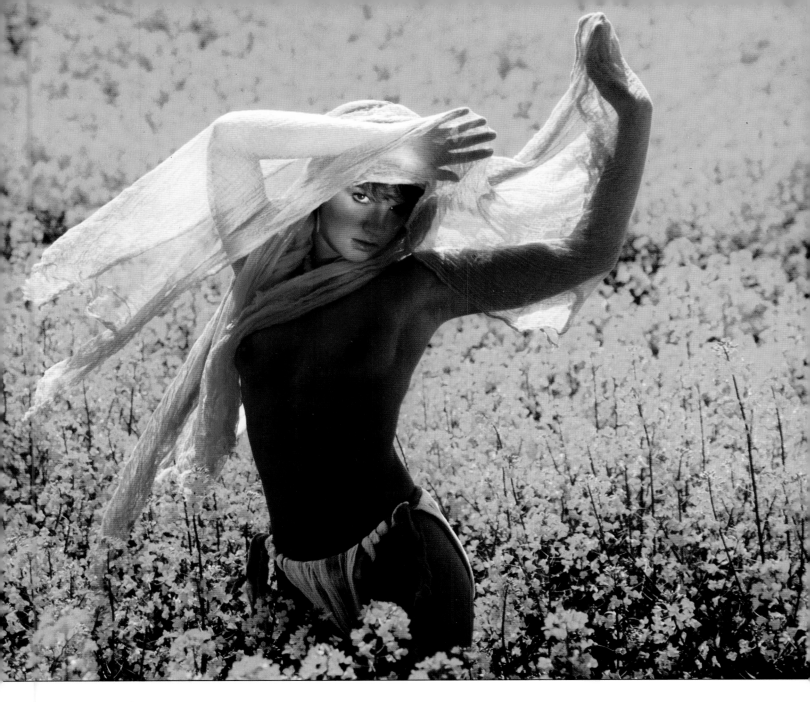

How to show the rich yellow flowers without making the model a virtual silhouette? The solution was found in the model's make-up box, in the shape of a very small hand mirror.

TECHNICAL DATA
Camera
Mamiya 645
Lens 150mm
(medium telephoto)
Film Kodak EPR64
Exp 1/125th – f11

PRO POINTERS

■ MANY TYPES OF mirror are available, in several colors, all of which have a slightly different effect on the light. Note also that colored gels can be placed over mirrors to influence the color of the light reflected further still.

■ MIRRORED SUNLIGHT can be used to create a bright rim light for your model. This is particularly useful in a situation in which you need her to stand out from the background.

Picture Portfolio

1, 4 & 5 These pictures use sun as backlight, and a single reflector to add frontal fill-in. In each case, gold is the chosen reflector. In all three pictures, the reflector position has been carefully adjusted until the exposure values taken from both model and background have matched.

2 A successful combination of bright midday sunlight, improvised reflection from the white walls, and fill-in light from a silver reflector placed to camera right. The result is a bright, finely balanced exposure, with all elements of the shot retaining full color and detail.

3 The afternoon sun provides the main light, with improvised fill-in from the sea and the boat's hull.

6 This relies entirely on reflection from the white walls and stairs to produce the kind of soft, flattering light that is perfect for glamour photography.

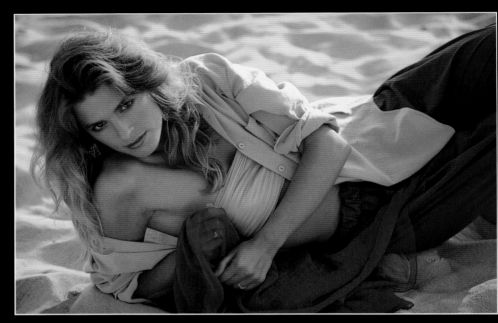

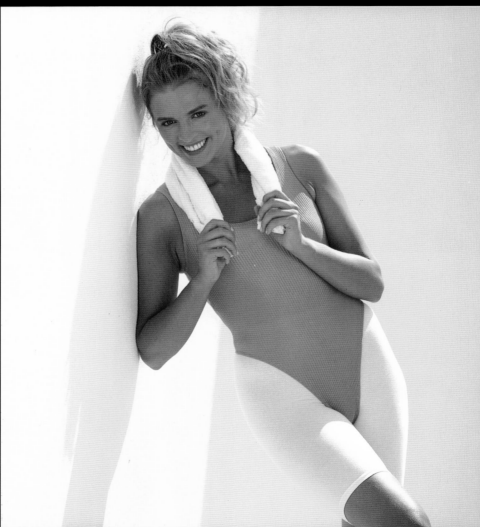

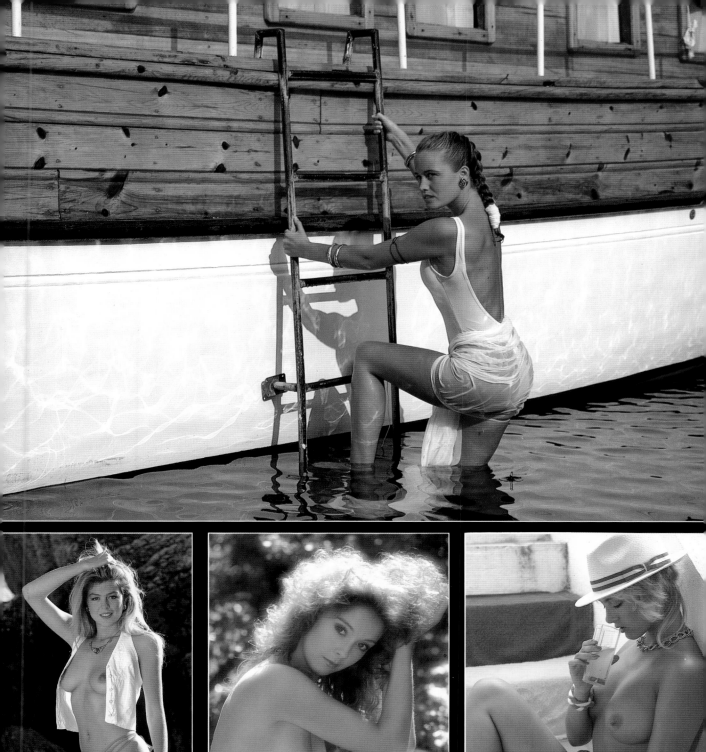

FILLING IN THE GAPS

TECHNICAL DATA
Camera
Mamiya RZ67
Lens 180mm (short telephoto)
Film Fuji RDP100
Exp 1/125th – f8
Filter 81b (warm-up)

There are sure to be occasions when the use of reflectors is inconvenient, or simply not possible. Picture, for instance, a bright but breezy day on the beach where you are trying to work, without an assistant, and end up fighting a running battle with the gusting wind, which seems intent on depositing your carefully positioned reflector in the sea. Your best solution to the problem is to substitute fill-in flash for the reflector.

Now imagine this – you are watching the sun setting dramatically over the sea, and your model's costume reflects the fiery colors in the sky perfectly, but the sun is by now so low that no reflector could possibly provide enough fill-in light to enable you to balance foreground and background exposures. The only solution is to use an independent light source to provide the frontal illumination, and the most convenient source is fill-in flash.

This technique serves the same main purpose as reflectors – namely providing an element of frontal illumination in an "against-the-light" situation, or filling-in any harsh shadow areas created by bright sunlight – but it has the advantage of being linked directly to the camera, therefore remaining under your control at all times.

A very subtle touch of fill-in flash has been used for this picture, yet its presence is revealed in no less than three ways: the small but important highlight in the center of the model's eyes (which shows that the flash gun is being held very close to the camera lens); the metallic sheen on the horizontal blinds; and the shine on the model's wet black swimsuit.

TECHNICAL DATA
Camera
Mamiya 645
Lens 150mm (medium telephoto)
Film Kodak EPR64
Exp 1/250th – f8
Filter 81b (warm-up) and soft focus

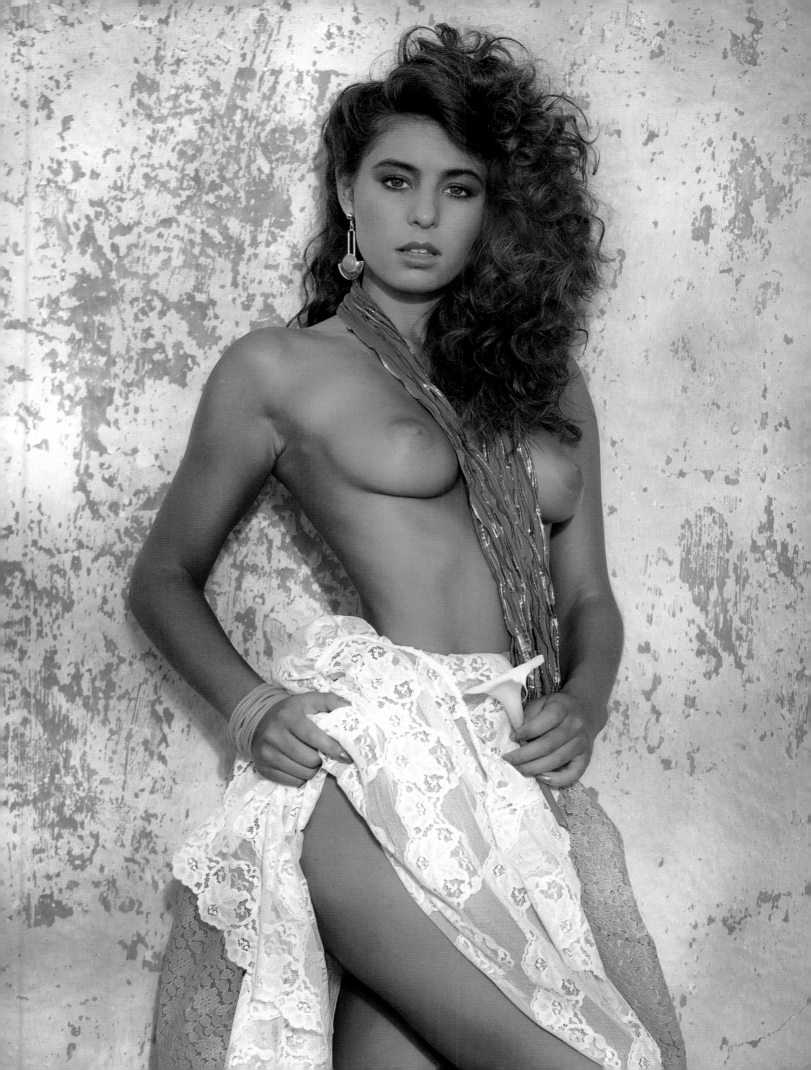

Fill-in flash

The aim of fill-in flash is to provide enough light to soften shadows and reduce image contrast (see page 83), without letting it dominate the whole shot. Fill-in flash is where you decide and set the exposure for the naturally lit elements of the scene, and fire an underpowered burst of flash to lighten (that is, reduce) the shadows.

This is achieved by setting up your flash gun so that it only fires at half or quarter power. The optimum ratio of flash to daylight is anywhere between 1:2 and 1:4, although the latter gives a very subtle effect that may not be sufficiently strong in a high-contrast situation.

The following is a working example of how to make your settings. First take a meter reading for the ambient light (daylight), and then set this on your camera. Remember that the shutter speed must not be faster than your camera's maximum flash-synchroniz-ation speed. In this example, let us say your reading is 1/125th at f11.

To achieve a flash-to-daylight ratio of 1:4, simply set your flashgun to an aperture two stops wider than the aperture on the camera lens – in this case the flash should be set to f5.6 (instead of the metered f11). Your flash gun will consequently underexpose by two stops.

If you need a stronger effect, set the flash to an aperture one stop wider, so obtaining a ratio of 1:2. If your lens is set to f11, for example, you should set your flash to f8. If you require a weaker burst of light, set the flash to an aperture three stops wider – f4 in this case.

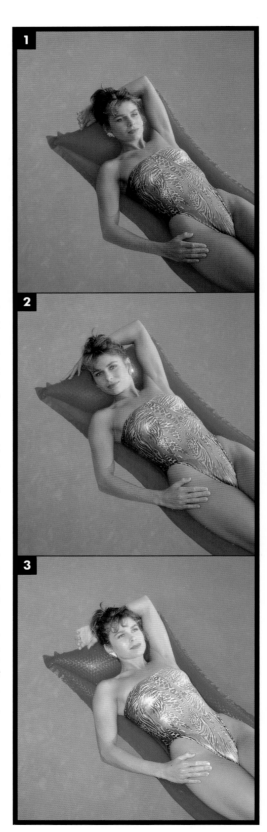

These three consecutively-taken pictures show the correct subtle effect of the technique, and an example of too much fill-in light being used.

1 This is taken with low evening sunlight only, and is a perfectly acceptable shot in its own right, although the near side of the model's body is dark and her eyes lack sparkle.

2 Fill-in flash is added to the scene at a ratio of approximately 1 : 4 (that is, flash set to aperture two stops under the lens aperture – f2.8). It shows just how delicately fill-in flash can be used to modify a shot, adding light and detail to the complete right side of the model's body.

3 A ratio of about 1 : 2 is used here (flash set to f4 – one stop wider than the lens), acceptable in very bright daytime conditions, but not in low evening light. The overexposed flash blasts the model with bright light, reducing color saturation and causing "hotspots."

TECHNICAL DATA
Camera
Mamiya 645
Lens 150mm (medium telephoto)
Film Fuji RDP100
Exp 1/125th – f5.6

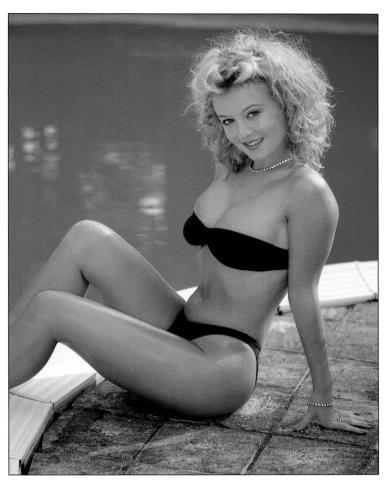

Sunlight illuminates the model from behind, creating shadows from her arms and upper body. The fill-in flash is used (at a ratio of about 1 : 3) to soften them and to highlight the glossy sheen on her body.

TECHNICAL DATA
Camera
Mamiya 645
Lens 150mm
(medium telephoto)
Film Kodak EPR64
Exp 1/125th – f5.6

An 81c warm-up filter modifies the color of the fill-in flash.

TECHNICAL DATA
Camera
Mamiya 645
Lens 150mm
(medium telephoto)
Film Kodak EPR64
Exp 1/30th – f5.6
Filters Soft-focus and 81c (warm-up)

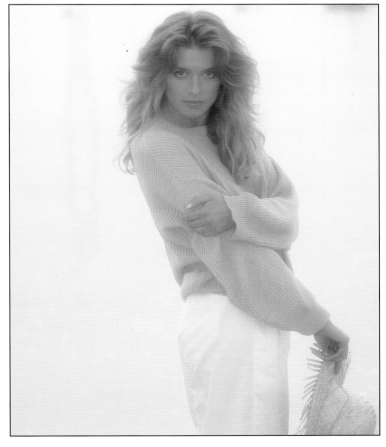

PRO POINTERS

■ SOME FLASH GUNS incorporate a "winder" setting, intended for use with motor-winds and power-drives, where up to three flashes per second may be required. This is almost guaranteed to be the weakest single consistent output on your flash gun, and you may well find, particulary in situations of less contrast, that a single flash on this setting will provide you with sufficient fill-in.

■ AS WITH ALL variable – and slightly unpredictable – techniques, it is advisable to experiment by bracketing your exposures and varying the flash settings until you are confident enough with your equipment to achieve consistent results.

87

FILTERING FOR GLAMOUR

The filters most frequently used by glamour photographers fall into two groups. The first comprises those used to balance variations in the color and strength of light. This type is made up of neutral-density and color-correction filters. They are used mainly to correct problems with the quality of light, rather than for purely aesthetic reasons.

It is possible, when working in extremely bright conditions, that the level of light may exceed the working range of your camera, even when using your fastest shutter speed and narrowest lens aperture (1/2000th at f32, for instance). Alternatively, the light may not be quite so dazzling, yet may still be too bright for you to control depth of field, should you wish to throw a distracting background out of focus by using a wide aperture.

In both cases, the answer to your problem is to use a neutral-density filter. These filters are made in shades of gray, and simply reduce the level of light reaching the camera lens. They are available in one-stop increments, permitting you to cut the effective light level by 1 to 4 stops without altering the aperture on your camera.

Color-correction filters are covered in Times of day on page 54. Note that, as light passes through the various colors and densities of the filters, it is corrected to render a "daylight" effect on normal color film.

The second group can be loosely titled "special effects filters." As the name suggests, these are used not to correct the light, but to modify it to introduce a specific effect. The most frequently used filters in this group, namely soft-focus and polarizing filters, are discussed in some detail in the following pages, together with warm-up filters, which – although strictly speaking color-correction filters – also have considerable value to the glamour photographer.

This early morning shot demonstrates very convincing use of an effects filter, in this case a graduated blue. The filter has been carefully positioned over the camera to affect only the upper part of the image, so there are none of the telltale artificial signs that betray the photographer. If the blue part were covering the model's head and arm, for instance, the use of the graduated filter would be instantly detectable, and the image would lose its credibility. While the primary purpose of the filter is to create an effect, it is also used here to balance the exposure values of field and sky and maintain color impact.

TECHNICAL DATA
Camera
Mamiya RB67
Lens 150mm
(short telephoto)
Film Fuji RDP100
Exp 1/60th – fd
Filter Graduated blue

OTHER TYPES OF FILTER

Other types of filter are worth mentioning in passing, but their usefulness to the glamour photographer is restricted.

 Multiple-image filters allow you to repeat your subject in various permutations. Up to 25 repeat images can be created around one main central image. Although novel the first time you use it, this effect is ultimately of little relevance to glamour photography.

Graduated filters are clear at the bottom, graduating to a color at the top. Their use is recommended in a situation in which the sky part of a scene is much brighter than the foreground. Careful positioning of the filter results in a darkening or coloring of the sky, so that its brightness becomes similar to that of the foreground. Lowering the contrast level in this way enables you to record detail in both areas, but these filters are obviously only of use to the glamour photographer if the model is occupying the foreground of the image. If the graduation affects your model, the result will look artificial and unconvincing.

 Starburst filters turn bright points of light into stars with up to 16 points. The lesser-pointed effect can be interesting when applied to highlights on water, but extensive use of starbursts is not recommended as you can easily detract from the impact of the real star, your model.

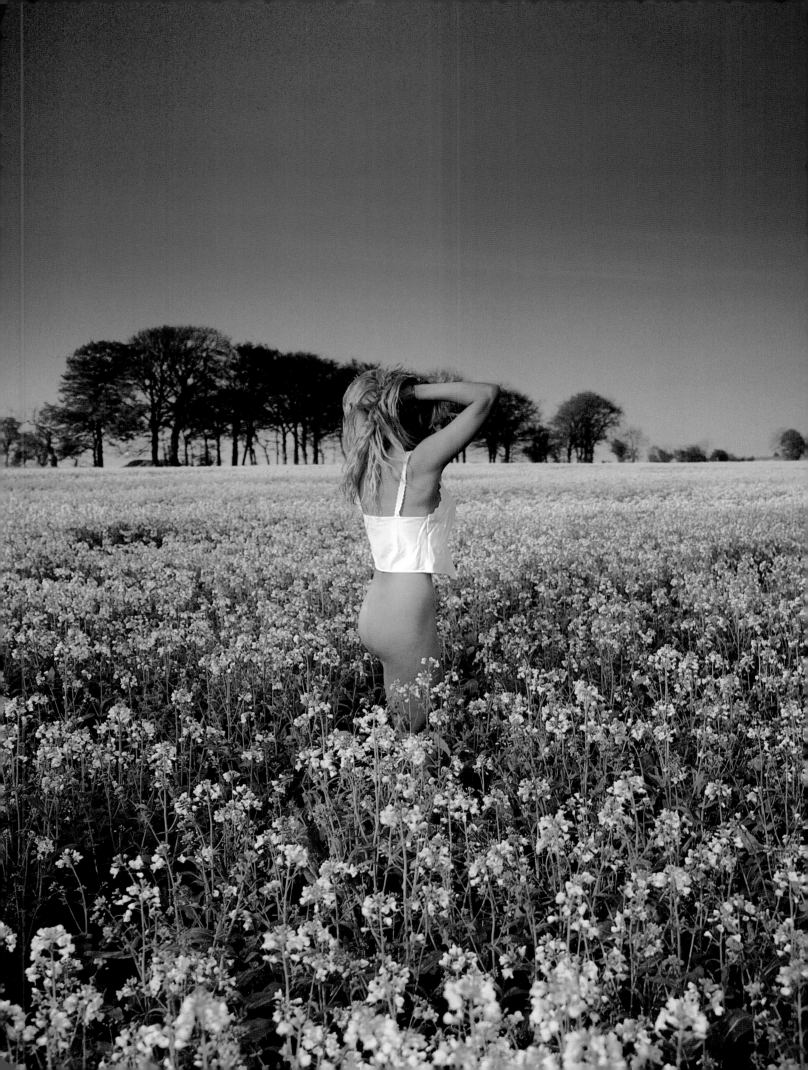

Softly softly

The evolution of camera technology has brought us to a point where today's lenses are guaranteed to produce excellent quality pictures, if used correctly. Every detail of a scene can be faithfully and accurately recorded, sometimes almost too vividly.

While no one would dispute the merits of ultimate image sharpness, the photographer may prefer, on occasion, to convey a less vibrant mood, perhaps suggestive of romance or sensuality. This is the perfect opportunity to experiment with a soft-focus filter.

This type of filter works by partially diffusing the highlights in a picture into the shadow areas. This has the effect of suppressing fine details, muting colors slightly, and sometimes introducing a delicate, ethereal glow, which is particularly noticeable in back-lit situations. These effects are achieved without compromising the actual quality of the image.

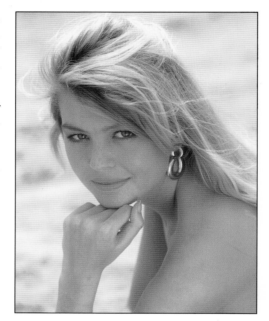

Left: Features such as the unfussy structure of the image, the use of a telephoto lens to clearly separate foreground from background, and the minimal color, all help to concentrate interest on the model. As a result, she must stand up under close scrutiny, and the added element of soft focus helps to make this possible, evening out any minor blemishes in her skin and make-up.

TECHNICAL DATA
Camera
Bronica ETRSi
Lens 200mm (medium-long telephoto)
Film Fuji RDP100
Exp 1/250th – f8
Filter Soft-focus

Right: This picture has a lot in common with the shot above, including the out-of-focus background, and the simple, tightly cropped structure of the image. Because the model is looking away, it becomes all the more important to ensure that the viewer's eye is not drawn to any slight imperfections, so once again the addition of a slightly soft-focus filter is a wise choice. An 81b filter removes any hint of midday blueness.

TECHNICAL DATA
Camera
Bronica ETRSi
Lens 200mm (medium-long telephoto)
Film Fuji RDP100
Exp 1/250th – f5.6
Filter Soft-focus

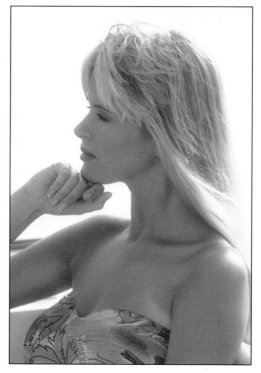

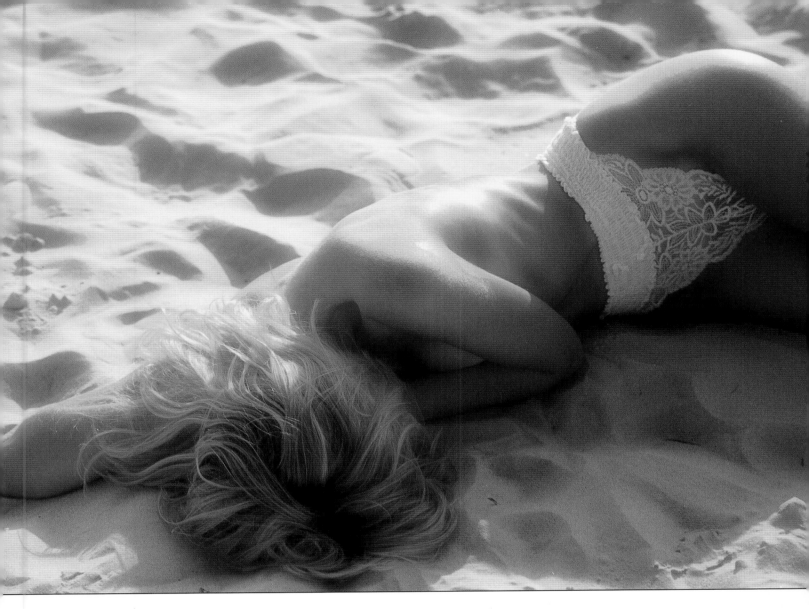

This slightly unusual glamour image conveys warmth and contentment, with the model in totally relaxed pose, offering her near-naked body to the caress of the sunlight. So involved is she with the serious business of sun worshipping that she seems to be completely unaware of the

camera, adding a candid feel to the shot. Limited use of color has the effect of focusing interest on the model's body and, in particular, on the delicate intricacy of her lace underwear.

TECHNICAL DATA
Camera
Mamiya 645
Lens 150mm (medium telephoto)
Film Kodak EPR64
Exp 1/250th – f5.6
Filters. Soft-focus and 81b (warm-up)

PRO POINTERS

■ The LEVEL of diffusion that is achieved with a soft-focus filter is partially controllable. Simply vary your lens aperture, remembering that the wider the aperture (f2.8 or f4, for example), the softer the result will be.

■ By MAKING your own soft-focus filter, you can be in complete control of the effect. Three popular methods are worth mentioning:
1) Smear Vaseline onto a clear filter (UV or skylight are the cheapest), bearing in mind that it can be difficult to clean off.

Leaving a small clear area in the center of the filter is vital, to ensure that you can see clearly enough to focus on your model. Varying the amount of grease, and its position on the filter, will allow you to adjust the soft-focus effect as you wish.
2) An alternative method is to stretch plastic wrap or gauze over the end of your lens-hood, so that the "filter" sits about 2 inches from the end of the lens. Smear Vaseline carefully around the edges of the plastic wrap, then cut a hole in the center. Distancing the filter from

the lens in this way will allow you to achieve an excellent soft-focus effect without resorting to the widest aperture settings.

3) Simply covering the end of the lens with gauze or a nylon stocking – with no gap between material and lens – creates an overall soft-focus effect, but is less subtle than the previous two methods, possibly leading to lens flare and causing unpredictable results when used in bright sunlight. It is likely to affect the color of your pictures radically and also increase the exposure time.

■ PROPRIETARY soft-focus filters vary considerably in the degree to which they soften the image. Some are so subtle that the effect is barely noticeable unless seen alongside a similar picture without the filter, while others can soften the image so much that the subject is scarcely discernable in the "mist." The gentler effect is usually preferable for glamour work, and is flattering in close-up shots, as very few models have perfect skin.

■ PROPRIETARY FILTERS also vary considerably in price, and this is one area in which extra cash really does mean better-quality results. Cheap soft-focus filters do not only soften the image, they can also cause it to blur and break up – by no means the desired effect.

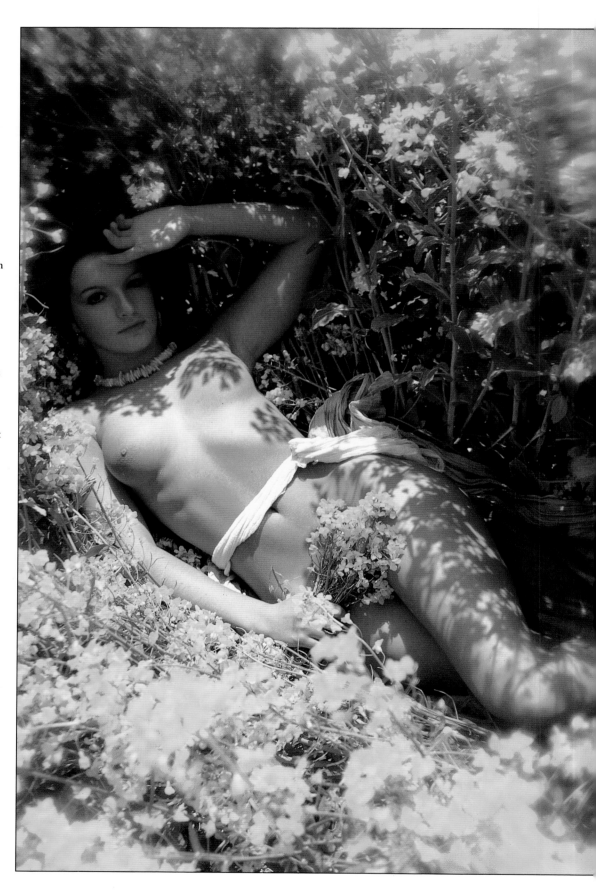

Left: This striking image utilizes a homemade soft-focus method. The softened flowers around the edges of the frame lead the viewer's eye directly to the center by creating a tunnel effect, exaggerating the impression of depth and lending the image an air of mystery. The model's expression, which is both serene and enticing, adds to the moody ambivalence in the shot.

TECHNICAL DATA
Camera
Mamiya 645
Lens 110mm (short telephoto)
Film Kodak EPR64
Exp 1/125th – f8
Filters 81b warm-up and homemade soft-focus

TUTORIAL

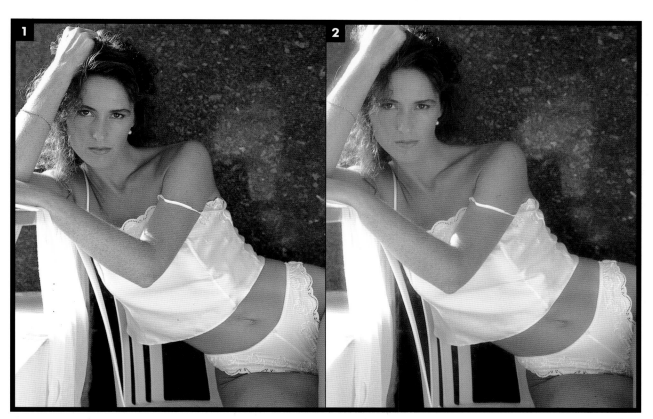

Adding a soft-focus filter to a shot can radically or subtly influence the mood of the scene.

1 This shows the scene without a soft-focus filter. The sultry warmth of the image, the model's relaxed pose, her white lingerie and the matching props, all appear slightly at odds with the bold presentation of this unsoftened image, and the picture could be seen to lack atmosphere as a result.

2 Add a soft-focus filter, and the mood of the image is more faithfully reflected in the presentation, as the filter reduces the overall contrast by diffusing the highlight areas quite subtly into the shadows. The bold, challenging aspect of the model's dark eyes, with their striking golden catchlights, is modified just sufficiently to lend a gentler impression to her image, more in keeping with her pose, and particularly the soft, feminine quality of her attire.

TECHNICAL DATA
Camera
Bronica ETRSi
Lens 150mm (medium telephoto)
Film Fuji RDP100
Exp 1/250th – f5.6
Filters Soft-focus and 81c (warm-up)

Picture Portfolio

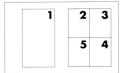

1 The soft-focus filter is used not just to flatter the model, but also to affect the mood. The atmosphere is more relaxed for the softening influence of the filter.

2, 3 & 5 An element of soft focus is frequently used in close-up situations to help flatter the model by slightly subduing the fine details which can detract from the overall image. Picture 2 employs a homemade filter, which creates a softer effect around the edges of the frame than in the middle. The model's head is only slightly affected by the diffusion, to stand out against her dress and the background which are softened. Pictures 3 and 5 use more conventional proprietary filters, which have a less marked diffusing effect, but affect the frame evenly.

4 Sparkling reflections on water are ideal for soft-focus glamour work. As the spangled highlights diffuse into the darker areas, they lift the brightness content.

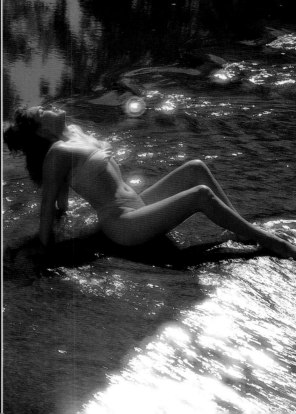

Polarizing filters

Light from the sun travels in waves, which vibrate in all directions. When these waves strike certain objects, some of the vibrations are subdued, and the reflected rays vibrate in a single plane. This light is known as "polarized" light, and, by blocking it, a polarizing filter is able to remove specular reflections from glass and water, and considerably reduce color-diluting glare from nonmetallic objects, such as foliage and painted surfaces. The result is greater clarity and purity of color in your pictures.

Blue sky also reflects light and so, for the same reason that a polarizing filter works on reflections from water or glass, it can be used to darken and intensify the blue of the sky at right-angles to the sun. A word of warning: because polarization is uneven across the sky, you may end up with a darker blue on one side of your picture, particularly if you are using a wide-angle lens. As this type of lens is not generally used in glamour photography, however, the problem should not affect you too often.

All the polarizing effects discussed can be gauged and adjusted by rotating the filter in front of your lens while looking through the camera viewfinder. Stop rotating when the effect is maximized, and start shooting.

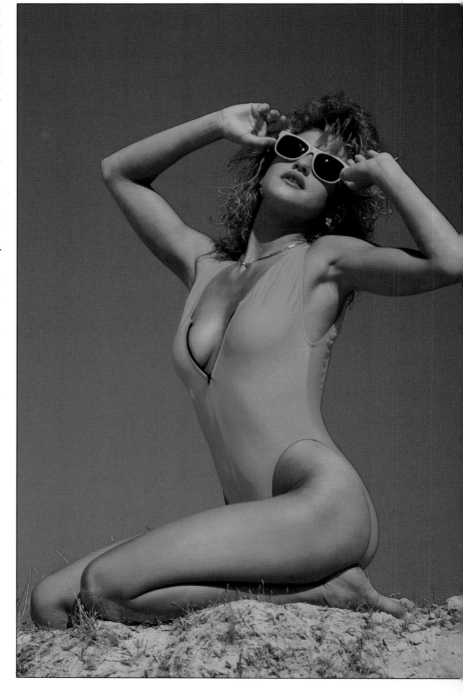

the already rich blue is saturated still further by a polarizing filter.

TECHNICAL DATA
Camera
Bronica ETRSi
Lens 150mm (medium telephoto)
Film Fuji RDP100
Exp 1/250th – f5.6
Filter Polarizing

A low camera angle maximizes the pictorial value of the sky, and

━━━ TUTORIAL ━━━

These comparison shots clearly demonstrate the benefits of using a polarizing filter in a situation where reflections from water have a negative effect on the image.

1 Taken without the filter, this picture lacks impact and interest because of the strong influence of reflected light. The sea mirrors the mast of a nearby boat and the clear blue sky, and the model's body lacks color. The exposure was 1/500th – f5.6.

2 By removing the reflected light with a polarizing filter, the exact same scene changes drastically for the better. The improvement in the sea is particularly noticeable, as previously unseen details of depth and richness of colour are revealed, while the troublesome reflection of the mast all but disappears. The model's body and the rocks also benefit, as the colors of both become far more saturated without the influence of reflected light.

Note that, because the pictures are taken around midday, one of the negative effects of polarizing, namely reducing detail in shadow areas, is minimized. This is because the only shadows present at this time of day fall directly beneath the model's body where they are of little pictorial relevance. For this shot, the exposure was 1/125th – f5.6.

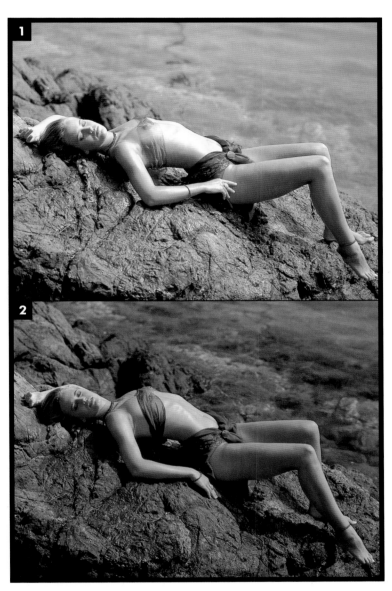

TECHNICAL DATA
Camera
Bronica ETRSi
Lens 150mm (medium telephoto)
Film Fuji RDP100

PRO POINTERS

■ THE LIGHT-ABSORBING effect of polarizing filters means that they lose the photographer approximately 2 stops of light. If you are using a slow film (50 ISO, for instance) and a wide lens aperture, the reduction in shutter speed is likely to leave you needing a tripod to avoid camera shake.

■ BY REMOVING reflected light from a scene, a polarizing filter can sometimes have a negative effect. Sunlight reflecting off water droplets or suntan oil on a model's body can be very appealing, for instance, enhancing the shape of the body. Polarizing can detract from the strength of the picture by appearing to flatten the body. In addition, shadow areas of a picture can become too dark and lifeless if reflected light is removed completely.

Picture
Portfolio

1		4
2 3	5 6	

1 – 6 All the pictures on this spread demonstrate the color-enhancing properties of polarizing filters, as all six pictures feature either sky or water, and half of them feature both. In every case, bright primary colors are chosen for the model's costumes and props, to emphasize the contrast between model and sky or water.

Note that the absence of specular glare is a critical factor in all the water shots, strengthening the blue of sea or pool in each case, and revealing the mirror effect on the wet sand in picture 1. Note also that all six shots are taken in bright sunlight because it is under these conditions that the effect of polarizing filters is most noticeable. It is also worth remembering that, because the filters account for up to two stops of light, their use is often impractical in low light conditions.

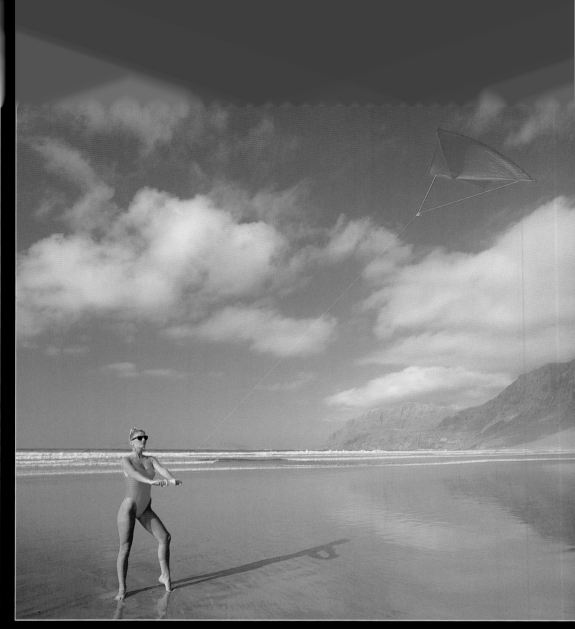

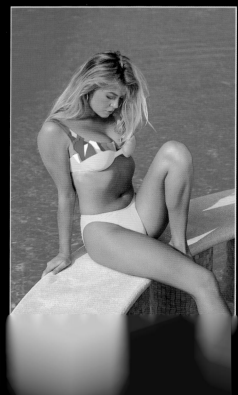

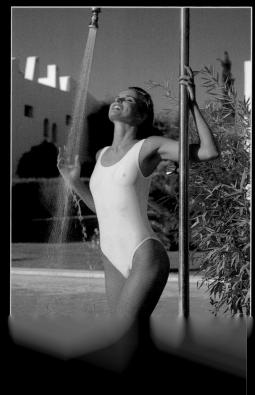

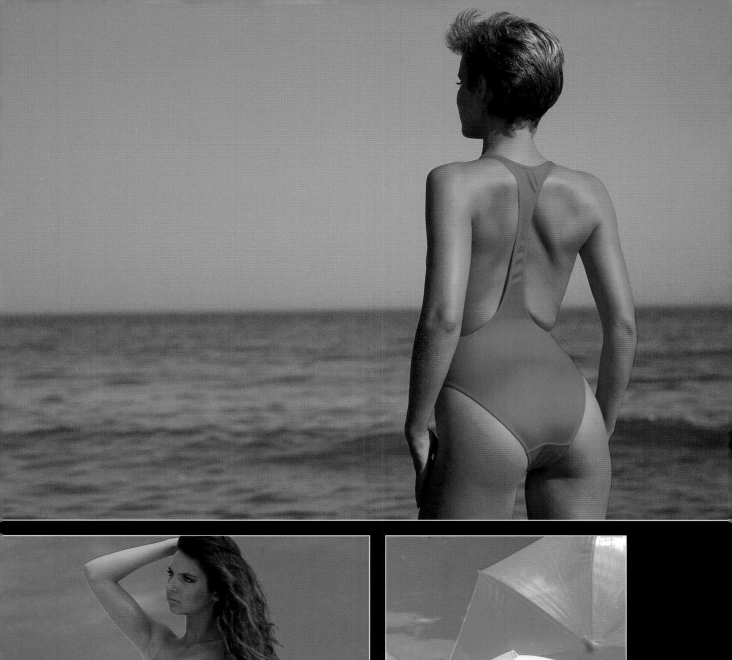
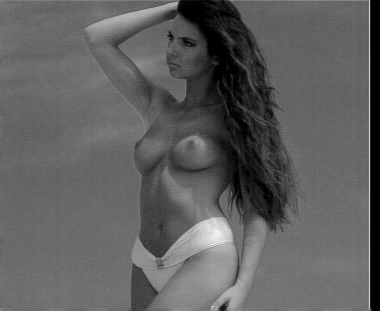

Winning warmth

There are four different filters within the warm-up group. All are of the 81 series, and all come in shades of orange. They vary in the degree to which they affect the light, from 81a, which warm only marginally, to 81e/f, which have a pronounced warming effect. Used as color-correction filters, they neutralize the slight blue bias present in the light around midday in bright sunlight, in dull, cloudy weather, and in the shade under blue sky.

Warm-up filters do not have to be used for purely compensatory reasons. They double as special effects filters (see page 88), adding to the pictorial "warmth" of the light, rather than compensating for the lack of it. This makes it possible for the photographer to recreate the flattering golden aspect of early-morning and late-evening sunlight at virtually any hour of the day (see Times of day on page 54).

PRO POINTERS

■ SKIN TONES tend to look more attractive with the addition of a warm-up filter, and models are always happy to have their tans enriched with so little effort on their part.

■ IT IS INVARIABLY better to err on the side of warmth when working with models. All would-be glamour photographers should carry a set of 81-series filters in their camera bags, and not be afraid to use them extensively.

First impressions suggest that this must be an early morning or an evening shot, but it is actually a good example of how an 81 series filter (81c in this case) can be used to imitate the favorable lighting conditions associated with the early or late daylight hours. The picture was taken at around 2. p.m. (a time of high color temperature and cool color casts), and the golden warmth is the result of adding the 81c filter.

TECHNICAL DATA
Camera
Mamiya 645
Lens 150mm
(medium telephoto)
Film Kodak EPR64
Exp 1/250th – f5.6
Filters 81c (warm-up)
plus soft-focus

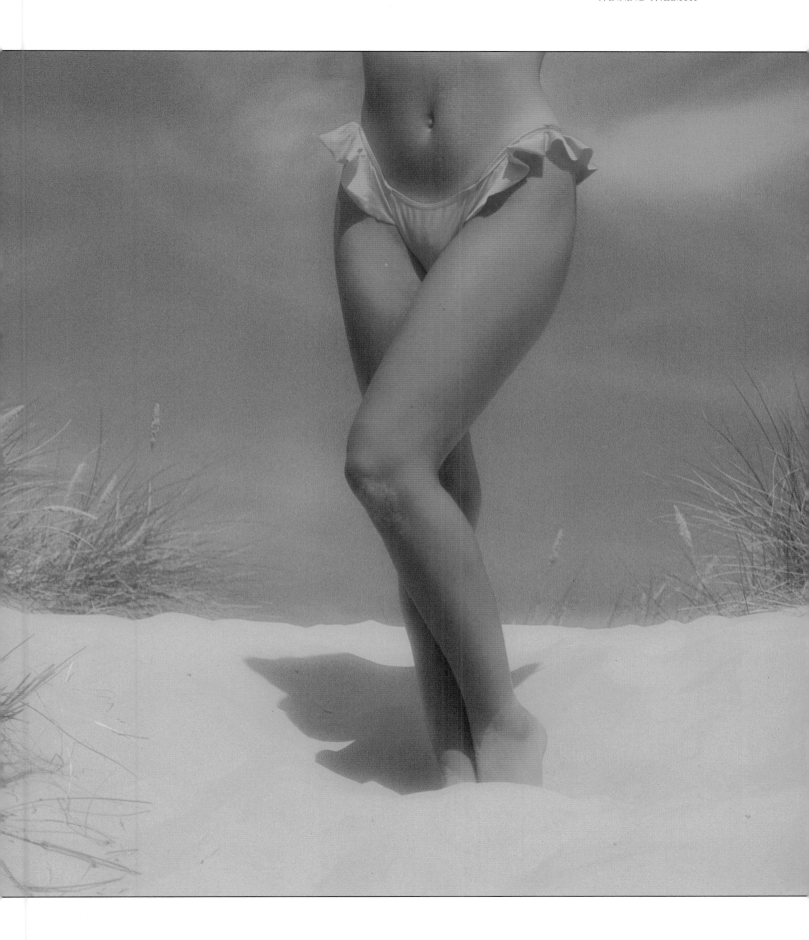

— TUTORIAL —

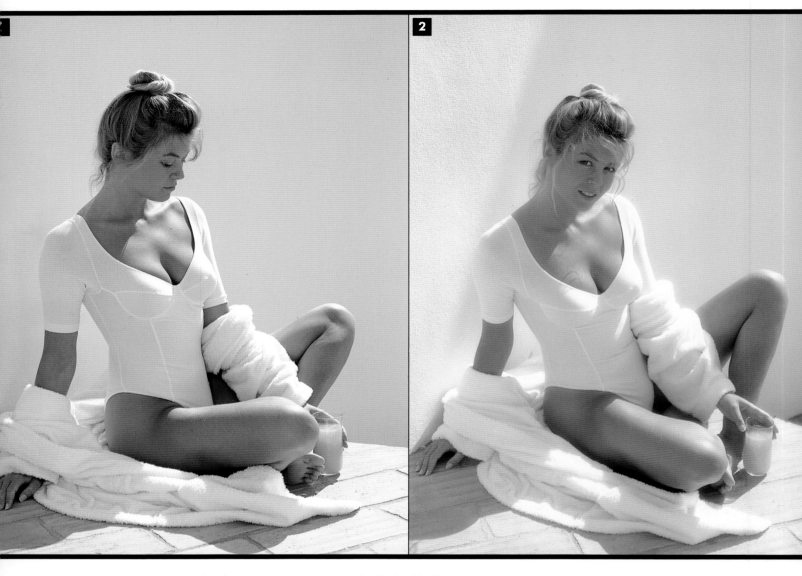

In this section we look at the extent to which an 81c filter warms an image, and the change of mood it can create.

1 The cool, crisp whiteness of this image is matched by the composed, confident, and distant attitude of the model. The absence of eye contact and the contrast between costume and skin in this unfiltered shot create a much more graphic image but not as attractive a rendition of the model. The exposure was 1/250th – f11.

2 The 81c filter has a marked effect, adding a warm, "evening" glow to the image. This shot was exposed for 1/250th at f8. Note that the overall warmer, and less direct, mood of the shot is highlighted by the gentle diffusing effect of a soft-focus filter. Add in the eye contact and this is a much more "human" shot.

TECHNICAL DATA
Camera
Bronica ETRSi
Lens 150mm (medium telephoto)
Film Fuji RDP100

Picture
Portfolio

	1	2
	3	4

1, 2 & 4 Warm-up filters prevent reflector-induced warmth (which colors foreground detail) from appearing too contrived by creating an overall warm impression. They are used both as color correction and effects filters.

1 Considerable fill-in light is provided by sunlit rocks. An 81c filter warms the image and prevents the background rocks from appearing too cold.

2 The very bright sunlight on a boat moored in a marina required the use of an 81 series filter, to cancel the blue cast that was apparent on the (shadow) side of the background boat.

3 In early evening sunlight, an 81b filter was added to recreate the warmth lost by the reflection from the pool.

4 The rocks and sea in the background appeared too cold and bleak before the 81b filter was added. A gold reflector adds a flattering glow to the model's back.

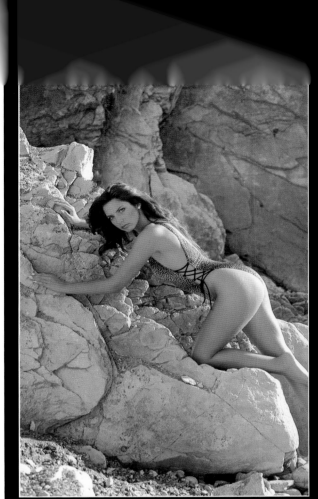

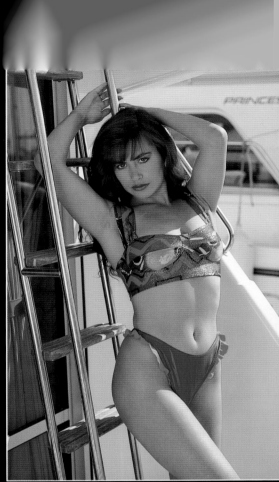

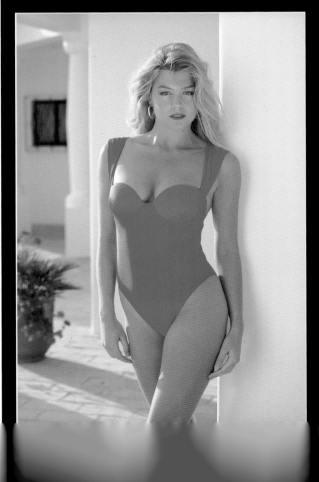

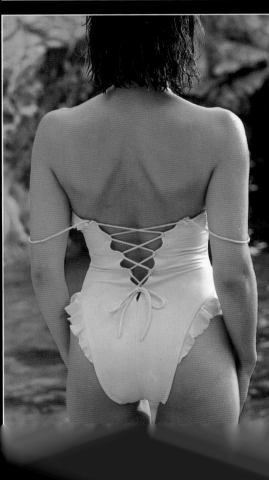

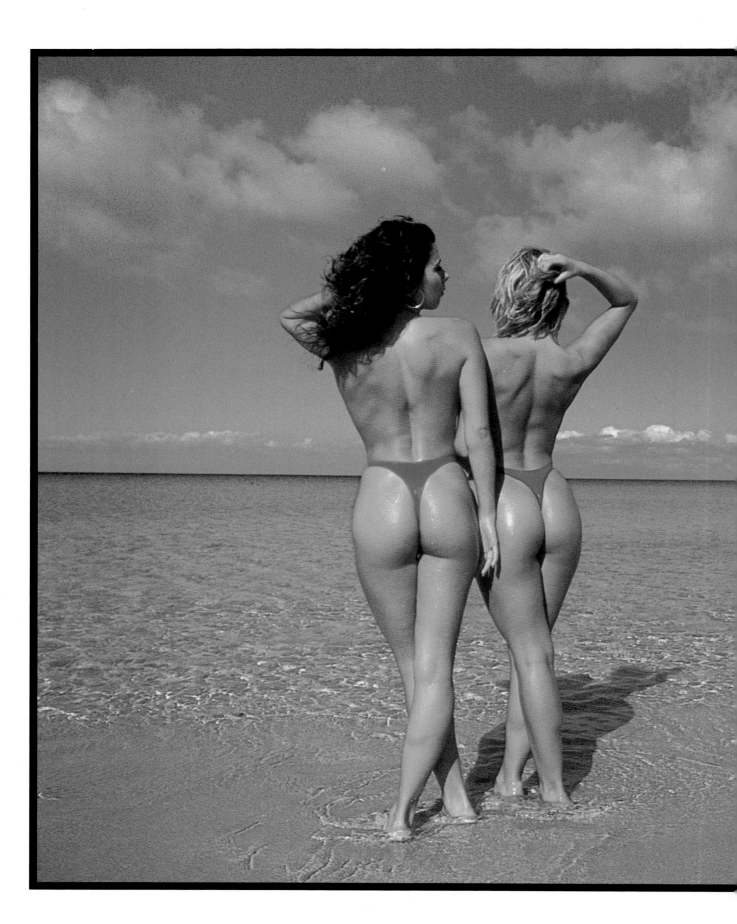

GLAMOUR LOCATIONS 4

The very best glamour photography is an amalgam of beautiful girl and beautiful setting – whether this is a romantic and intimate bedroom interior or a deserted beach at sun-up. Choose your locations carefully to give your pictures the edge.

This image could be seen to epitomize the concept of location glamour photography, featuring tanned and beautiful models in an exotic tropical island location, where the sky is blue, the sea clear, and the sun (no doubt) is always shining. A polarizing filter is partly responsible for the clarity and saturation of the colors. By eliminating reflected light from the sea, sky and models' bodies, the true, undiluted colors of each are revealed.

TECHNICAL DATA
Camera
Olympus OM4
Lens 28-70mm
zoom, set at 70mm
(short telephoto)
Film Fuji RDP100
Exp 1/250th – f8
Filter Polarizing

THE GREAT OUTDOORS

While it may seem a less obvious choice of environment for glamour, the country-side may present the more adventurous photographer with a wide variety of potential locations to be explored. Woodlands, fields, and secluded beaches combine privacy with openness to provide beautifully lit and highly atmospheric settings. Your model becomes a natural focal point, complemented by the sympathetic colors and textures of her surroundings.

Right: By lying the model down, we minimize shadows and maximize the pictorial value of sunlight on flesh, highlighting the contrast between flesh and stone. The depth of the image is accentuated with a wide-angle lens.

TECHNICAL DATA
Camera Nikon F3
Lens 28mm (wide-angle)
Film Kodachrome 25
Exp 1/250th – f11

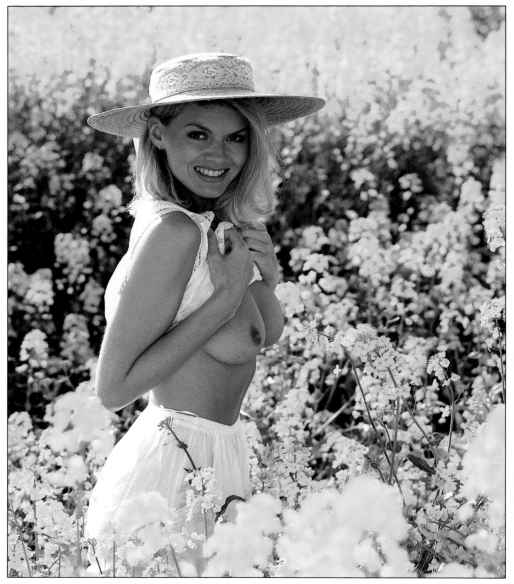

Left: Bright sunlight is not always impossible to use. In this shot, the hat shields the model's face from the glare, while the highly reflective flowers and a burst of fill-in flash counteract the harsh shadows.

TECHNICAL DATA
Camera Hasselblad
Lens 150mm (medium telephoto)
Film Fuji RDP100
Exp 1/500th – f5.6
Fill-in flash used to balance exposure.

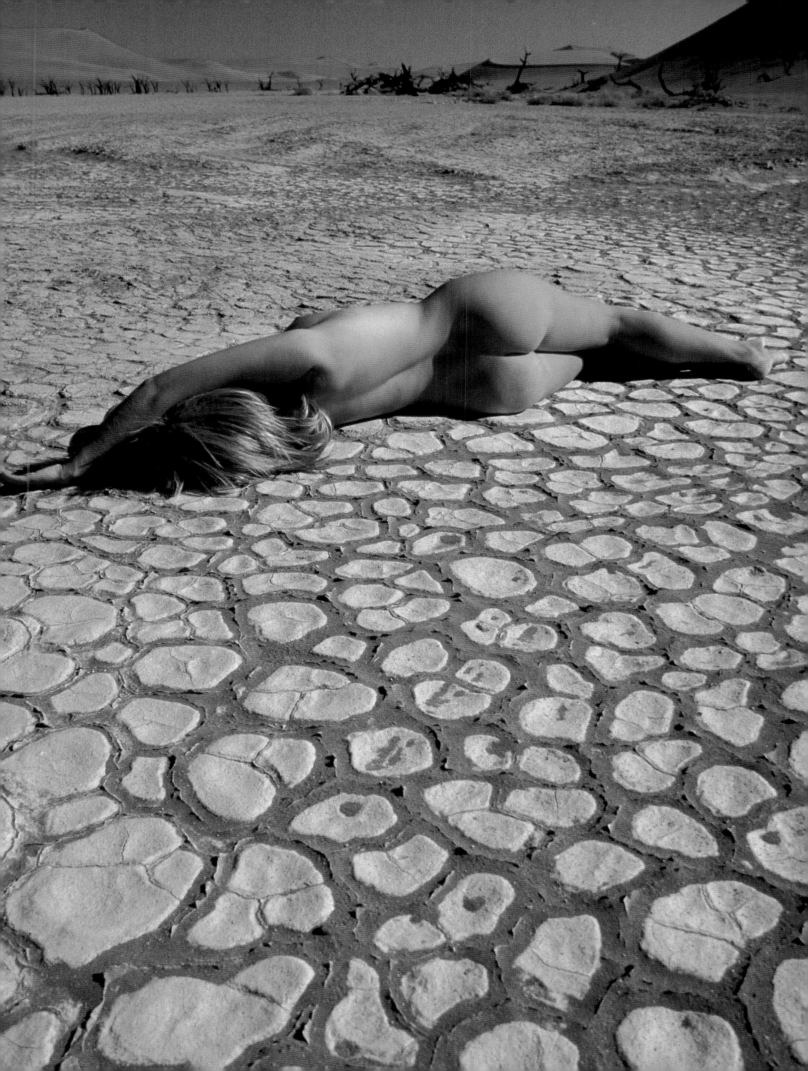

Fields and forests

The light affecting inland locations, particularly woodland areas, creates a different set of problems for the glamour photographer. An abundance of predominantly green foliage is sure to introduce an unhealthy cast, which needs careful handling to prevent it from being reflected in your model's flesh tones. The enclosed character of some of the most attractive woodland locations can also make working with natural light a problem. The main benefit of such locations is the almost guaranteed privacy, however, so the lighting problems are worth solving.

PRO POINTERS

■ To NEUTRALIZE the green cast reflected by foliage, try these methods:
1) Reflect light onto your model with a gold reflector (rather than silver or white).
2) Add warm-up filters of the 81 series.
3) Make use of the warm quality of early-morning and evening sunlight.

A combination of any of the three methods above should enable you to achieve the desired result in your pictures.

■ HEATHER REFLECTS a far more pleasantly colored light than green foliage, and removes the necessity for color correction. Interestingly, heather photographs best in overcast light – sunlight has the effect of

sapping the intensity of color, and can produce too many areas of contrasting light and shade, which weakens the image.

■ WILDFLOWERS, such as foxgloves and bluebells, can be a problem to locate in any quantity, but they can reward the glamour photographer with striking, unusual pictures.

■ THE LESS CLOTHING your model wears, the stronger the effect, as any additional area of solid color detracts from the natural beauty of flesh and flowers. If clothing has to be worn, the best choice of color is white.

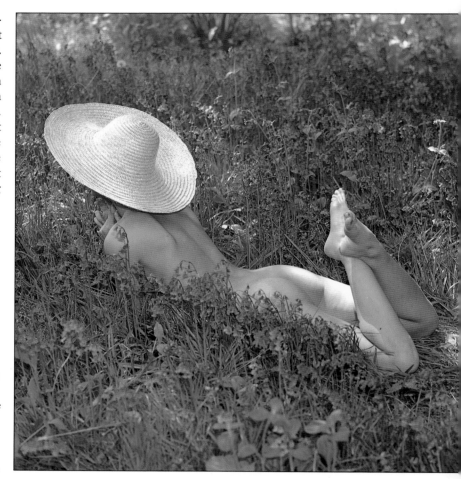

The low camera angle emphasizes the richness of color of the bluebells. Flowers are mostly not directly sunlit, as this reduces impact of color. The less clothing worn, the stronger the natural impression of flesh and flowers.

TECHNICAL DATA
Camera Hasselblad
Lens 150mm (medium telephoto)
Film Fuji RDP100
Exp 1/125th – f5.6
Filter 81b (warm-up)
Fill-in flash used to balance sunlight/ shadow exposure.

The main light for this unusual shot is a tungsten spotlight, positioned to camera right just above the model's head height and powered by a small generator. The unfiltered tungsten light warms the model's flesh and picks out the tall plant against the night sky.

TECHNICAL DATA
Camera
Bronica ETRSi
Lens 150mm
(medium telephoto)
Film Fuji RFP100
Exp 1/30th – f8

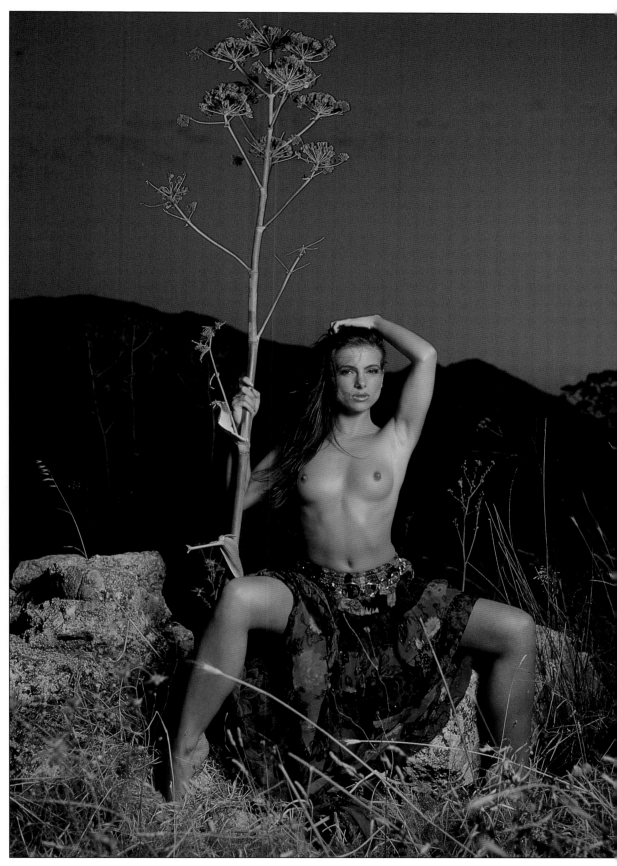

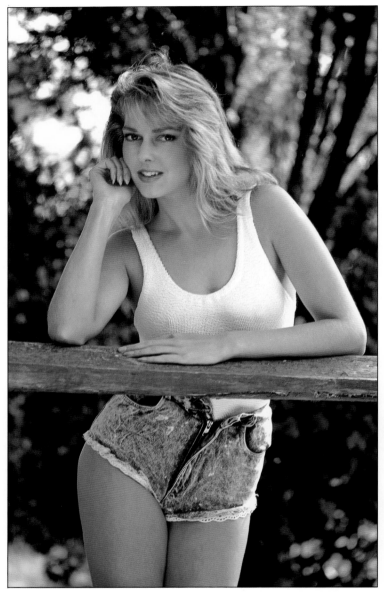

Below: Evening sunlight (used as backlight) gives delicate rim light around the model, adding to the soft, innocent feel of the image.

TECHNICAL DATA
Camera
Mamiya 645
Lens 150mm (medium telephoto)
Film Kodak EPR64
Exp 1/30th – f5.6
Filter 81b (warm-up)

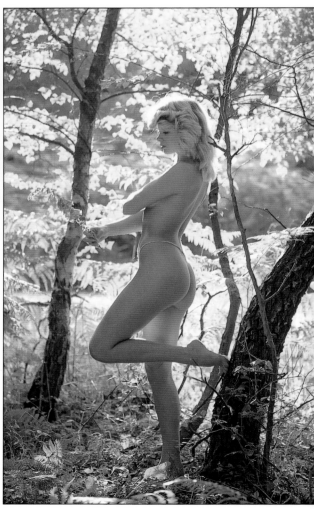

Above: A wooden fence makes an appropriate natural prop in a pastoral setting. A white reflector was used (camera left) to reflect light into the model's face, contrasting with the foliage behind.

TECHNICAL DATA
Camera
Mamiya RB67
Lens 180mm (short telephoto)
Film Kodak EPR64
Exp 1/60th – f5.6
Filter 81a (warm-up)

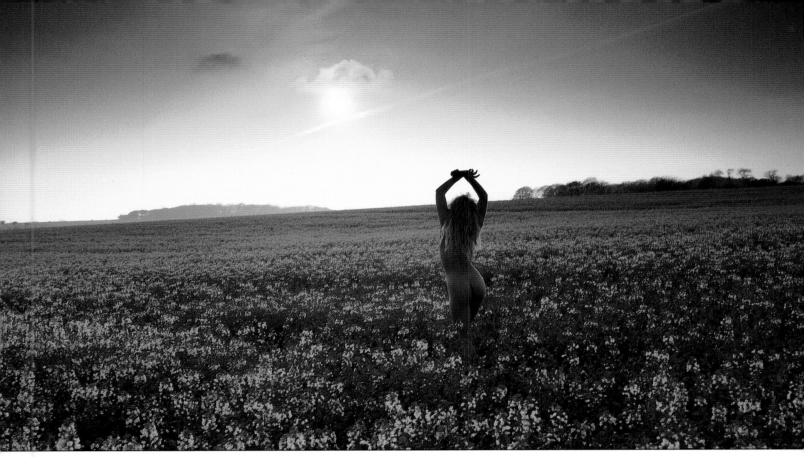

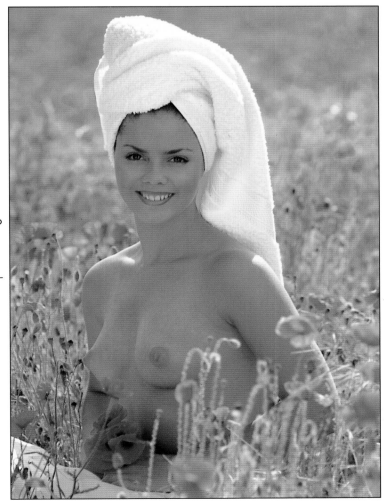

Above: This sunrise shot is enhanced by a pink graduated filter, which also balances the exposure enough to include the sun in the shot with the aid of a wide-angle lens.

TECHNICAL DATA
Camera
Mamiya RB67
Lens 65mm (wide-angle)
Film Fuji RHP – 400
Exp 1/60th – f8
Filter Graduated pink added to sky

Left: Low angle, telephoto lens, and wide aperture all combine to maximize the color of the poppies. An 81a filter and two large white reflectors were used to counteract the green cast from the field.

TECHNICAL DATA
Camera Hasselblad
Lens 150mm (medium telephoto)
Film Fuji RDP100
Exp 1/250th – f5.6
Filter 81a (warm-up)

Picture Portfolio

1	2	4	5
	3		6

1 & 6 These were shot with a medium telephoto lens, arranging foliage close to the camera lens to introduce an element of voyeurism. Both shots are backlit, with reflectors to balance light and 81b warm-up filters to counteract green cast from foliage.

2 & 5 Overcast light is used here, as both heather and bluebells look best without direct sunlight.

3 The tree-filtered sunlight is bounced back with a gold reflector to counteract the cool tones of the foliage and forest floor.

4 & 5 These shots were taken through soft-focus filters to enhance the gentle, dreamy, and romantic feel.

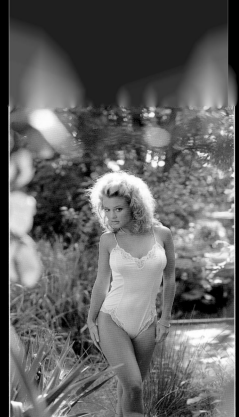

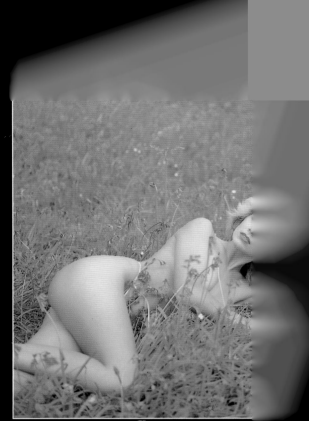

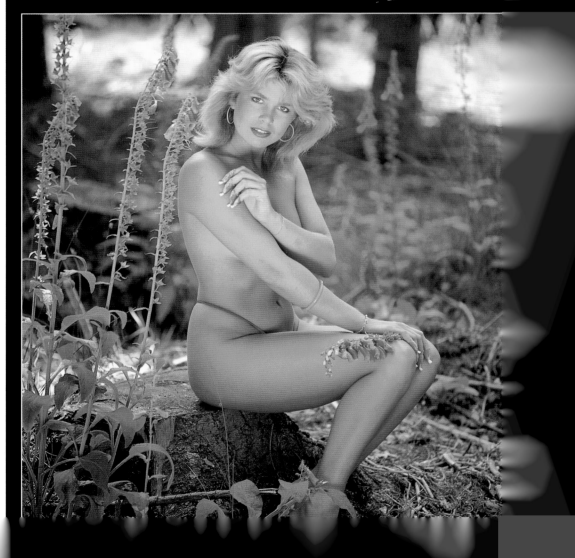

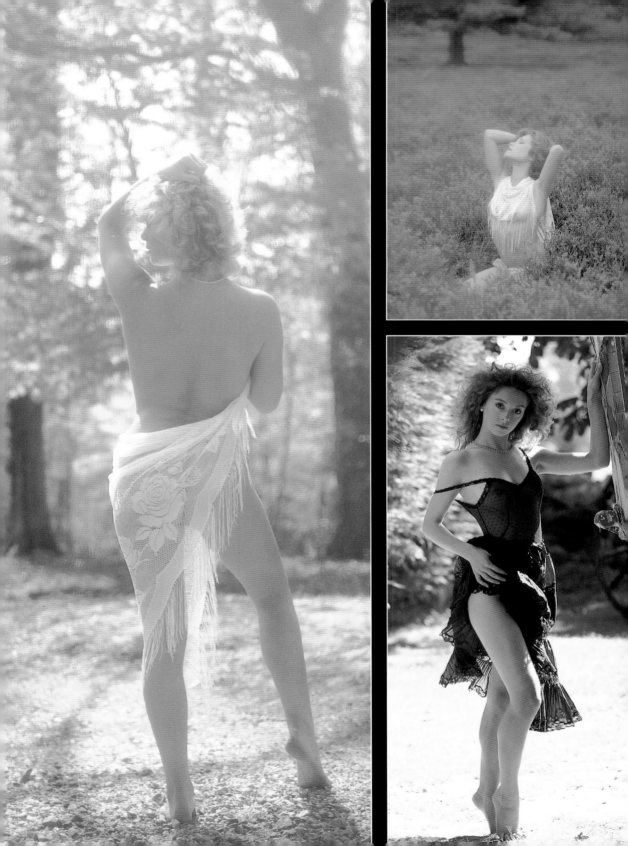

WATER

Water has a special place in glamour photography, as the combination of the female form and water-associated locations invariably results in successful pictures.

The sea, as represented in this section of the book by beaches and boats, offers an almost infinite variety of glamour locations, while the privacy of swimming pools and the intimate nature of showers guarantee each their own particular appeal.

Right: Completely natural light, with generous reflection from the white water, naturally balances the light and shade areas.

TECHNICAL DATA
Camera
Mamiya RB67
Lens 250mm
(medium telephoto)
Film Kodak EPR64
Exp 1/15th – f5.6

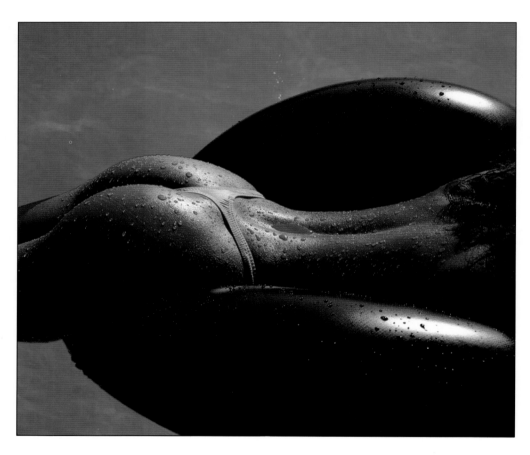

The polarizer removes surface reflections from the water, the model's skin, and the inner tube, enhancing the color of water and tan. This is increased by under-exposing by 1/2 stop.

TECHNICAL DATA
Camera Hasselblad
Lens 150mm
(medium telephoto)
Film Fuji RDP100
Exp 1/250th – f11
Filter Polarizer

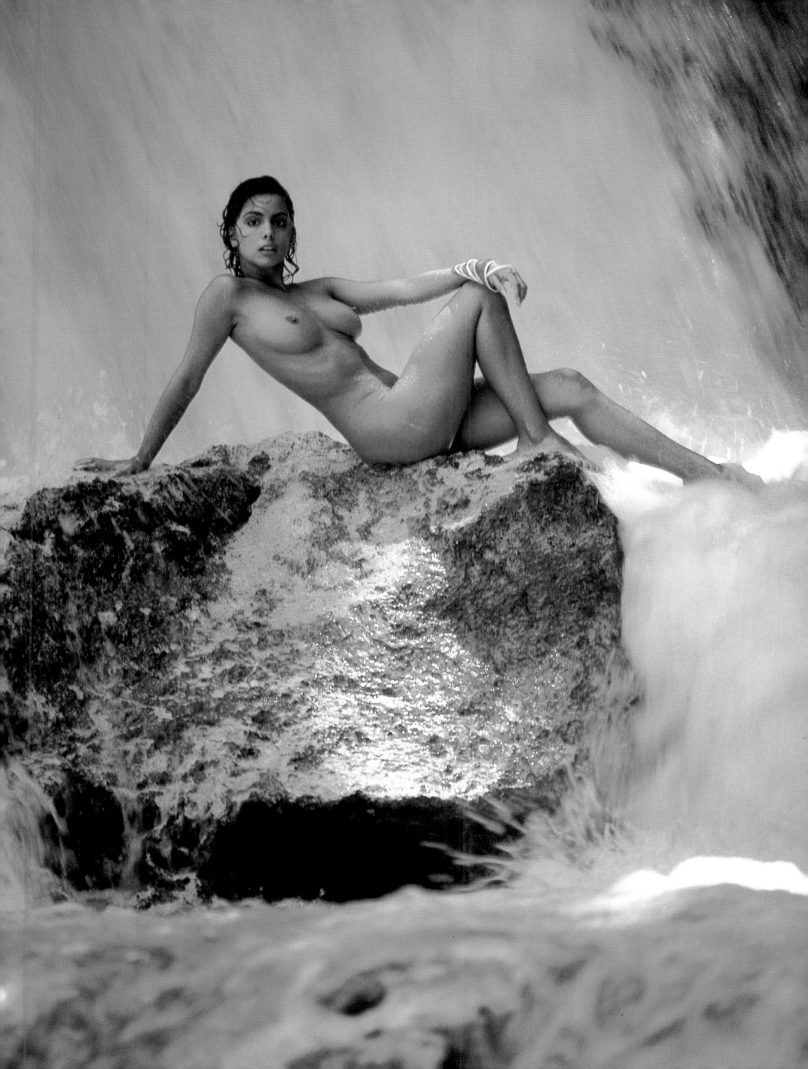

On the beach

Think of a beach, and your mind is likely to conjure up an image of bright sun, clear blue water, and an expanse of golden, untrodden sand stretching into the distance. There may well be a palm tree or two, swaying lazily in the sultry breeze. The beach suggests freedom, fantasy, luxury and relaxation, and no small measure of glamour. In truth, there is no more appropriate outdoor location for a glamour model.

Considering the lighting aspect, an open beach is one of the few places where the glamour photographer can work in direct sunlight all through the day, weather permitting, of course. The shadow-connected problems associated with shooting glamour in the midday sun have already been considered (see Times of day on page 54), but the disadvantages are offset on a beach by the naturally reflective qualities of water and sand. The generally open aspect of a beach also promotes a consistently high level of light, which allows for fast shutter speeds and narrow apertures, giving the photographer the potential to freeze motion in model or sea if required, and to work without the restriction of a tripod. All things considered, the beach is the place to be.

With direct evening sunlight, the warm color of the light is enhanced by the model's orange shorts. A polarizer was used to strengthen color and remove reflections from the sea.

TECHNICAL DATA
Camera Nikon F3
Lens 28-70mm zoom, set at 70mm (short telephoto)
Film Fuji RDP100
Exp 1/125th – f8
Filter Polarizer

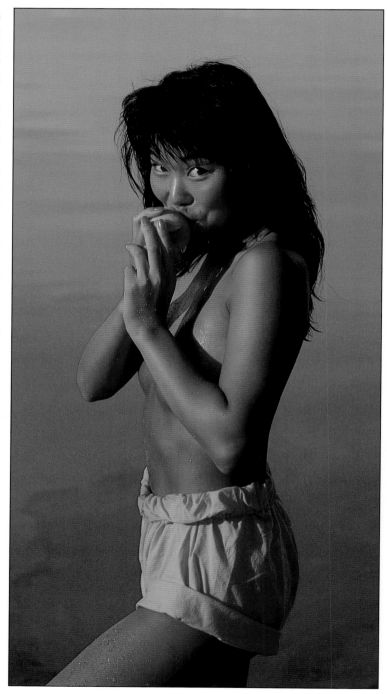

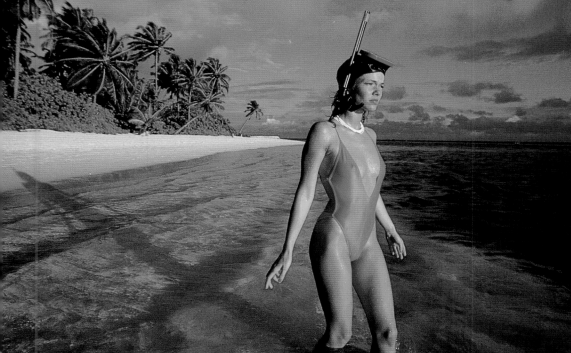

PRO POINTERS

■ As with all locations, try to make a pre-shoot visit to your chosen beach to establish such vital factors as the direction of light and its approximate position and effect at a specific time of day. It is pointless arriving with your model at a secluded beach for an evening shoot, for instance, only to find that the sun's rays are obscured from your chosen spot by the same lazily swaying palms that attracted your attention in the first place.

■ A high lighting angle (midday sun) can be unusually advantageous to the glamour photographer, because it makes taking pictures of a model lying down a relatively simple task. Shadows are minimized by the highly reflective quality of sand, and the beach location justifies the pose. A classic image of a beautiful woman stretched out on a beach makes an effective glamour statement, particularly if she is apparently oblivious to the camera, and appears to be abandoning herself to the sensual caress of the warm sun. Including the sea in the background adds to the impression of freedom and excitement.

■ Be sure to study the tide tables relevant to your location. This applies especially to smaller coves and bays, where the photogenic appeal of the location may

without frowning. A polarizer accentuates the sky/sea and swimsuit/sea contrasts.

TECHNICAL DATA
Camera
Minolta 9000
Lens 35mm (wide angle)
Film Kodachrome 64
Exp 1/60th – f8
Filter Polarizer

Above: This could only be shot with late evening sunlight so the model can look straight at the sun

Below: Clean, saturated colors and tight cropping add to the graphic feel of the shot – the red towel contrasts beautifully with the blue of the sky and the sultry brown of the flesh.

TECHNICAL DATA
Camera Nikon F3
Lens 50mm (standard)
Film Fuji RDP100
Exp 1/250th – f8
Direct sun too bright for facial shots, but ideal for body shapes.

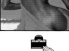

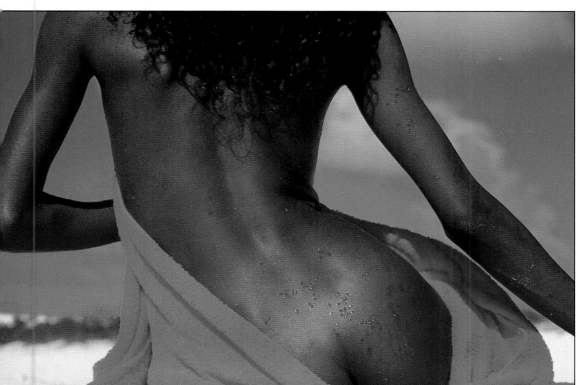

117

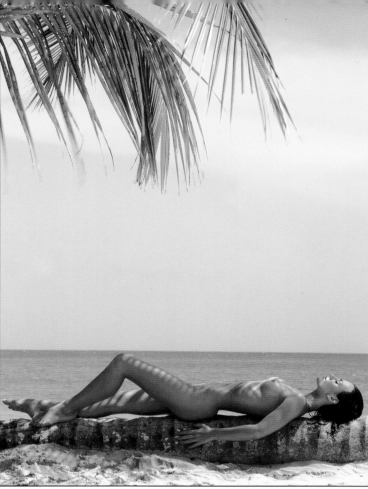

well be directly related to the state of the tide. When the tide is in, the light reflects from the clear and tranquil water, illuminating the surrounding rocks and crevices. This provides a perfect opportunity to photograph your model as she emerges nymph-like from the sea as it laps gently at the shore.

Tide out, and the scenario changes somewhat: the surrounding rocks appear dull and lifeless without the benefit of water-reflected light, and pictures of your model struggling to keep her footing on seaweed-covered rocks with the sea somewhere in the distance, are unlikely to win any awards – the glamour has gone out with the tide.

■ SAND DUNES often include such features as trees, tall grass, and wild-flowers, all of which have photographic potential either as specific locations for your model, or simply to add background interest. A single tree in an otherwise exposed area of sand can offer a further alternative to the "problem" of shooting glamour in the midday sun – even working in the shade, you should have more than sufficient usable light at your disposal, courtesy of the golden reflective quality of sand.

The sun through palm fronds casts a shadow on the model's skin – echoed by the ringed effect of the fallen tree trunk.

TECHNICAL DATA
Camera
Mamiya RZ67
Lens 180mm (short telephoto)
Film Fuji RDP100
Exp 1/250th – f11

The model is positioned to create shadow, and thus shape, on her right-hand side. A polarizer cuts down reflection to enrich the colors of sky and sea.

TECHNICAL DATA
Camera
Canon EOS 1
Lens 105mm
Film Fuji RDP100
Exp 1/250th – f8
Filter Polarizer

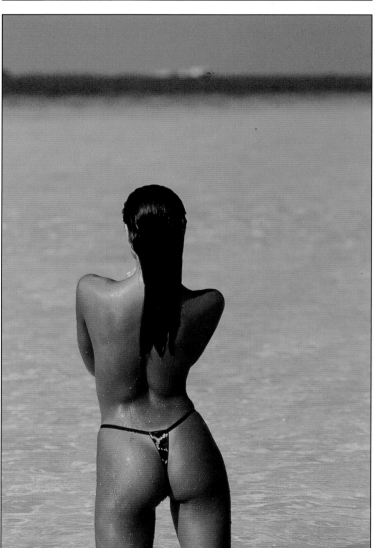

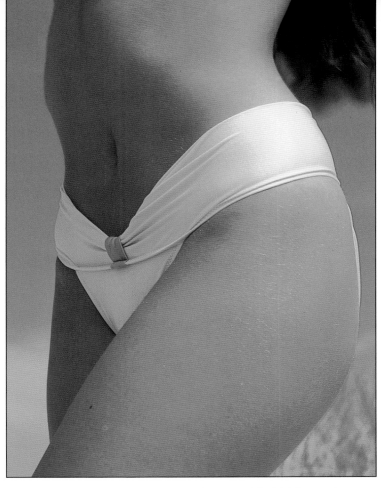

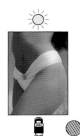

Reflection from golden sand provides fill-in light in shadow areas.

TECHNICAL DATA
Camera
Mamiya 645
Lens 200mm
(medium telephoto)
Film Kodak EPR64
Exp 1/60th – f8
Filters Polarizer and
81b (warm-up)

Beaches need not always be represented by sea and sand – rocks and gravel can be equally interesting to the glamour photographer. Gravel banks, rocks, and rock-pools sometimes display a repetition of design and color which can be enhanced or exaggerated by the sun, while a rocky coastline offers the photographer a wide variety of backgrounds with which to work. The constantly shifting sun changes the color and character of rocks, so that they vary from dark, moody, and almost abstract while in shadow, to warm, detailed, and involving when illuminated by a low sun.

A further variation on the beach theme is offered by sand dunes. An undulating dune always offers interesting areas of light and shade, and its elevation can be used to good purpose if you wish to shoot up at your model to include a wide expanse of sky. Note that a polarizing filter may be of use here to deepen the blue of the sky (see Polarizing filters on page 96).

The model was only 10 feet from the edge of a rock shelf and in deep shadow. An assistant with a gold reflector just out of shot (to the right) provided fill-in light to an otherwise dark spot.

TECHNICAL DATA
Camera
Bronica ETRSi
Lens 100mm (short telephoto)
Film Fuji Velvia 50 ISO
Exp 1/125th – f5.6
Filter 81b (warm-up)

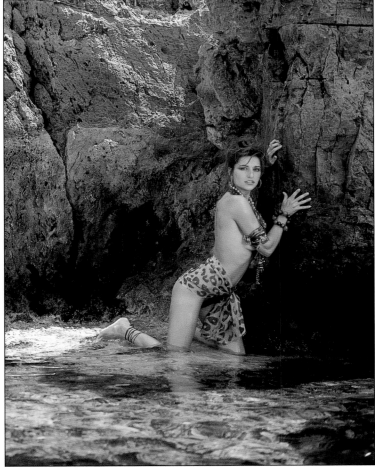

Picture Portfolio

1	3	4
2	5	6

1 When sunlight fades fast, meter every few seconds.

2 When the sun is too strong, try body shots. A gold reflector balances the light to keep detail in the black lace.

3 With the model "lit" by a gold reflector, the warm tones and sheen of her flesh contrast nicely with the cold, craggy rocks.

4 The sand dunes are foreground and background and reflectors.

5 The model's hair shields the sunlight, and a gold reflector softens and warms the shadows.

6 Bold, primary colors and low camera angle maximize color contrast. A reflector replaces light shielded by the umbrella.

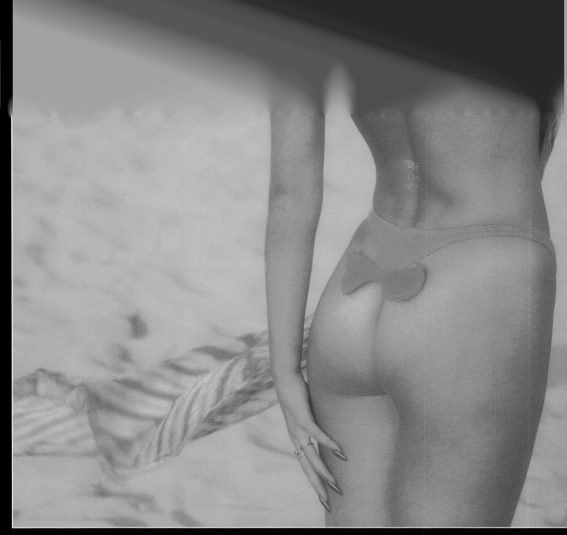

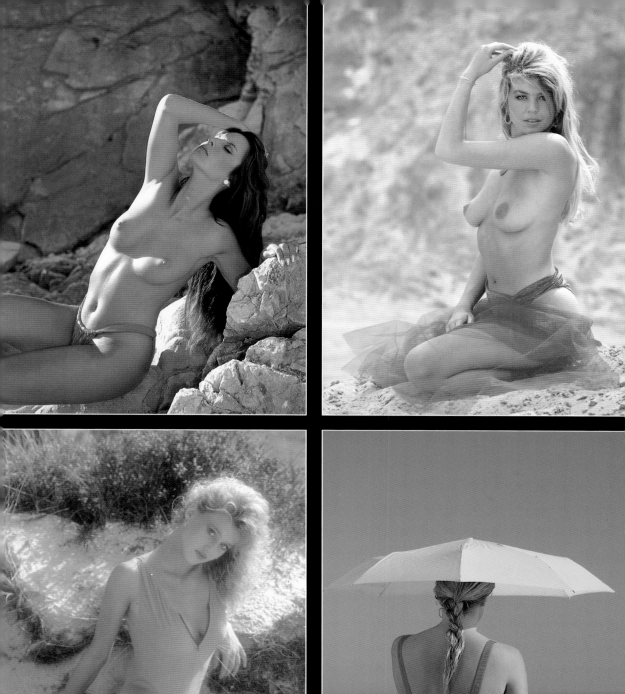

Boats

Consider this fact – two-thirds of the earth's surface are covered by water. There are hundreds of thousands of nautical square miles of freedom at the disposal of the adventurous glamour photographer, with a guarantee of privacy rivaled only by the most inhospitable of dry-land locations. The price of a ticket permitting unrestricted access to two-thirds of our planet? A boat!

Travel by sea has long been associated with glamour, wealth, excitement and freedom, so the idea of using a boat as a platform for glamour photography is an entirely appropriate one. To prove this, picture a beautiful, bikini-clad siren, sunning herself provocatively on the foredeck of a luxury cruiser as it powers through a sparkling, azure sea. The image clearly has sensual and exotic connotations, and could almost be said to epitomize the concept of glamour. Interpret the scene photographically, and the resulting pictures are sure to be a success.

Cropping close to your model avoids distractions, and enables you to compose your pictures using parts of boats as unobtrusive yet complementary backdrops, confirming your surroundings without diluting the glamour in your pictures. Do not be afraid to include relevant marine extras, such as mooring ropes, as these add to the sense of location.

Unfortunately, you are bound to attract a fair amount of attention by working with a scantily clad model in a busy marina. Even if entirely good-natured, the comments of onlookers make concentration difficult for both photographer and model, and the natural curiosity of others may make it necessary for you to change your camera position more often than you would wish, to avoid their inclusion in your pictures. The only alternative is to crop so tightly to your model that the shot is of her alone, with no additional distracting elements.

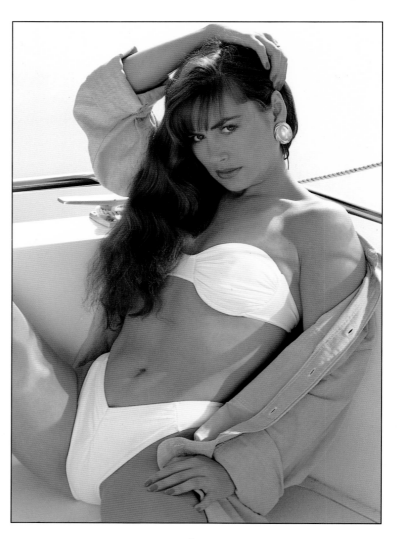

Much shadow-softening light is reflected by the boat's superstructure. A gold reflector was used to put highlights in the model's eyes.

TECHNICAL DATA
Camera
Bronica ETRSi
Lens 100mm (short telephoto)
Film Fuji RDP100
Exp 1/125th – f8
Filter 81c (warm-up)

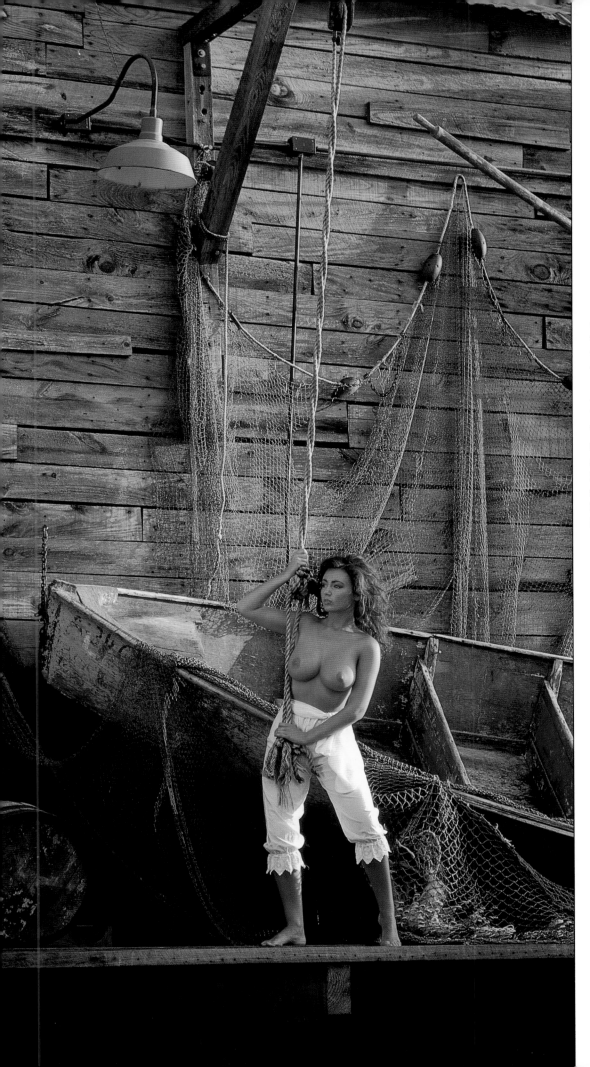

Low, warm-colored light picks out every detail in nets, boat and wooden panels, while the model is lit by a tungsten spotlight held just out of shot to camera left.

TECHNICAL DATA
Camera
Mamiya RB67
Lens 180mm (short telephoto)
Film Kodak EPR64
Exp 1/30th – f8

123

TUTORIAL

A high viewpoint (the boat's flying bridge) makes good use of near-midday sun. The strong diagonal composition of the model lying on the boat walkway with the sea below, seen from overhead, adds to the impact of the image.

1 The brightness allows a hand-held exposure, despite two stops lost by using a polarizer with 81b warm-up filter. The shot used a 150mm medium telephoto lens and Fuji RDP100 film, at 1/125th – f5.6.

2 Removing the polarizer loses some color richness, but gives a hand-held exposure even with the boat going at 15 knots. Movement in the water adds to the 3D aspect of the image. The exposure was 1/250th – f8.

3 With the boat stationary, the image lacks the impact of the previous shot, but has greater shadow control. Lens, film and exposure were as for picture **2.**

TECHNICAL DATA
Camera
Bronica ETRSi
Lens 150mm
Film Fuji RDP100

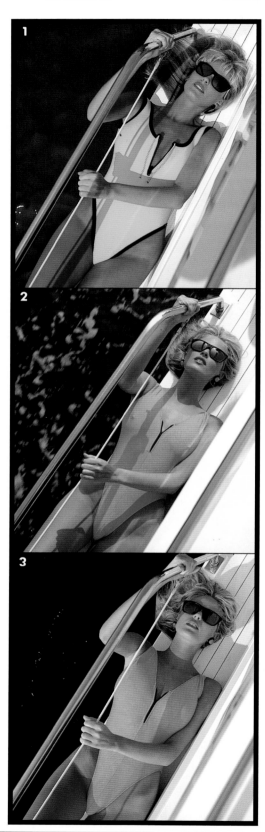

PRO POINTERS

■ ONE OF THE benefits of working on the water is the very high level of illumination, or brightness factor that boats offer, especially if they are white-bodied. This can be the case even in poor light, when what little light there is becomes maximized by reflection. You are also unlikely to need to use a tripod when working on a boat, thanks to the brightness factor. This offers greater flexibility, enabling you to consider situations and to shoot from positions a tripod would make impossible.

■ THE SHELTER afforded by a marina places at your disposal a superb daylight studio, if your boat has an open cockpit or seating area. If possible, use the sun as a back light only, and allow the reflective surfaces of the boat to bounce light back onto your model from all sides. A single gold reflector may be put to good use in this situation for no less than three reasons: to improve your model's skin tones, to add a golden sparkle to the eyes, and to obviate the need for light-stealing color-correction filters. Remember that adding to the overall brightness level by reflection is invariably preferable to reducing it by filtration.

■ IF YOU ARE working on a moving boat, take out your camera only when you are ready to shoot. Sea salt is ever-present in the breeze, and it is highly corrosive. Whenever possible, work with the body of your camera protected, to minimize exposure to wind and spray – waterproof covers are available to fit most cameras, but a simple plastic bag can be equally effective.

■ THE BRIGHTNESS factor can sometimes cause problems, however. Light reflecting from the polished bodywork of a white boat can be so bright as to be virtually blinding, making glamour photography an uncomfortable occupation for both photographer and model. She may well have to wear sunglasses throughout the shoot, which may not always be a problem, but does restrict the options available.

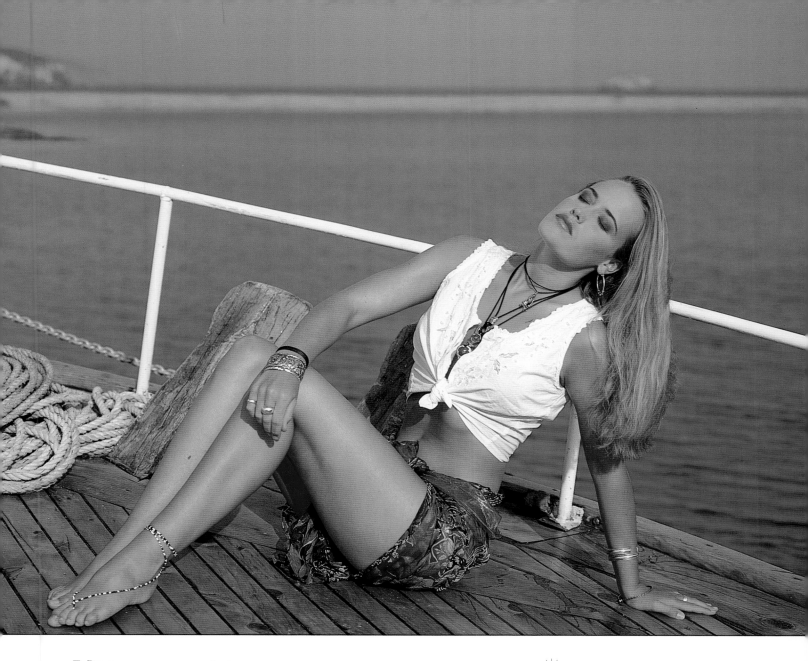

■ Boat decks and walkways become scorchingly hot under bright sun, and it is possible that your model may burn herself if you are working through the heat of the day. Ask her to change her position frequently, and be sure to avoid the most exposed parts of the boat until they have cooled down.

■ The boarded walkways that intersect marinas may prove invaluable as platforms for glamour photography. They will enable you to take pictures of your model on the boat from angles which would be impossible while at sea. Once again, the reflective qualities of boats also assist considerably – even the narrow walkways between boats are sufficiently bright to permit good glamour photographs to be taken.

Be aware, however, that the essential paraphernalia of other boats, such as masts and radio aerials, may be very distracting if allowed to break the lines of your model's body.

Late afternoon sunlight directly illuminating model on highly polished wooden deck – no reflectors used. Note how including the sandbar on the horizon balances the unusual diagonal aspect of the steeply raked deck.

TECHNICAL DATA
Camera
Bronica ETRSi
Lens 100mm (short telephoto)
Film Fuji Velvia 50 (rated at 40 ISO)
Exp 1/125th – f8

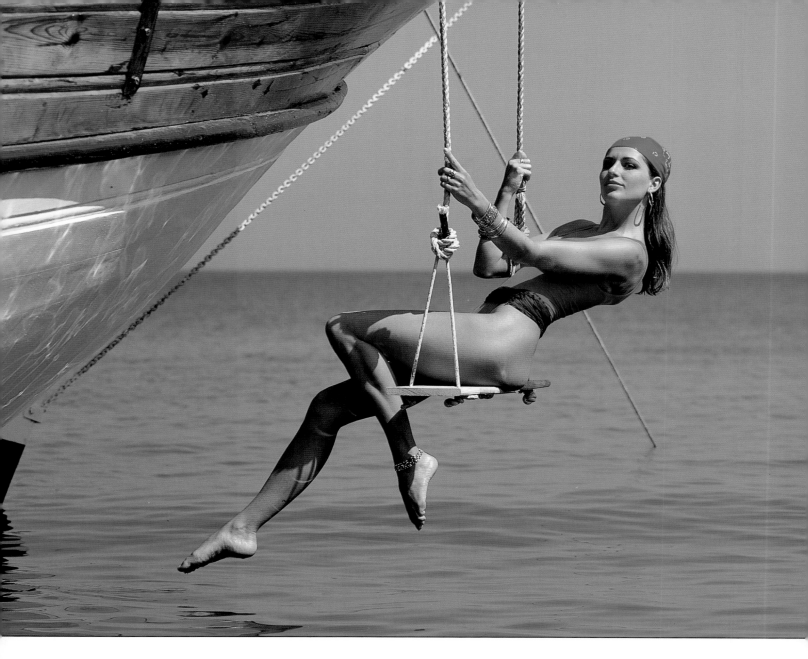

Do not forget when shooting glamour at sea that you may well need to use color-correction filters of the 81 series to balance the blueness of the light. Under a clear blue sky, at sea, on an exceptionally bright day, you may even need an 85b filter, but normally 81c is sufficient to compensate through the middle of the day, reducing to 81a or 81b during early morning and evening.

Note that wooden-bodied craft reflect a much warmer-colored light, and you are far less likely to require correction filters when working on such boats.

With light coming from direct sunlight, the water's surface and the hull of the boat, this shot shows the advantage of trying something different. In this case, the model swings on a hastily constructed bosun's chair.

TECHNICAL DATA
Camera
Bronica ETRSi
Lens 150mm (medium telephoto)
Film Fuji Velvia 50
Exp 1/250th – f8
Filters 81b (warm-up)

Picture
Portfolio

1 Using bright morning light – some reflected back onto the model – this scene evokes a natural carefree feeling.
2 One advantage of using boats is access to secluded islands. Lighting again comes as sunlight supplemented by a single gold reflector.
3 This was a "between shoots" picture and shows just how much light the deck reflects – giving highlights in the eyes.
4 The model was walking back to the cabin to get changed when the photographer noticed the potential of the shot and asked her to walk back again. Lighting as for 3.

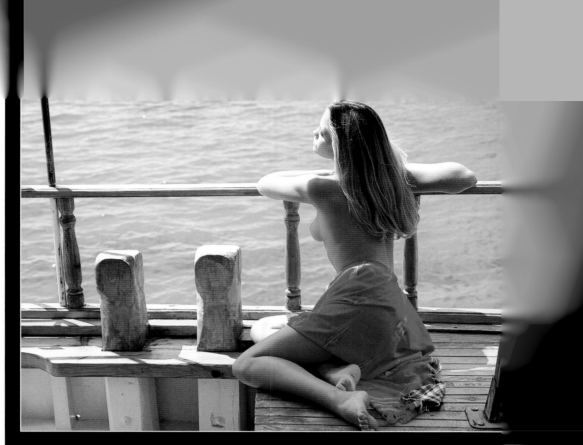

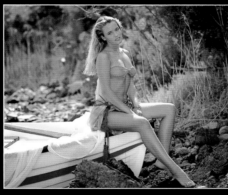

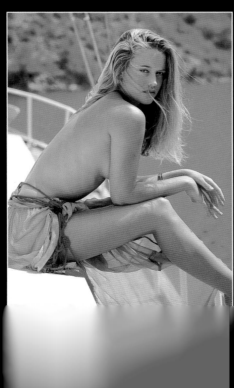

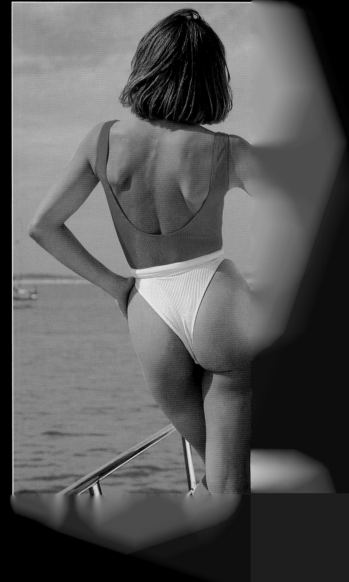

Pools

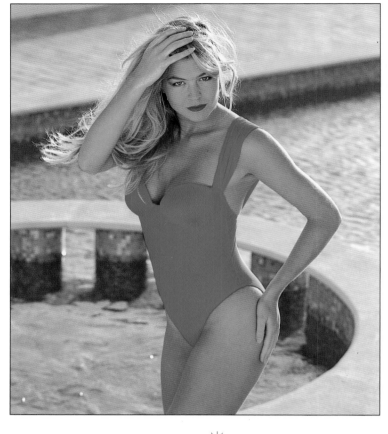

Women and water together create a wealth of opportunities for the glamour photographer, and a private swimming pool is one of the best locations in which to explore the potential of this combination. The privacy of the pool is a vital factor in achieving successful results, as it affords you complete control over your photographic session and therefore enables you to make the most of the situation. Whether your model is in the water, lying by the pool or floating languidly on an air-bed, the azure "color" of the water should be emphasized in your pictures, as this is inevitably the most striking characteristic of a swimming pool, and is suggestive of leisure, pleasure, and glamour.

PRO POINTERS

■ CONSIDER SHOWING only a section of the pool in your pictures, as this can create an impression of a vast expanse of water, limited only by the viewer's imagination. Being this selective also enables you to crop out unwanted features, such as drains, filters, and hoses, which are often found in and around pools. Equally, however, you should not ignore the potential of a wider-angled shot, possibly showing the shape of the pool and its environs.

■ SUN REFLECTED off water creates glare, which you need to deaden to reveal the true color of the pool. This is easily achieved by using a polarizing filter, but note that this can have a detrimental effect on the rest of your picture – removing all the reflected light from a scene can also eliminate the necessary life and sparkle. It is better to experiment by varying the elevation of your camera position, as reflections are at their worst when the camera angle is approximately 45 degrees to the surface of the water, yet are far less apparent at higher and lower angles.

■ THE MANNER IN which light rays are refracted by water can result in some strange distorting effects, with your model's limbs appearing to change shape quite drastically under water. The effect is beyond your control, so the only answer if your model is standing thigh-deep in water is to crop your image close to the water level.

■ CONSIDER CAREFULLY the colors of your model's swimwear. In general, bold, primary colors are more effective than fussy, patterned mixtures. Soft, pastel shades have little impact, but they are useful for suggesting a gentle, more relaxed atmosphere.

A gold reflector was used to add warmth to the face, bright highlights to the eyes, and to exaggerate the contrast of the red costume against the blue pool.

TECHNICAL DATA
Camera
Bronica ETRSi
Lens 150mm (medium telephoto)
Film Fuji RDP100
Exp 1/125th – f5.6
Filter Polarizer

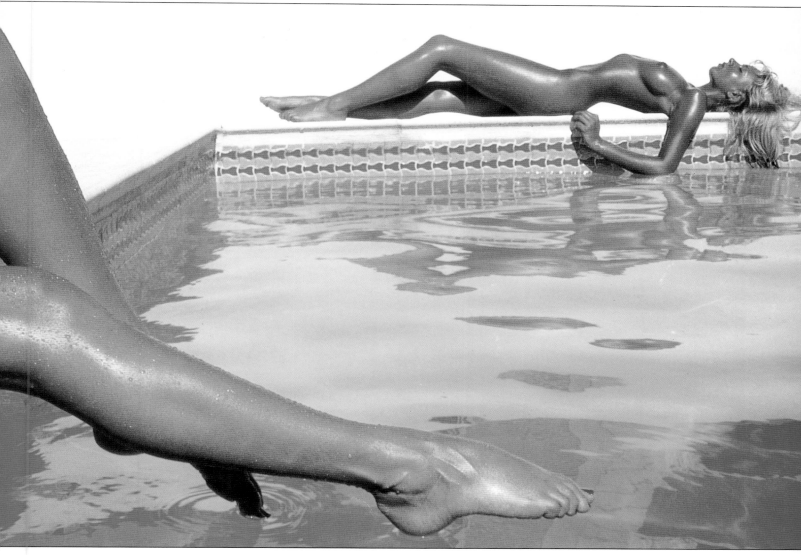

Two models and a narrow aperture give a graphic image.

TECHNICAL DATA
Camera
Olympus OM4
Lens 50mm (standard)
Film Fuji RDP100
Exp 1/125th – f16

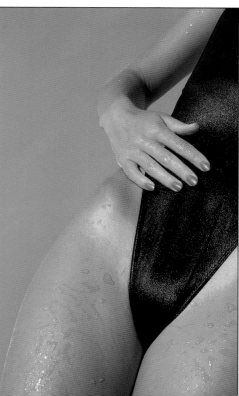

Black costumes always make an impression especially when wet.

TECHNICAL DATA
Camera
Mamiya 645
Lens 150mm (medium telephoto)
Film Kodak EPR64
Exp 1/250th – f8
Filter 81b (warm-up)

129

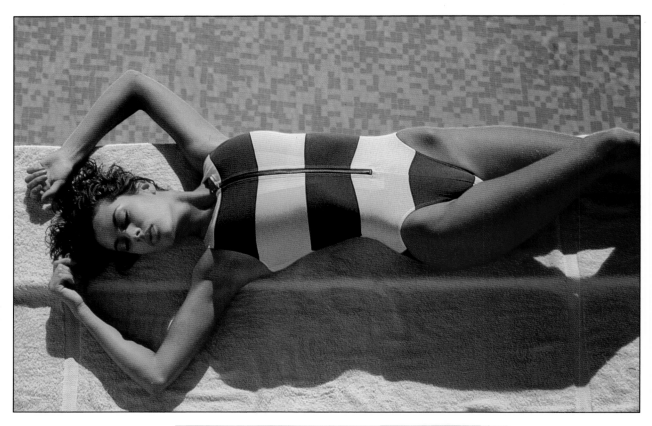

Above: Lighting is by direct sunlight, with a white reflector placed at the bottom of the frame to soften the shadows cast by the model's body, but what makes the picture is the "thirds" composition.

TECHNICAL DATA
Camera
Olympus OM4
Lens 50mm (standard)
Film Fuji RDP100
Exp 1/250th – f8

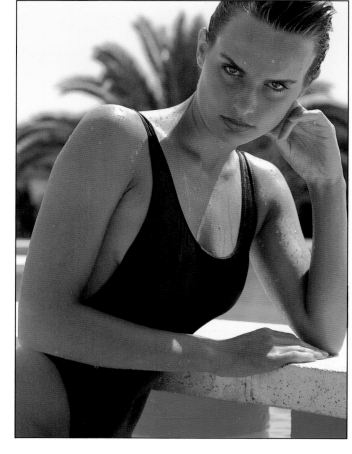

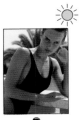

Left: The unusual angle lets the model dominate the frame. The backlit subject has fill-in from the pool, reduced with an 81c warm-up filter.

TECHNICAL DATA
Camera
Mamiya 645
Lens 150mm (medium telephoto)
Film Kodak EPR64
Exp 1/250th – f5.6
Filter 81c (warm-up)

Picture Portfolio

1 This shot makes good use of the chrome steps while the model's make-up matches the color of the umbrella.

2 The only drawback of shooting from a high position is that the model is unable to keep her eyes open due to the bright light. The problem is overcome by adding sunglasses. A gold reflector adds a glow to the model's back.

3 Here a cool mood is conveyed thanks mainly to the choice of towel color. Lighting is by natural sunlight only, with some element of reflection from concrete.

4 This shows just how vibrant primary colors can be.

5 Less vibrant colors in this example have an altogether different effect.

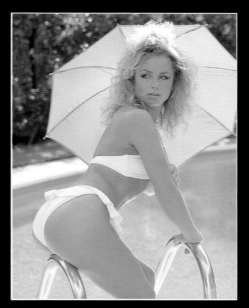

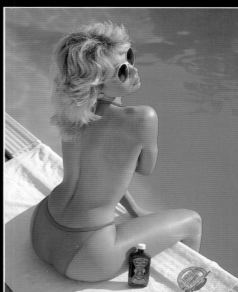

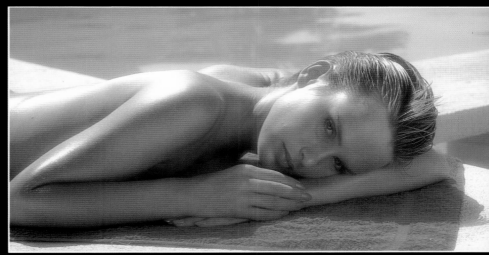

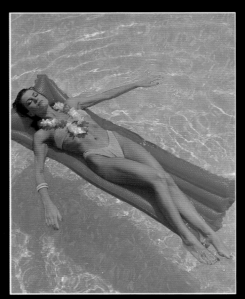

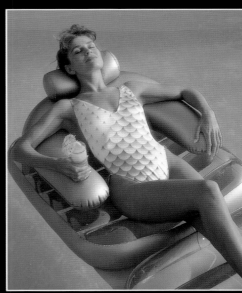

In praise of showers

Outdoor showers are guaranteed to elicit a spontaneous response from your model, especially if the water is refreshingly cool. Your best pictures may well come from the early phase of a shower session, when the novelty of the event can produce an excited and slightly shocked reaction – the first touch of cold water will probably make your model draw breath, and you should be ready to record the moment.

It may seem unlikely that an open-air shower can suggest the same intimacy as a private one, but once your model becomes accustomed to the temperature and flow of the water, she may surprise you by acting as if she is alone in her own bathroom, oblivious to you, your camera – and probably anyone else who might be watching! Try not to interrupt her self-involvement, and be sure to have loaded enough film – if you break the session for any reason, you are sure to lose the spontaneity, and the second take is never as good as the first.

As soon as your model shows signs of "wilting," end the session – once cold she is soon bound to lose interest in the shower and, from the photographer's point of view, purplish flesh tones and goose bumps do not make for good glamour pictures! Remember that you are relying on your model's spontaneity to put the life into your pictures, and that showing consideration for her well-being can only benefit your future working relationship.

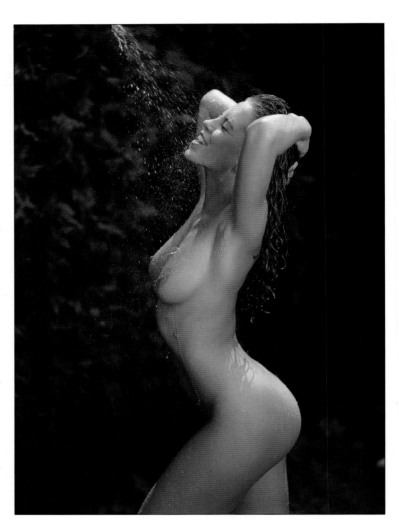

This shot shows the mixed reaction to the water falling on her body; part shock, part pleasure.

TECHNICAL DATA
Camera
Mamiya RB67
Lens 180mm (short telephoto)
Film Kodak EPR64
Exp 1/250th – f5.6
Filter 81b (warm-up)

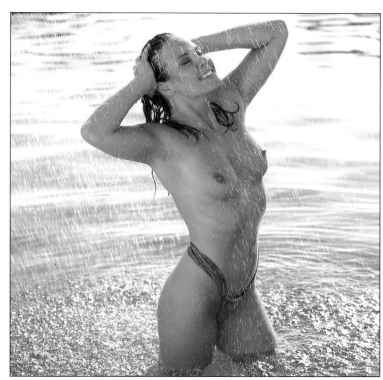

In this case, the spray totally surrounds the model, so backlit droplets fill the frame and also brighten the surface of the pool.

TECHNICAL DATA

Camera Hasselblad
Lens 150mm
(medium telephoto)
Film Kodak EPR64
Exp 1/125th – f5.6

Tumbling water is blurred by a slow shutter speed, and its color contrasts with the model's tan and her yellow bikini. The slightly overcast conditions provide soft, almost shadowless light.

TECHNICAL DATA

Camera
Mamiya RZ67
Lens 250mm
(medium telephoto)
Film Fuji Velvia
RVP50
Exp 1/30th – f5.6

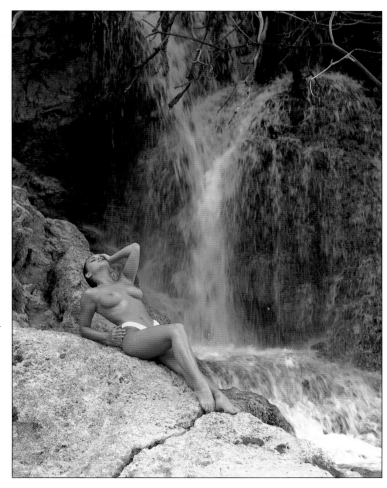

PRO POINTERS

■ WITH REGARD to lighting, remember that a meter reading taken from your model's skin tones before she turns on the shower may not be entirely accurate for the shoot itself – light reflecting from the shower can boost the light level noticeably. You must not interrupt the "flow" of the session to take fresh readings, so try to anticipate any changes in the light level and react accordingly, bracketing your exposures if necessary.

■ MAKING YOUR own garden shower allows you greater control over the session. Place reflectors in the most light-effective positions to illuminate your model and the water. Sun shining through droplets of water makes an attractive backdrop, and frontal reflection bounces light not only onto your model, but also onto the water, so that the individual droplets are effectively lit from both sides. This makes the maximum use of available light, and leads to sparkling results.

■ NOTE THAT the pictorial impact of an outdoor shower may be emphasized by selecting bright, primary-colored items of clothing for your model. If you wish to underline her near-nakedness, black is the most sensible choice.

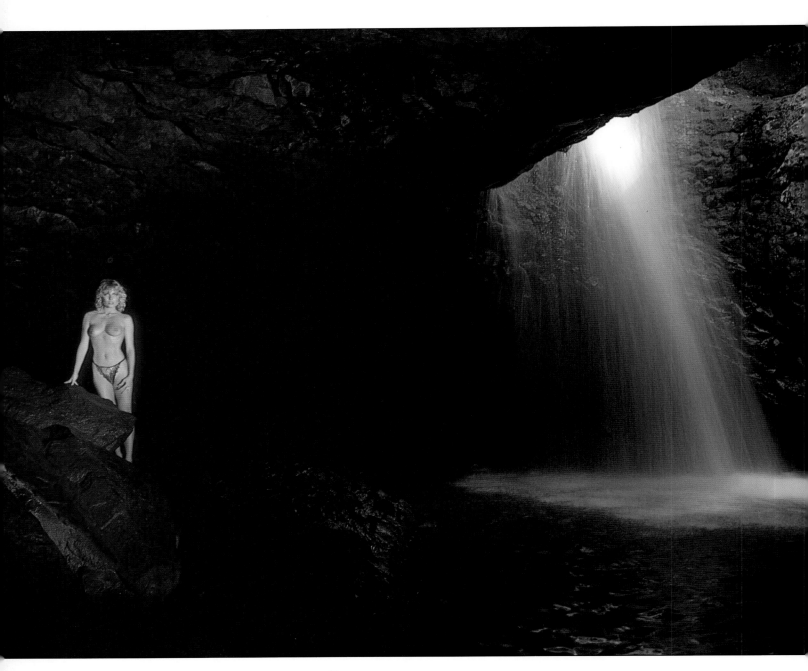

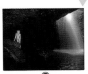

This shot combines two interesting effects: a long exposure reduces the waterfall to a blue blur; and lighting the model with a powerful hand-held tungsten spotlight makes her appear golden.

TECHNICAL DATA
Camera Nikon F4
Lens 28-70mm zoom, set at 70mm (short telephoto)
Film Kodak Ektachrome 100
Exp 1 second at f22
Lighting Hand-held tungsten spotlight

Picture Portfolio

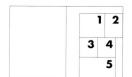

	1	2
3	4	
	5	

1 & 4 Home-made garden showers provide back-lit water framing the model and reflectors are placed either side of the camera. In Picture **4**, the shower is a part of the subject, striking the model, this impact is strengthened by using silver reflectors.

2 uses an existing shower by a pool. The stand makes a prop for the model to hold her position despite the water flow. A gold reflector boosts the already warm light.

3 A ready-made waterfall, a beautiful model, and golden evening sunlight are the key ingredients.

5 Direct light shadows can be kept to a minimum by the model lying down.

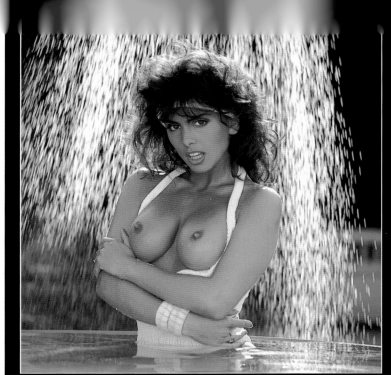

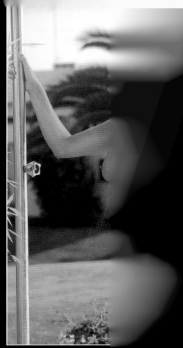

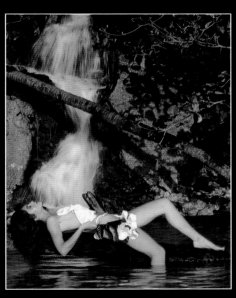

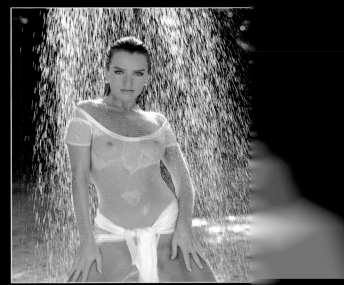

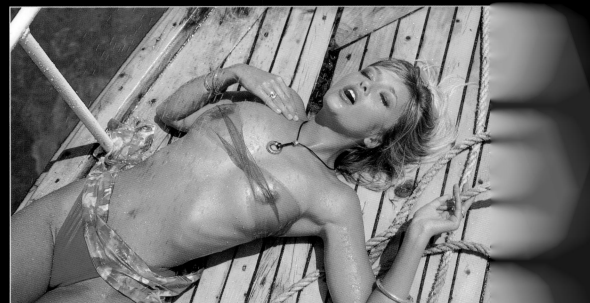

CARS, MOTORCYCLES, ACTION

One of the most overworked clichés in glamour photography is the combination of girl and machine. Straightforward pictures of glamour models leaning against exotic cars, or sitting suggestively astride powerful motorcycles, have such obvious chauvinistic associations that today's society frowns upon their use in advertising. This does not mean that the combination is no longer a potent one, but it does make it that much more difficult for the glamour photographer to produce widely acceptable images.

The mistaken belief of many would-be glamour photographers is that "girl+motorcycle/car = successful pictures." In truth, the equation is nowhere near as simple as this, and a more original and thoughtful approach is called for. Both lighting and styling play important roles in this alternative approach.

An important decision is how the model should relate to the car or motorcycle. Is it an equal relationship visually; or is it the model or the vehicle that is intended to draw the main attention? Long shots can acquire a kind of classic beauty if the pose is elegant rather than suggestive, so the lines of the body complement the lines of the machine.

Alternatively, you can choose to come in close and develop an almost abstract composition, in which both elements are seen only in part. This can supply very bold, sensuous shapes and dramatic contrasts of light and shadow or surface texture.

The late-evening sunlight, rich blue sky, and wild landscape – the model adds the final touch to a successful image. Her nakedness echoes the natural location, and she emphasizes the massive size of the vehicle, itself dwarfed by the landscape.

TECHNICAL DATA
Camera
Pentax 6 × 7
Lens 150mm
(medium telephoto)
Film Fuji RDP100
Exp 1/60th – f11

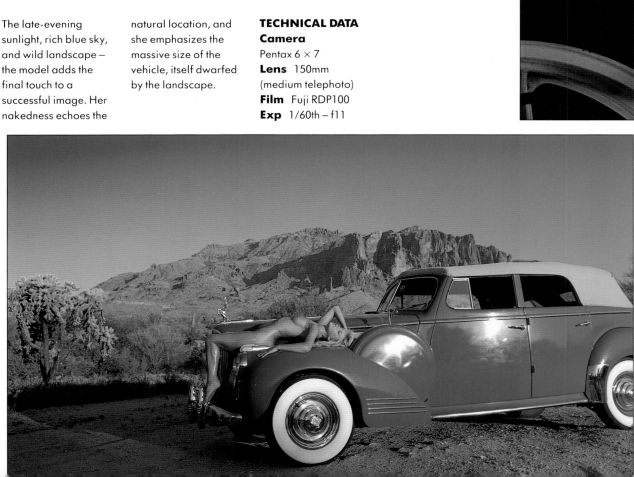

This studio shot succeeds for three reasons: the low lighting angle; the almost abstract quality of the shot from tight cropping; and the limited use of color.

TECHNICAL DATA
Camera Hasselblad
Lens 100mm (short telephoto)
Film Fuji RDP100
Exp 1/125th – f8
Lighting Studio flash (*single large studio unit with soft box, on floor to camera right. Striplite behind bike, creating graduated background*)

Dynamic styling

A well thought out combination of style and technique is the key to successful machine shots. In the example shown on this page, although the girl is provocatively dressed, she gives the impression of being in control of the motorcycle and her situation. Her pose and the way the camera position relates to it both imply that, with the model appearing slightly aloof and her gaze directed out of the frame rather than into the camera. The choice of location is also important, in this case suggesting a wild freedom. All such details help you to rework this kind of image in a non-clichéd style.

Strong, direct sunlight may illuminate the subject evenly, eliminating the need for fill-in lighting. If you do need additional brightness, you can combine fill-in flash with a reflector, or use two types of reflector. For example, the model might be "warmly lit" with a gold reflector, while a carefully placed, smaller silver reflector would cast light onto chrome detail on a motorcycle or car without creating harsh, burnt-out highlights.

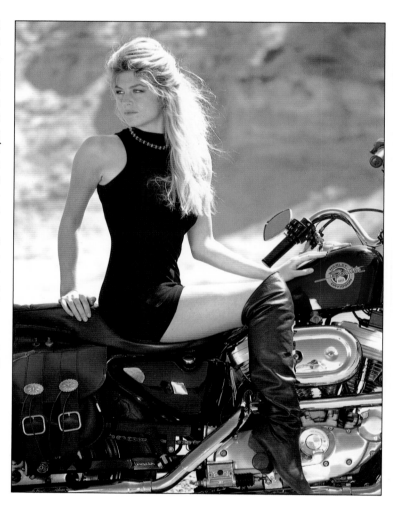

PRO POINTERS

■ MANY MODEL-and-machinery shots fail because the photographer takes the trouble to light one element, yet ignores the other. Whether some photographers are more interested in girl or motorcycle/car is immediately apparent from studying the finished pictures. Try to balance your lighting in order to accord equal status to each element, rather than making the machine the excuse for the girl, or vice versa.

■ MAKE SURE the model seems at ease in the situation, both in regard to her specific pose and the overall mood of the shot. Taking time to find a balanced, comfortable pose in collaboration with the model may lend additional grace or dynamism to the picture.

Using the afternoon sun as a backlight, frontal illumination supplied by two gold reflectors – a 3¼-foot circular gold, held just out of picture left lighting the model, and a large, 6½- × 3¼-foot gold, farther back and to camera right, lighting the bike. The surrounding sand also helps to lift light levels.

TECHNICAL DATA
Camera
Bronica ETRSi
Lens 150mm
(medium telephoto)
Film Fuji RDP100
Exp 1/125th – f8
Filter 81b (warm-up)

Picture Portfolio

1 Studio tungsten striplites directly above the car pick out flared parts of the vehicle's body with white light. The model adds a sense of scale, confirming that it is in fact a real car and not a scale model.

2 A tightly-cropped approach to shooting model and machinery in an outdoor situation. Lighting is direct (evening) sunlight only, emphasizing the bright red bodywork of the car, with no fill-in light necessary.

3 Evening sunlight is soft enough for the model to be able to open her eyes and look straight into the sun. No attempt need be made to justify this image of girl and bike – it is an excellent picture that succeeds because it combines an attractive model, good lighting, interesting props, and carefully considered composition.

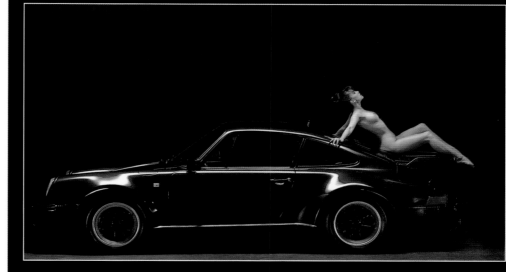

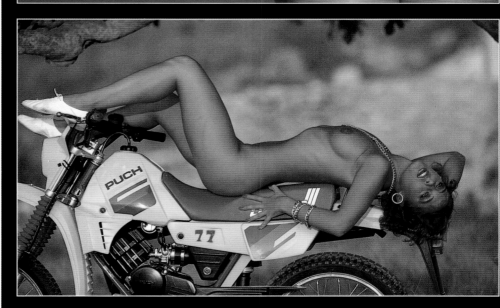

INTERIOR SHOOTS

igh on the list of the most popular locations for indoor glamour photography are the bedroom and the bathroom. A partially dressed model may look out of place in a kitchen or dining-room setting, but the same could not be said of either bedroom or bathroom. On the contrary, each provides a totally appropriate location for glamour.

Finding examples that are suited to photography is a different matter. As previously mentioned, no matter how beautiful a room may be, if it is not spacious enough to accommodate you, your model and your lighting, then it is just not suitable.

Let us assume that you do find your ideal rooms, and that you have made your pre-shoot reconnaissance trip to establish approximate lighting requirements. It is now the day of the shoot, and you arrive at the chosen location with your model. The first task is to set up your lighting, so that you are ready to start work as soon as your model has prepared herself – try to avoid keeping her waiting while you fiddle with lights and camera, as this does little to create the right mood for glamour photography.

Daylight through windows on stairwell behind model is the only light. Obviously planned and shot in the morning before the office opened, the composition is emphasized by the use of a wide-angle lens.

TECHNICAL DATA
Camera Hasselblad
Lens 55mm (wide-angle)
Film Fuji RDP100
Exp 1/30th – f11

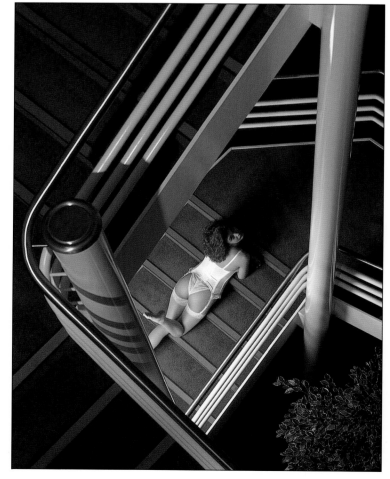

Right: A giant hotel bed, shot from a balcony, gives a new perspective. A large soft box placed below and to the right of the camera is supplemented by a white reflector to the left.

TECHNICAL DATA
Camera Hasselblad
Lens 100mm (short telephoto)
Film Kodak EPR64
Exp 1/125th – f11

140

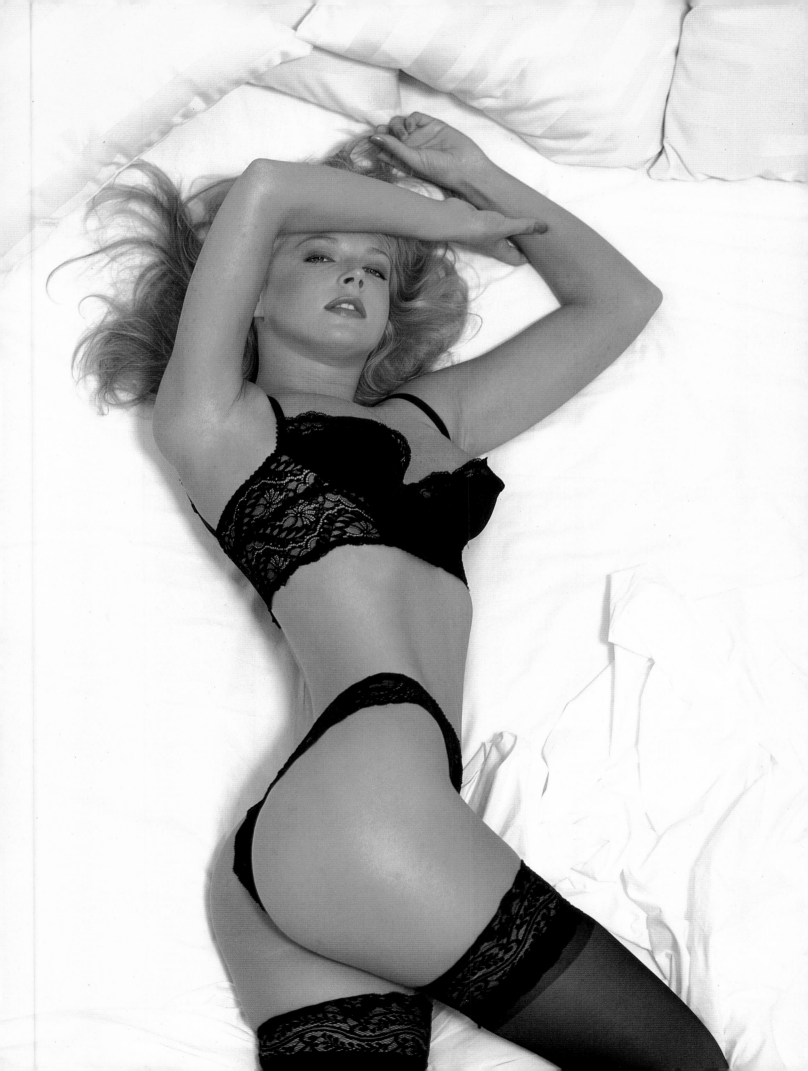

Sleepy shots

A bedroom affords a perfect opportunity to experiment on location with the tungsten/flash mixture previously described (see Mixing tungsten and flash on page 32). Your aim should be to emphasize the allure of your model by matching the mood of the lighting to the intimate associations of the bedroom. To this end, the seductive warmth of tungsten, and the almost shadowless softness of diffused electronic flash, can combine to create the right impression on your viewer.

As already discussed, tungsten lamps are very fragile, and must be transported with great care, but their use is recommended in spite of the inconvenience. Regarding electronic flash, the most suitable type is the self-contained unit, as it is compact and portable. All the major manufacturers of studio flash produce "location kits," which normally include two of these units, together with reflective umbrellas, stands, and other allied accessories, all packaged in a single, strong case. Most professional glamour photographers find these kits invaluable.

PRO POINTERS

■ As a general rule, be sparing with light in the bedroom – the intimate atmosphere will soon be lost if you are careless and flood the room with light. With sensual feminine fabrics as satin, silk and lace, you can only reproduce the delicate, tactile qualities of such materials by caressing your model and her environment with light. An element of soft focus may be used gently to enhance mood and atmosphere in the bedroom, but filter your light too heavily and the definition of individual textures can dissolve into a misty blur.

■ A low level of light can lead to long exposures, normally ill-advised for glamour photography. In most circumstances, a long exposure increases the likelihood of your model moving, but bedroom sessions are the exception. The model is less likely to move if stretched out on a bed, or propped comfortably on a pile of cushions.

■ While the obvious focal point of the bedroom is the bed itself, do not ignore the photographic potential of other aspects, such as the dressingtable. Remember to meter initially for the tungsten, then set your flash to contribute half a stop less light to the overall exposure. Avoid overpowering the tungsten, to ensure that its warmth shows in your pictures.

This shot uses a mixture of tungsten and flash, biased with the tungsten half a stop stronger than the flash exposure.

TECHNICAL DATA
Camera
Mamiya 645
Lens 150mm
(medium telephoto)
Film Kodak EPR64
Exp 1/30th – f8
Filters Soft-focus
plus 81b (warm-up)

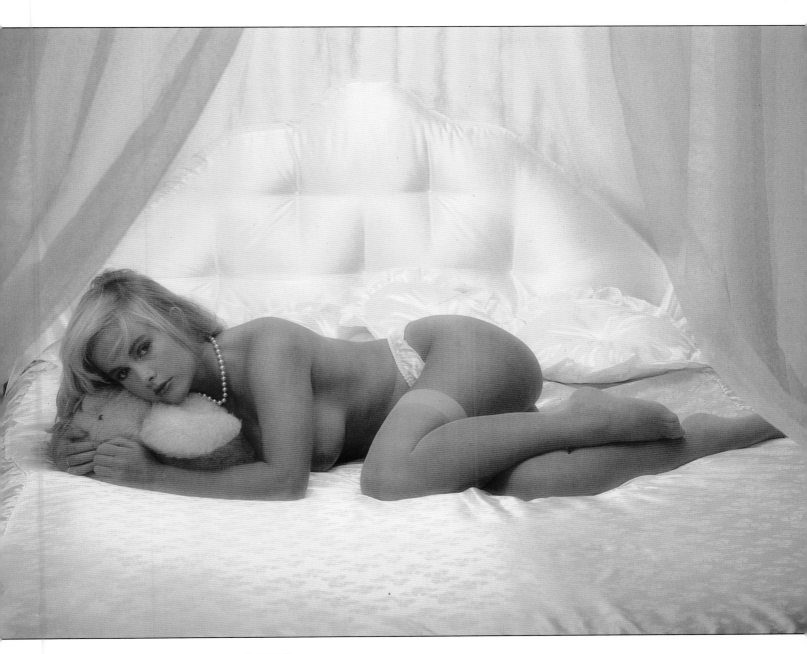

Four-poster beds present an interesting challenge to the photographer. Lighting them subtly, but evenly, is made difficult by their very nature – four posts can create many unwanted vertical shadows. The answer, as shown here, is to introduce the majority of the lighting from above, preferably through the canopy if the fabric permits. Fill-in light (a tungsten spot in this case, to add a warm glow to the model's flesh tones) can come from the sides, but meter carefully to minimize conflicting shadows.

TECHNICAL DATA
Camera
Mamiya 645
Lens 110mm (short telephoto)
Film Kodak EPR64
Exp 1/15th – f8
Filters Soft-focus plus 81b (warm-up)

Women and water

Bathrooms present the photographer with a chance to explore the winning combination of women and water in an indoor location. Baths and showers offer a wealth of opportunities for glamour photography, and electronic flash is the sensible choice for lighting such situations.

The main reason for this advice is one of common sense. As has been discussed, tungsten lamps heat up very quickly, and, while this is of little consequence in a bedroom, where a little extra warmth is most likely to enhance the atmosphere, it can be a serious drawback in a wet bathroom. Tungsten lamps are sensitive at the best of times, and exposure to moisture more or less guarantees their early demise, possibly even by exploding rather than simply fusing. Play safe – keep tungsten as far away from water as possible. Electronic flash is comparatively "safe" in a bathroom. If you use a soft-box reflector, the element itself is not even exposed, but the combination of electricity and water must obviously still be handled with extreme care.

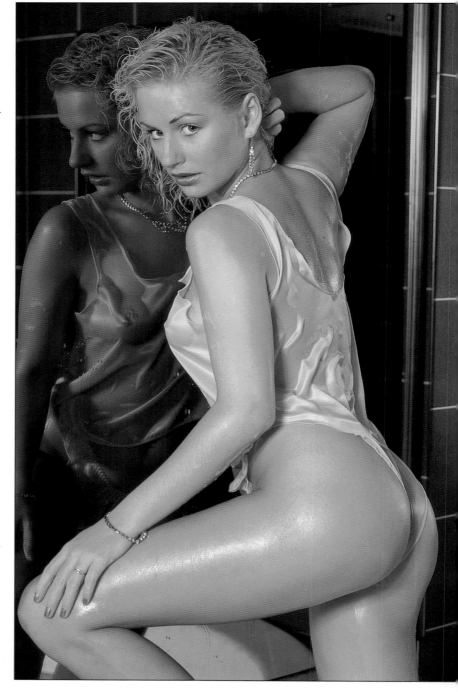

A single soft box subtly emphasizes the glamorous "wet look."

TECHNICAL DATA
Camera
Mamiya 645
Lens 110mm (short telephoto)
Film Kodak EPR64
Exp 1/60th – f8.5
Filter 81b (warm-up)

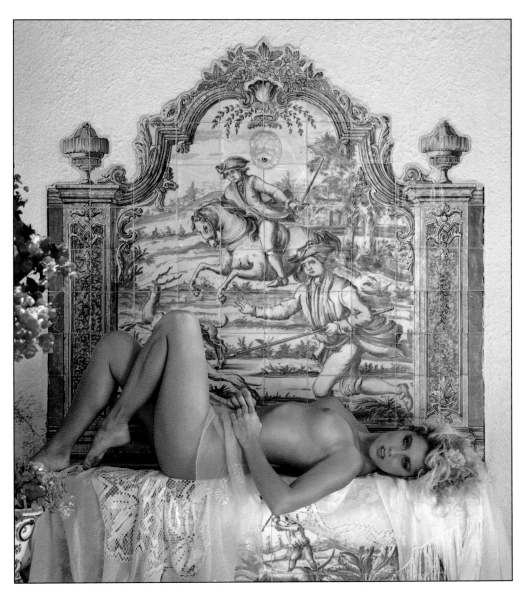

In addition to the window light, a white reflector to camera right adds fill-in light to the face – further emphasizing the model's strong make-up.

TECHNICAL DATA

Camera
Mamiya RB67
Lens 180mm (short telephoto)
Film Fuji RDP100
Exp 1/15th – f5.6
Filter 81b (warm-up)

PRO POINTERS

■ IN ADDITION to safety, flash is appropriate to a bathroom location for at least four reasons:
1) The extra power of flash enables the photographer to select a faster shutter speed than would be possible with tungsten, so that the movement of water in a shower can be "frozen," if desired. The extra speed also allows you to capture your model's enjoyment of either shower or bath. In contrast to the bedroom situation, you can encourage her to react to her environment. Be assured that water brings even the most reserved of models to life!
2) The daylight color temperature of flash guarantees a true rendition of colors, an important consideration as far as direct visual impact is concerned.

3) Bathrooms are usually small enough for a single diffused flash source to provide sufficient bright, even-lighting to fill the room, keeping leads and cables to a minimum and leaving the maximum amount of space in which you and your model work.
4) A diffused light, easily created by adding a large soft box to a single flash unit, is the preferred form of illumination in a bathroom in order to avoid sharp, specular highlights on chrome fittings or on the shiny, tiled surfaces.

■ BATHROOMS ALWAYS contain mirrors – sometimes too many to make the photographer's task an easy one. Compose your pictures carefully to avoid unwanted reflections.

■ IF THINGS GET a little steamy in the bathroom, be sure to change films and lenses outside the room so that no moisture enters your camera.

Picture Portfolio

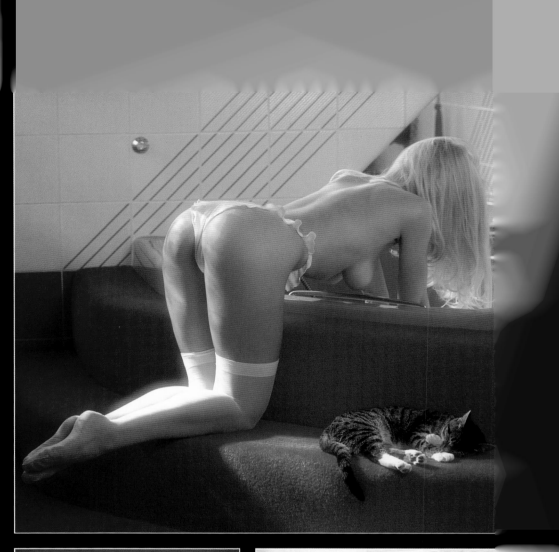

1 A delicate mix of daylight and electronic flash, using the rays of morning sun shining through the windows to create a series of bright highlights.

2 The shiny-tiled floor mirrors the model and stool. The photographer has elected to rely on daylight and reflection alone for the exposure, maximizing the "white light" effect on the floor.

3 A classic bathtime image, cleanly lit with electronic flash.

4 A languid pose shows off sinuous curves and glowing flesh tones, lit with a single tungsten spot-light. With daylight-balanced film, this gives a "golden glow."

5 The same tungsten technique to exploit the opulence of the golden-walled room.

6 Again, a tungsten light is used on daylight film to create the golden warmth, as if the model is lit by the fire glow.

7 The warmth comes from gold reflectors, redirecting afternoon sunlight.

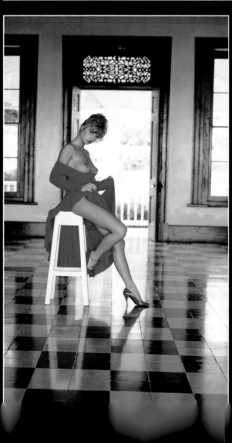

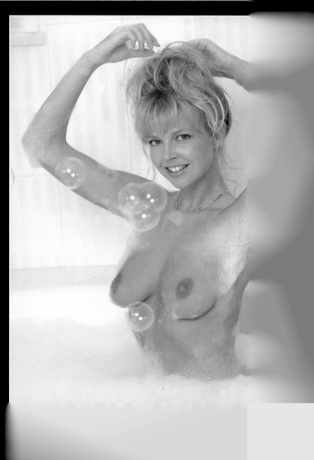

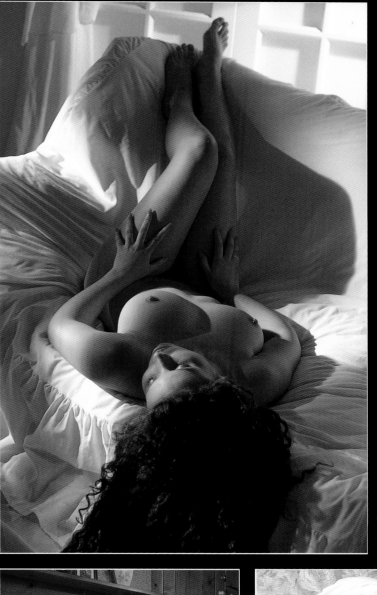
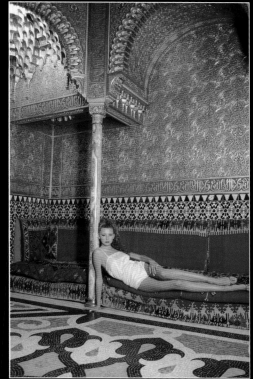
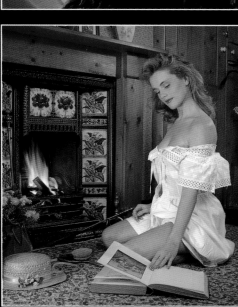
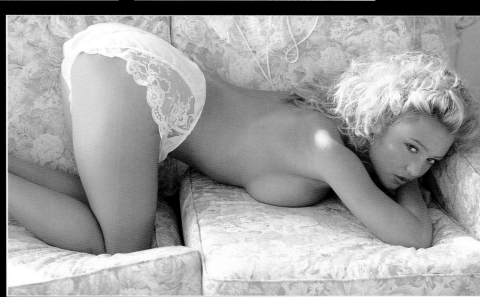

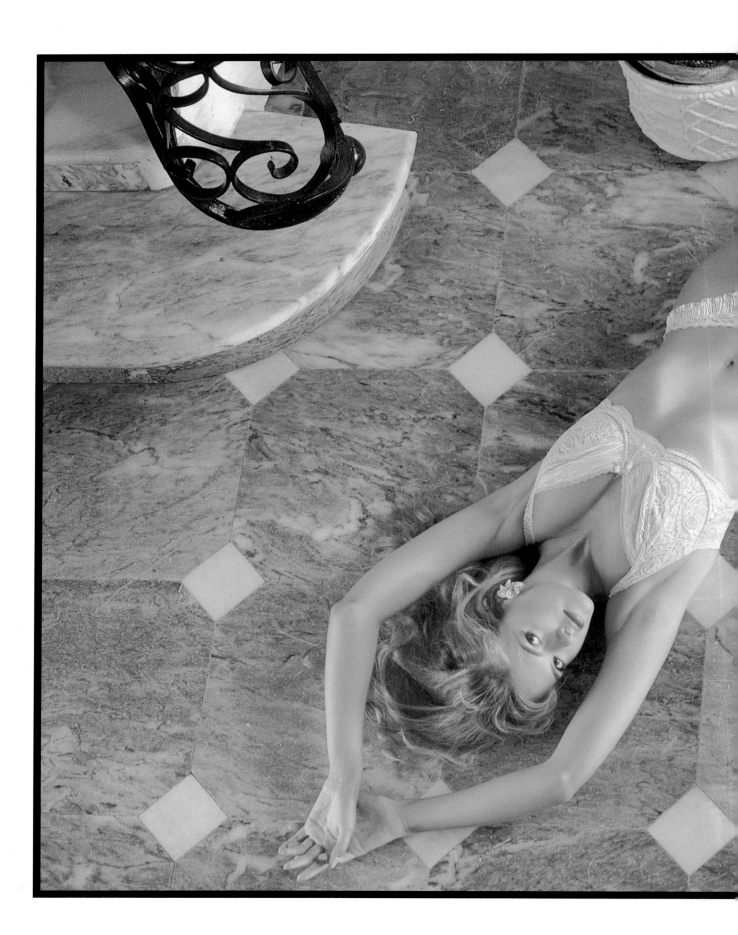

PROFESSIONAL GLAMOUR

5

As an aspiring glamour photographer, your ambition is probably to make a living from the profession. The reality of the situation is that glamour is an extremely competitive area of photography, but you should not be discouraged because it is also one of the most accessible. The glamour spectrum is broadening, and there is now every chance for talented and original new photographers to be accepted into the professional glamour world.

The balcony of a luxurious marble-floored villa made an ideal viewing platform, enabling the photograher to create this unusual image. Lighting is predominantly daylight with a small amount of tungsten fill-in to add warmth to the model's flesh tones.

TECHNICAL DATA
Camera
Mamiya RZ67
Lens 180mm (short telephoto)
Film Fuji RDP100
Exp 1/15th sec – F11

Types of publication

The range of publications using glamour images is vast, and is constantly being extended. Obvious examples of potential markets for the photographer include books, magazines, and calendars, to which may be added fashion-related publications such as brochures, posters, and a plethora of journals.

Book publishers are well aware of the selling power of glamour, as is evidenced by the number of fictional works featuring pictures of models on the covers. Magazine markets include the ubiquitous adult press, including the well-known *Playboy, Penthouse,* and many more, but do not forget that other types of magazine are frequent users of glamour images – the photographic press is just one good example.

Turning to calendars, there are two types of glamour calendar: stock and bespoke. Stock is the more practical outlet for the free-lance photographer, as the images are chosen by the publisher from various sources, including speculative submissions by free-lancers and selection from stock agency files (see far right). Bespoke calendars are seen by many to represent the pinnacle of glamour photography, as they are commissioned by, and shot for, a single client. The amounts of money involved in photographing and producing a calendar are considerable, but the kudos attached to shooting bespoke is unquantifiable – it is enough to say that, if Pirelli request your services for next year's calendar, you can safely feel that you have made the big time!

Promotional brochure The confidence in the statement that accompanies this promotional image for a major lingerie company echoes society's happily changing attitude to glamour in the '90s.

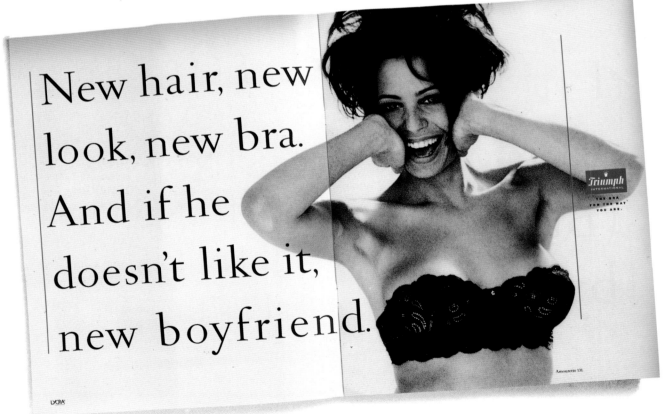

New hair, new look, new bra. And if he doesn't like it, new boyfriend.

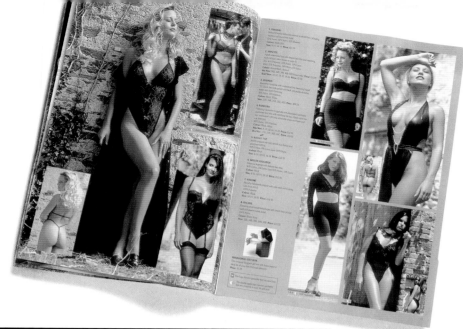

PRO POINTERS

■ THERE IS NO substitute for intensive research when it comes to understanding the market for glamour photography. Reference books such as the *Literary Market Place* offer invaluable assistance, listing the addresses and telephone numbers of every publisher, and detailing their titles. However, the best way of finding the most appropriate markets for your pictures is to study the styling and content of as many books, magazines and calendars as possible on a regular basis. Researching over a period of months (years in the case of calendars), you should be able to ascertain with some accuracy just what kind of image each publisher uses most regularly, and thereby deduce which publications are most suited to your particular style of glamour photography.

Catalog (above) Many lingerie and swimwear companies produce lavish full-color brochures such as this. They often use a combination of fashion and glamour models, and are always shot by professional photographers.

Fashion Glamour's link with fashion is becoming ever closer, as this striking image taken from a feature on ethnic fashion in a women's magazine clearly illustrates.

■ MARKETS ABROAD are more difficult to assess, for the obvious reason that publications from overseas are unlikely to be widely available outside their country of origin. This is one of the best reasons for marketing your pictures through a stock agency. These establishments lend an image to a client, for a fee of course, then replace it in the files until the next appropriate request. The top agencies have offices worldwide, and your pictures can be exposed

151

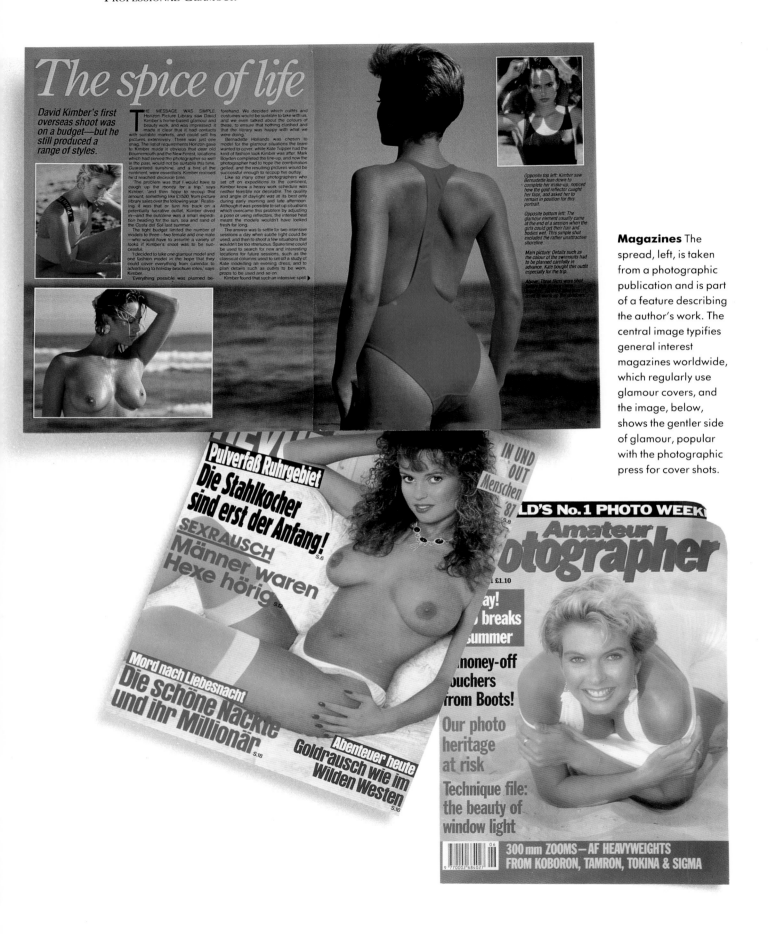

The spice of life

David Kimber's first overseas shoot was on a budget—but he still produced a range of styles.

THE MESSAGE WAS SIMPLE. Horizon Picture Library saw David Kimber's home-based glamour and beauty work, and was impressed. It made it clear that it had contacts with suitable markets, and could sell his pictures, extensively. There was just one snag. The list of requirements Horizon gave to Kimber made it obvious that dear old Bournemouth and the New Forest, locations which had served the photographer so well in the past, would not be suitable this time. Guaranteed sunshine, and a hint of the continent, were essentials. Kimber realised he'd reached decision time.

The problem was that I would have to cough up the money for a trip,' says Kimber, 'and then hope to recoup that amount,' something like £1500, from picture library sales over the following year.' Realising it was that or turn his back on a potentially lucrative outlet, Kimber dived in—and the outcome was a small expedition heading for the sun, sea and sand of the Costa del Sol last summer.

The tight budget limited the number of models to three—two female and one male —who would have to assume a variety of looks if Kimber's shoot was to be successful.

'I decided to take one glamour model and one fashion model in the hope that they could cover everything from calendar to advertising to holiday brochure roles,' says Kimber.

Everything possible was planned be-forehand. We decided which outfits and costumes would be suitable to take with us, and we even talked about the colours of these, to ensure that nothing clashed and that the library was happy with what we were doing.

Bernadette Hollands was chosen to model for the glamour situations the team wanted to cover, while Kate Tupper had the kind of fashion look Kimber was after. Mark Boyden completed the line-up, and now the photographer had to hope the combination gelled, and the resulting pictures would be successful enough to recoup his outlay.

Like so many other photographers who set off on expeditions to the continent, Kimber knew a heavy work schedule was neither feasible nor desirable. The quality and angle of daylight was at its best only during early morning and late afternoon. Although it was possible to set up situations which overcame this problem by adjusting a pose or using reflectors, the intense heat meant the models wouldn't have looked fresh for long.

The answer was to settle for two intensive sessions a day when subtle light could be used, and then to shoot a few situations that wouldn't be too strenuous. Spare time could be used to search for new and interesting locations for future sessions, such as the classical columns used to set off a study of Kate modelling an evening dress, and to plan details such as outfits to be worn, props to be used and so on.

Kimber found that such an intensive spell ▶

Opposite top left: Kimber saw Bernadette lean down to complete her make-up, noticed how the gold reflector caught her face, and asked her to remain in position for this portrait.

Opposite bottom left: The glamour element usually came at the end of a session when the girls could get their hair and bodies wet. This simple shot excluded the rather unattractive shoreline.

Main picture: Details such as the colour of the swimsuits had to be planned carefully in advance. Kate bought this outfit especially for the trip.

Above: These films were shot ...

Magazines The spread, left, is taken from a photographic publication and is part of a feature describing the author's work. The central image typifies general interest magazines worldwide, which regularly use glamour covers, and the image, below, shows the gentler side of glamour, popular with the photographic press for cover shots.

Book covers These are printer's proof copies of three book covers. Always ask the publisher for printer's proofs, in preference to actual books, both for their superior quality and to enable them to be displayed flat in your portfolio.

to innumerable new markets: picture researchers the world over constantly use stock agencies as a major source of material.

Agencies do have their drawbacks, however. The standard agency commission is 50% for each and every transaction, and payment is never made to the photographer until the agency has been paid by the client. This irregularity and unpredictability of payment makes it unwise to rely on stock sales for a living, unless, like some of the more prolific glamour photographers, you are able to submit large numbers of images on a regular basis, thus putting yourself in a more rewarding position financially. It should be noted here that agency standards are extremely high, and only a small percentage of submitting photographers have their work accepted. The other side of the coin is that being accepted is a confidence-inspiring affirmation of your commercial viability.

■ ANY INVOLVEMENT with the advertising side of glamour photography, such as brochures of lingerie or swimwear collections, requires a disciplined photographic approach. The clothing must be seen in the best possible light to ensure that details of design and colors of fabric are reproduced precisely.

153

February

	MON	TUE	WED	THU	FRI	SAT	SUN
			1	2	3	4	5
	6	7	8	9	10	11	12
	13	14	15	16	17	18	19
	20	21	22	23	24	25	26
	27	28					

January

March

Reflections 1995

Calendars In calendar work, it's usual for the pictures to be linked by a common theme, as in the example shown here. The first unusually transposes a selection of original color images to sepia tinted black-and-white, while the second is the product of a glamorous commission involving a castaway cruise in the Aegean Islands.

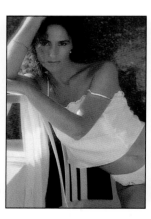

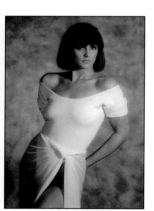

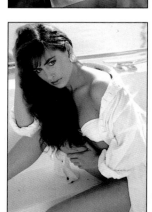

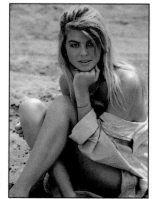

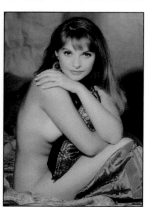

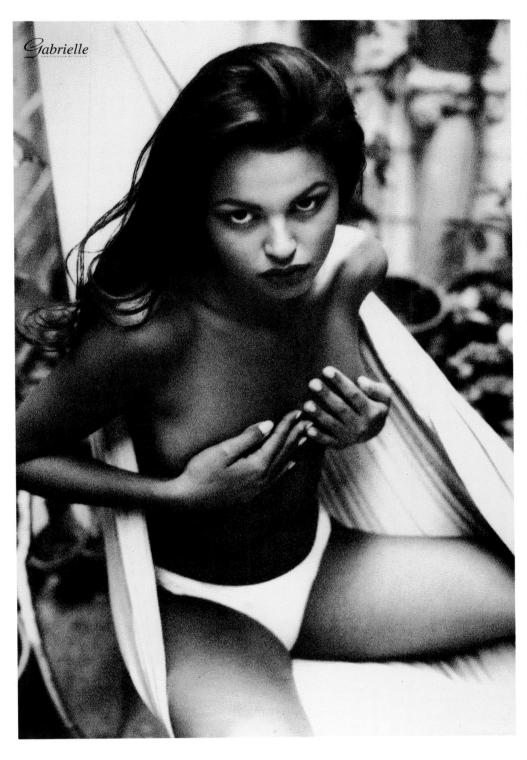

Gabrielle

Any deviation from average midday color temperature is likely to affect the colors, so, if you are forced to work in the warmer-colored light at either end of the day, be sure to use color-correction filters to re-balance the light. White reflectors should be used in preference to gold or silver, and all "effects filters" should be avoided – even a polarizing filter can cause problems by reducing reflected light, perhaps rendering a glossy fabric dull and lifeless. Fill-in flash should be used sparingly, if at all, for the exact opposite reason, as too much flash can cause a heavy, luxurious fabric to take on an appearance of decidedly inferior quality. Remember that, although you are still photographing a glamour model, her job in this instance is to provide the most effective vehicle possible for the clothing – you are selling the fashions, not the model.

■ THE FEES PAID to glamour photographers vary considerably from one publication to another, the only consistency being that advertising work tends to pay better than editorial. Be prepared to accept quite low fees initially, remembering that it is important for your pictures to be seen in as many publications as possible in order for you to gain the necessary credibility that leads to commercial acceptance.

Posters The popularity of poster art has enabled the cream of contemporary fashion and glamour photography to be seen as fine art, with many companies now printing high-quality limited editions of selected photographic images.

155

Getting the job

Assuming that your photography has reached a sufficiently high standard to facilitate acceptance into the world of glamour, your next step is to establish how best to promote yourself to potential clients.

A first-class portfolio is the basis of every professional photographer's working career, and the yardstick by which you are judged. You should show your clients a representative selection of all your pictures.

When putting together your portfolio be sure to include examples of indoor and outdoor work, and generally display your photographic versatility. It may be appropriate when meeting certain clients to tailor your portfolio to their requirements – doing your homework and researching the types of pictures used by a specific client should influence picture selection on such occasions.

Remember that you are selling not just your skills as a photographer, but yourself as well, so personal presentation and attitude are all-important. Glamour photography is a business, and your perceived qualities need to combine business sense and common sense with the technical ability and intelligence to satisfy your clients' requirements. Photographers cannot afford to be primadonnas, so a complacent attitude and personality quirks are not likely to endear you to a potential client, no matter how special your work may be.

Presenting yourself A good portfolio is the basis of every professional photographer's working career. Displayed here are the author's own portfolios, containing published work. Also included are examples of self-promotional materials, including business cards and letterheads.

PRO POINTERS

■ TRY TO OBTAIN copies of all your published work and include these in your folio. Nothing impresses a potential client more than concrete evidence of your commercial acceptance, assuming, of course, that the quality of reproduction does your photographs justice. Publishers' proofs, or cromalin copies, are ideal items for folio display, as they are frequently of a higher quality than the final mass-printed reproductions.

■ WHEN APPROACHING potential clients, always try to find out the name of the person with whom you should be dealing, rather than simply asking for "the Art Editor," or similar. Most magazines carry detailed listings of their editorial staff, which makes your task simpler.

■ IT IS WORTHWHILE investing in self-promotional material such as business cards and letterheads, to enhance your professional image. A telephone answering machine is vital to enable clients to leave messages for you in your absence, and a fax machine is another very useful business tool, enabling you to transmit and receive written information.

USE YOUR HEAD

So you've got a job! You are to produce the cover photograph for a new novel. You have been given a synopsis of the story, a budget for the shoot, an artist's impression of how your picture should work within the cover layout, and a very tight deadline.

Study each aspect of the assignment carefully to ensure that logistical problems do not intrude on your creative input. The budget is your main guide. There is no point in being over-ambitious with your plans if the budget does not allow for extravagance. Model fees, studio or location hire, and props, as well as film and processing costs, must all be evaluated. Don't forget that your own fee also has to be drawn from the budget.

Choice of model and location are usually left up to the photographer. If, however, a book's synopsis describes the heroine as having "eyes the color of cornflowers" and a "mane of wild, golden hair," and her situation as "spending her first summer away from home, working as a lifeguard at a Caribbean beach club," then you must take note of these guidelines.

Taking the model first, you know that she has to have blue eyes and long blonde hair, and, with the nature of her job in the story, she is sure to be deeply tanned and very fit-looking. Study model-agency catalogues and make a shortlist of suitable girls before contacting their agencies to discuss availability. You should then arrange to see the possible girls with their portfolios.

Don't forget to visit your chosen location before the shoot, to check on lighting and possible camera angles, tides, potential

Agency brochures and models' cards
All professional models have their own composite cards, which feature a selection of images chosen to emphasize their versatility, while agencies produce glossy catalogues to display their range of models.

props, and the degree of privacy you can expect. With reference to the book, an attractive proposition for the cover could be a low-angle shot looking up at the model on the steps of her lifeguard tower.

The model's elevated position allows the shoot to take place at whatever time of day suits you, as your camera angle relative to her will exclude the other people on the beach. The direct sunlight should guarantee a bright blue sky (possibly enriched by polarization) to be included in the background.

Having confirmed your model booking, make time to meet with her to discuss the shoot, with particular reference to clothing and props. The artist's impression of the cover layout is important at this stage: if your creative director suggests a red swimsuit to tie in with the color of the cover typography, then you would be advised to follow that lead – you must always satisfy your client's wishes first, but do not be afraid to shoot alternatives of your own choosing. After all, the client has chosen you for your photographic vision, not just your technical ability.

All goes well on the day of the shoot, but your job is not over until the finished transparencies are approved by the client. Process the exposed films as soon as you can, and be sure to deliver on time – your best-ever pictures are of no value if they arrive after the deadline.

Index

Credits

All photographs are by David Kimber with the exception of the following: Ace Photo Agency 116 (Bo Cederwall), 38*a* & *b*, 109 (Ian Spratt), 151*b* (Bob Tanner), 137 (Ross Vincent); Image Bank 117*b* (Amanda Clement), 55, 118*b* (Paolo Curto), 18/19 (Sergio Duarte), 46*a* (Robert Farber), 20 (Nino Mascardi), 42, 104/5, 129*a*, 130*a* (Chris Thomson); Rayment Kirby 51*al*, 110*l*; Pictor International 85, 107, 115, 118*a*, 135*cl*, 141, 145, 146*bl* & *br*; PictureBank Photo Library Ltd 1, 2/3, 21, 25, 26*a*, 43, 44, 46*b*, 47, 48, 56, 61*b*, 62, 63*a* & *b*, 65*bl*, *br*, *c* & *tr*, 67, 71, 72, 89, 98*a*, 106, 108, 111*a* & *b*, 114, 117*a*, 123, 132, 133*a* & *b*, 134, 135*al* & *cr*, 136, 139*a* & *b*, 140, 147*al* & *bl*, 148/9; Chas Wilder, 152, 153, 154, 156.

We would also like to thank the following organisations for permission to reproduce copyright material: Ann Summers Ltd 151*a*; Athena International Ltd 155; Smithy's Model Agency 157; Triumph International 150.

Key: *a* above, *b* below, *c* center, *l* left, *r* right

Every effort has been made to obtain copyright clearance. Quarto would like to apologise if any omissions have been made.